William Gaunt

THE RESTLESS CENTURY

Painting in Britain 1800-1900

William Gaunt

THE RESTLESS CENTURY

Painting in Britain 1800-1900

PHAIDON PRESS LIMITED, Littlegate House, St Ebbe's Street, Oxford

Distributed in the United States of America by E. P. Dutton, New York

First published 1972 Second edition (paperback) 1978 © 1972 by Phaidon Press Limited All rights reserved

ISBN 0 7148 1835 6

Library of Congress Catalog Card Number: 78-51023

Printed in Italy by Amilcare Pizzi SpA., Milan

Contents

A NEW AGE may be said to have come into being in the period of storm and stress—physical, emotional and ideological—marked by the end of the eighteenth century and the beginning of the nineteenth. It was shaped by war, by political and industrial revolution and revolutionary ideas, and by social change. In the arts the departure from all that was ordered and classical during the reigns of George II and George III was defined in the emergence of the Romantic movement.

The Romantic spirit took several forms. In one respect it was an urge to find relief from the burdens of a time of manifold pressures. Such refuge was to be found in nature, the more distinct from the urban environment the better, especially the wild or unpeopled landscape as opposed to the eighteenth century's man-made rurality. A mental escape could also be made into an historical past, imagined as more glamorous than the present.

Yet this was not all. Reaction from the rational spirit of the eighteenth century produced a leaning towards the mysterious and the excessive. The revolutions in France and America created a keener desire for freedom of individual expression. The violence of the Napoleonic wartime seems, as violence has done in the twentieth century, to have produced a corresponding or counteracting violence of mood in art. The post-war exhaustion of the years 1820 to 1830 gave rise to the mood of Romantic despair all over Europe.

Britain gave an outstanding literary example and impetus to Romanticism. Wordsworth and the Lake School of poets fostered the contemplative recourse to nature and 'the wild secluded scene', and Byron, eloquent in the cause of freedom, and in person a defiantly Romantic figure, fascinated Europe with his poetic tales of picturesque adventure. Sir Walter Scott was the magician who could re-create the past and arouse a new enthusiasm for the medieval times that had earlier been stigmatized as barbarous by the title of 'Gothick' (Plate 35). A parallel complex of ideas and feeling can be traced in the visual arts. The Romantic element was strong in the early years of the century, gradually waning in force and significance, though with certain exceptions, until towards the middle years when realism made fresh headway.

The Great Exhibition of 1851, which bisects the century, also marks the difference between its halves. In the first half, the century suffered for a long time after Waterloo from post-war problems affecting industry and agriculture. It was not until 1846 that the Corn Laws imposed in 1815 were repealed. They had kept the price of corn at an artificially high level for the benefit of the landowners until the abuse could no longer be defended. Industrial production out-stripped for some

time the requirements or purchasing capacity of an impoverished world, creating a prolonged slump and consequent unemployment and misery.

Unrest was constant from the time in 1811 when the Luddites attacked and destroyed the hated machines that had supplanted home industry and thrown even the serfs of the factory out of work, to the period of Chartist demonstration in the 1840s that sought a new deal for the working man. Yet during the same period the middle class was steadily rising to power and wealth. The Reform Bill of 1832 made a new political pattern, in which the centres of industry gained representation in Parliament at the expense of the 'rotten boroughs' and other preserves of the landed gentry. The repeal of the Corn Laws, ushering in an era of free trade as well as giving a certain relief to the poor, strengthened the industrial and commercial class still further.

The problem of poverty was never exorcized from Victorian Britain even in the most prosperous years, yet there was a new momentum in the second half of the century. The railway boom, the new steamship lines, the expansion of trade with the rest of the world—to which the Exhibition of 1851 added its fillip—and a world-wide *imperium* gave an unexampled prosperity to an upper middle class. This prosperity in turn produced a great age of picture-buying. It would evidently be mistaken to think of the affluent Victorian public as being uninterested in art, though its preferences were clearly enough marked.

It is possible to trace a development of middle-class taste from the eighteenth century in pictures with a story of everyday life, domestic in sentiment or atmosphere—such as Henry Walton (1746–1813) and Francis Wheatley (1747–1801) produced—to the social realism of the 1870s and 1880s (Plates 125 and 126). Narrative was a consistent interest (Plates 88, 92, 105, 137 and 142); it was not until the end of the century, and partly under Impressionist influence, that narrative painting lost some of its hold on artist and patron. Yet in this period of change many different factors were operative. A rich complexity is to be found in the imaginative art and landscape of the Romantic phase.

ONE OF THE MOST EXTRAORDINARY figures in British art, or indeed in the world's art, crosses the troubled area of revolution and war into the nineteenth century—William Blake (1757–1827). He was unique in the nature and complexity of his mental life and powers of expression. He was a 'mystic' in the sense of having adopted Swedenborg's belief in the transcendent importance of the spiritual life; a poet, capable equally of exquisite lyrics, epics of mysterious and reverberating depth, vivid paradox and challenging audacities of thought; and withal a designer and painter of tremendous invention.

In some personal respects reminiscent of the great William Hogarth (1697–1764), though his opposite in pictorial creation, Blake was a little man with much of the middle-class John Bull about him: pugnacious, stubborn, prejudiced, insular, sturdily independent. In 1800 he was forty-three and had already achieved much, though the final expansion of his genius was still to come. He had worked for many years at the craft of reproductive engraving in which he had first been trained, pleased to think that though it produced no glory it was honest labour that kept him free. He had produced immortal lyrics and set them in a splendid framework of design engraved by his own process and, with the assistance of his wife, coloured by hand. The process consisted in painting the wording, in Blake's own delightful calligraphy, and the associated illustration or decorative border, with an acid-resistant fluid on a copper plate. Text and design were left in relief when the plate was etched with acid and could be printed like a woodcut. Blake first applied the process to the *Songs of Innocence*, publishing the work himself for want of a commercial publisher. The result was similar to the illuminated manuscript of the days before the invention of printing and recalls Blake's love of all things Gothic, including the tombs he had been set to draw as a youth in Westminster Abbey, the stony gravity of whose figures he often reproduced in his own original drawings and prints.

This approval of the Gothic, which he declared superior to the 'classical' in any form, was an aspect of his rebellious attitude towards the rules and formulas typical of the eighteenth century. The 'happy songs, Every child may joy to hear' of 1789 were followed by the exultation in revolt of *The French Revolution*, 1791, and the *America* of 1793. Blake's vigorously expressed criticism of Sir Joshua Reynolds (1723–92) as President of the Royal Academy and creator of rigid canons of appreciation, was of a piece with the works in which he celebrated the political disintegration of an age.

It is clear in more specific terms that Blake had an aversion to oil painting, with

which Sir Joshua and the Academy were mainly concerned. He found it repugnant as being primarily a means of rendering material qualities and objects. 'The nature of my work', he said, 'is visionary or imaginative.' The oil medium was suited to portraiture as a record of surface appearance, to the 'vegetative universe', as he contemptuously termed landscape, or the still life, which in a Swedenborgian view was so much dead matter. Yet he followed Michelangelo in considering the human figure as the essential means of giving shape to human feelings and ideas.

Tempera was the medium most suited to provide the 'firm determinate outline' he insisted on as the essence of a visionary conception. 'Fresco' he called his version of tempera, using a gum vehicle instead of egg yolk. In this medium, and in water-colour and line engraving, he brought his work to a superb culmination in the first quarter of the nineteenth century. A cardinal event was the exhibition of 1809 at 28 Broad Street, accompanied by the famous manifesto of the *Descriptive Catalogue* with its appeal to the public, 'from the judgment of those narrow blinking eyes that have too long governed art in a dark corner', its assertion of the value of 'clear colours unmudded by oil'. *The Canterbury Pilgrims from Chaucer* was not a subject that best suited him and came as an anticlimax after the popular version of the same theme by Thomas Stothard (1755–1834), but the 'Heroes' of the exhibition, the 'Spiritual Forms' of Pitt and Nelson, allegorically 'directing the storms of war', though the 'tempera' had somewhat darkened, remain sublime in their almost Oriental rhythms (Plate 5).

Blake has been criticized for the imperfect anatomy of his figures, and manner-isms derived from engravings after Michelangelo and others; but such criticism is irrelevant to the vitality of line, the flow of composition, the exalted treatment of Biblical themes. Works such as the *Elijah in the fiery chariot* and *Satan smiting Job* in the Tate Gallery collection in London, and the two final masterpieces—the line engravings illustrative of the Book of Job and the watercolours for Dante's *Divina Commedia*, subsidized by John Linnell (1792–1882) in 1824—put Blake among the great masters of imaginative and loftily inspired design.

In terms of art, Blake was not entirely severed from his contemporaries. Some comparison can be made with John Flaxman (1755–1826) in his outlines for the *Iliad* and *Odyssey* (re-engraved by Blake for the English edition). He adapted types of childhood innocence and feminine beauty from Thomas Stothard's super-ficially charming draughtsmanship. With his elder contemporary and friend, Henry Fuseli (1741–1825), there was an exchange of influence. Blake, in Fuseli's words, was 'damn good to steal from', though there are instances where it can be

seen that Blake borrowed a pose or gesture from Fuseli for emphatic effect. They were alike in their scant regard for 'nature'. Fuseli's pretence of having to put up an umbrella when looking at a landscape by Constable was Blake's distaste for the 'vegetative world' in another form. Both were dedicated to imaginative expression but Fuseli did not move on Blake's spiritual plane. His was the more surrealist area of disturbing dream, terror and suspense.

Fuseli carried into the nineteenth century the literary form of imaginative art that he and others had earlier explored in subject matter taken from Shakespeare (Plate 8). It was in keeping with the later development of the Romantic spirit that he should turn to Milton and, in 1799, found a Milton Gallery in emulation of Boydell's Shakespeare Gallery. *Paradise Lost* evoked the immensities dear to the Romantic mind. In a sense, Satan, as Milton described him, was the archetype Romantic hero, whose desperate defiance of celestial law and order had a sublimity of its own. It is perhaps no accident that of his own works, Sir Thomas Lawrence (1769–1830), the most celebrated portraitist of the age, most valued the huge, theatrical picture of *Satan summoning his legions* (London, Royal Academy).

Blake considered that Fuseli's *Satan building the bridge over chaos* was to be 'ranked with the grandest efforts of imaginative art'. The humanized and Byronic Satan was imagined by John Martin (1789–1854) in 1824 as a vigorous and darkly handsome being presiding over the Infernal Council in a vast amphitheatre. The fascination of the immense, the supernaturally sinister, was expressed by Martin in various themes (Plate 21). The Bible, read in the home of his childhood, had filled his mind with images of gloom, wrath and catastrophe (and helped to drive his weak-minded brother into lunacy). Where Blake had envisaged the battle of good and evil in the human mind, Martin saw a war waged by some outraged and implacable Being on the human race, the toppling of great cities by the wrath of heaven, descending in electric storm and flood.

Martin's pictures of the fall of Babylon or the Deluge were coarser aspects of Romanticism, a machinery designed to produce a thrill of fear or amazement, like that of the film epics of Cecil de Mille. The love of the immense and the grandiose aims of personal ambition that went with it had other examples. They appear in the work of James Ward (1769–1859), the brother-in-law of George Morland (1763–1804). In his *Gordale Scar, Yorkshire* (1815; London, Tate Gallery), large scale and gloom combined in his escape from the eighteenth-century rural idyll. His projected allegory of Waterloo on a canvas 36 by 21 feet, was larger than the wall it was to occupy; Ward made the romantically paranoiac proposal that an

enlarged gallery should be built for its host of figures—Virtues and Demons, Victory and the Genius of Britannia as well as Wellington and Blücher. His *Bulls fighting* (Plate 9) was intended to complement and, in the process, rival Rubens's *Château de Steen*.

Romantic imagination was alternately lyric and epic in the work of the Irish painter, Francis Danby (1793–1861). Melancholy of mood and setting distinguished his first Academy success, the *Disappointed love* of 1821 (Plate 40). But the attempt to rival Martin led him to the stupendous in *The Delivery of Israel* (1825), *The Deluge* (Plate 65) and the painting of the blackened sun and earthquake convulsion described in the Book of Revelation, the *Opening of the Sixth Seal* (1828). Though Danby was accused of plagiarizing Martin, the latter returned the compliment after twenty-five years in *The Great Day of His Wrath*, an imitation of Danby's *Sixth Seal*.

Romantic ambition led others to attempt rivalry with the old masters in history painting. The most extraordinary instance is that of Benjamin Robert Haydon (1786–1846). Never can classical subject matter have been painted with wilder enthusiasm or more desperate anxiety than Haydon's *Dentatus* or his *Xenophon's first sight of the sea*. It is an irony that his most successful works were in the humorous genre his ambition despised (Plate 19). It was an entirely Romantic despair that led to his suicide in 1846.

Ambition was unsettling to others. Correggio in Parma, Titian, Velazquez and Murillo in Madrid, diverted David Wilkie (1785–1841) from his early detailed genre (Plate 17) to the changed style and effort that gave greater richness and depth in the works of 1829, following his visit to Italy and Spain, though he did not entirely grasp the lessons conveyed by the masters he favoured. William Etty (1787–1849) was another painter who attempted a romanticized 'grand manner' (Plate 45) in history painting and allegories. He was better equipped by his study of Rubens and Titian for the unpretentious but beautifully executed studies of the nude, the section of his work that has come to be valued most highly (Plates 32 and 42).

That there should be a 'School of Blake' was not to be expected in view of the unique individuality of his work, but there is no more agreeable episode in these disturbed Romantic years than the mustering of disciples that came to Fountain Court in veneration. John Linnell, who did so much for Blake in the last great phase of the *Job* and *Dante* illustrations, cannot be described as a follower. He was success-fully making headway as a portrait painter. In landscape he had the feeling for

nature that Blake did not share. It was through Linnell, however, that a group of young men formed round Blake when he was between sixty and seventy. Linnell brought Samuel Palmer (1805–81), not yet twenty, to see Blake in 1824. Both Linnell and Palmer introduced others: Edward Calvert (1799–1883) and George Richmond (1809–96), fellow students at the Academy; Frederick Tatham, the son of Linnell's architect friend, Charles Northcote Tatham; and a pupil of John Varley (1778–1842), Francis Oliver Finch (1802–62). The old and tranquil village of Shoreham in Kent offered members of the group such a refuge from the disturbed post-war metropolis as French painters around the same time found in Barbizon. Palmer lived continuously there from 1827 to 1833–4, his friends visiting him at intervals, even Blake, not long before his death, paying one visit in spite of his dislike of the country.

The group acquired the name of 'the Ancients' in reference to the intended pursuance of ideals proper to an innocent 'Golden Age'. But except for a brief flash of inspiration in Calvert, it was Palmer who stood out far above the rest in the originality of his technique, an intensity of feeling that makes one think of Van Gogh, a buoyant optimism expressed in a billowing cloud above the 'valley of vision', a sense of wonder in the valley's aspect under the moon (Plate 38). The influence of Blake was a main support in this period of rapturous painting and drawing (often in a mixture of media) but it was the influence of a serene and noble mind in an age of uncertainty and disappointments rather than the lesson of style.

The mood was that in which Blake had projected his own conception of a Golden Age in the woodcuts for the selection of Virgil's pastoral poems edited by Dr Thornton. The stream, the shepherd, the crescent moon in these small wonders of design, were images that fostered the spirit of Shoreham and the Romantic nostalgia for another and happier age than that in which Palmer and his friends considered themselves to live.

3 Crowning achievements in landscape

IN THE FIRST HALF of the nineteenth century, landscape painting in Britain was an art more widely practised than ever before and, in the work of certain masters, the splendid fruit of earlier development. Interest in landscape had grown with what may be called the 'discovery of Britain' in the later years of the eighteenth century. The discovery was in part a Romantic appreciation of the monuments and ruins of the past in their country surroundings, and of the wild beauty of mountain and lake. The record of these picturesque scenes had come to engage the pencil and watercolours of a host of amateurs as well as professional painters. By 1800 there was an established route following in the tracks of such a pioneer as Paul Sandby (1725–1809) and leading to North Wales, the Lake District and Yorkshire.

A local attachment, not necessarily to such vistas of picturesqueness or grandeur as these districts afforded, was another feature of the early part of the new century, strikingly evident in the artist of the flat East Anglian lands. The stay at home enforced by Continental war seems to have made for a fresh look at homely insular scenes and increased affection for them—among a number of landscape painters. There were others, however, who were more in the mood for travel after their compulsory isolation, eager to renew the Grand Tour, on the cessation of hostilities. The two greatest exemplars of these contrasting attitudes are also two of the greatest of all landscape painters, John Constable (1776–1837) and John Mallord William Turner (1775–1851).

'The scenes on the banks of the Stour', said Constable of his native region, 'made me a painter and I am grateful.' Though he visited the Lake District in 1806 and made numerous sketches there, he admitted to his biographer, C. R. Leslie, that the solitude of mountains oppressed his spirits. Constable's affection for landscape was not devoted only to Suffolk nor is his work to be appraised in regional terms alone. He may be contrasted with John Crome (1768–1821), his older contemporary, a great master also but one more closely tied to a locality, to Norfolk and his native Norwich, where he achieved the feat of founding a local school (Plates 10, 11, 14 and 46). There is a contrast also in the fact that Crome was still an eighteenth-century man in method and outlook. Constable, on the other hand, was an innovator: he was essentially concerned with 'the light and shadow that never stand still'. In the pursuit of this effect in nature he gave a new freshness and beauty to the means he used. He chose kindred subjects at Dedham (Plate 25) and Hampstead Heath (Plate 47), at Yarmouth and Brighton (Plate 58) on the east and south coasts, and at Salisbury (Plate 60) and Stoke-by-Nayland, and the spectator may recognize with pleasure the English character of his subjects in Suffolk, Sussex and

Dorset. Into his paint he introduced a myriad surprises and scintillations of colour that render light as an enveloping atmosphere in a way never previously attempted.

Constable was ahead of his time. He was a realist of a kind that would come later in the century—and then primarily in France instead of his own country; he was an impressionist before the term had been thought of. He was scornful of any artificiality, suspicious of unusual conditions or extreme effects that might upset the nice balance of normality he looked for in nature, and he was scrupulous in conveying what he felt to be true. That painting might be looked on as a branch of natural science was an observation that underlines his objective and experimental approach. It was the science that noted in the green of a meadow any number of different tones, thus imparting a life and animation to the surface that a flat green would lack. In France, Delacroix was keenly alive to the importance of this method —to the extent of retouching his *Massacre de Scio* with cross-hatched passages of bright colour—a result, it seems almost certain, of having seen Constable's *The haywain* (London, National Gallery), which had been sent to Paris for the Salon of 1824.

The famous Salon, in which Stendhal praised the new realism, was a triumph for Constable, though perhaps he did not realize what a place of European influence he at once attained. British art was already a subject of serious discussion in France; Lawrence, Wilkie and Constable, prior to the Salon, all had their Parisian admirers. The year 1824 was a sensation primarily through Constable's three works—*The haywain*, *A lock on the Stour* and *London from Hampstead Heath*. They were reinforced by watercolours by the young and brilliant Richard Parkes Bonington (1802–28) and by Copley and Thales Fielding, the *art Anglais* of watercolour also bringing its suggestion of direct handling and fresh colour.

Never without honour in his own country, Turner had no such instant success abroad nor indeed did he seek to obtain it, constant traveller though he was. He and Constable differed widely in their evolution as artists even if certain likenesses of taste and influence can be discerned. Their views of landscape history were much the same. They equally admired Sir George Beaumont's Claudes. Constable, recognizing no distinction of merit between oil painting and watercolour, added to the venerated names of Richard Wilson (1714–82) and Thomas Gainsborough (1727–88) those of J. R. Cozens (1752–97) and Thomas Girtin (1775–1802). At Dr Monro's house the young Turner copied Cozens's Alpine scenes and worked alongside Girtin.

There was a further point of likeness in their susceptibility to the landscape of the poets, in Milton's *Paradise Lost* and James Thomson's *The Seasons*, much quoted in

Constable's *Discourses* and in appendage to Turner's picture titles. But the differences were all that could be imagined between the Romantic and the Realist. Turner represents every stage of the Romantic evolution, first in his picturesque topographical watercolours, much occupied with the remains of Gothic architecture, then in his delight in all that is dramatic and excessive in nature, awesome Alpine heights and depths, the force of tempest and avalanche (Plate 20), the rage of ocean and conflagration (Plates 3 and 66). He sought to fill his work with associated ideas, making a commentary on the unending conflict of man and the elements, in which man was always the loser, and on the inevitable decline and fall of civilizations. In this evolution, extending over the first fifty years of the century, Turner eventually came to the stage when he transformed the reality of appearances into the abstract vibration of colour.

In strong contrast to Turner's restless wanderings through France, Belgium, the Rhineland, Switzerland and Italy, as well as in Britain from the Isle of Skye to the Isle of Wight, is the home-keeping not only of Constable but still more of John Crome and the Norwich Society of Artists, to whose exhibitions Crome contributed regularly from 1803 to 1820—a hint of likeness to the French Barbizon again appearing. Wilson's breadth of style and Gainsborough's early translation of Dutch landscape painting into purely English terms were factors in the formation of Crome's art, a basis for the grandeur of his *Slate quarries* (Plate 11), the majestic tree form of *The Poringland Oak* (London, Tate Gallery), the 'air and space' of *Mousehold Heath* (London, Tate Gallery) and the mystery of *Moonrise on the Yare* (Plate 10).

In Norwich (Plate 46), a city with an unusual number of people of some wealth, who were interested in the practice of painting, the 'School' was an intricate relation of professional and amateur, art masters and pupils, and families also. Fourteen years younger than Crome, John Sell Cotman (1782–1842) became a second leading spirit in the School from 1807, though less confined to the regional subject. Frustrated in various ways—by the time he had to devote to pupils and by the requirements of his patron at Yarmouth, Dawson Turner, who diverted him to archaeological tasks that were not his *métier*—Cotman showed a capacity for highly original design in the few oils he was able to produce as well as in the best of his watercolours. Crome had such worthy pupils as James Stark (1794–1859) and George Vincent (1796–about 1831); Cotman's following included Thomas Lound (1802–61) and the watercolourist John Thirtle (1777–1839). The list, including Crome's and Cotman's sons, could be greatly extended and, covering the best part of a half-century, still provides an interesting field of local research. But 'Old Crome'

remains the single giant, with Cotman as a brilliant but restless and somewhat untypical second as far as the character of the School is concerned.

The rapturous reception of Constable's painting in France, its influence on Delacroix and Corot and the affinity with, if no direct influence on, the art of the Impressionists, contrasts strongly with the slight effect his art had on the English public. The life of light and colour shocked those habituated to brown trees and yellow varnish. The sculptor, Chantrey, one varnishing day, swept a coat of varnish over a Constable landscape: 'there goes all my dew', said the painter. His *Opening of Waterloo Bridge*, exhibited in 1832 and full of sparkling colour, was dulled down after his death by a dealer who thought the dullness an improvement.

Turner was much more akin to the leaders of the Romantic movement in France, Géricault and Delacroix, in expressing a sense of violence and tragedy than to the Impressionists, who excluded any such matter from their canvases. Nor does his colour in itself indicate the relation with Impressionism that has sometimes been suggested. On the contrary, it ultimately tended to abstract expression with more relevance to the art of the twentieth century. It was this characteristic in Turner's later works that seemed incomprehensible to his contemporaries and led to the assumption that after *The 'fighting Téméraire'* of 1838 (London, National Gallery) he went into a steep decline; whereas the 1840s can now be viewed as years of extraordinary masterpieces (Plates 66 and 69).

His wide-ranging and soaring genius was beyond imitation. The descriptive character of a marine painting by Clarkson Stanfield (1793–1867) or George Chambers (1803–40; Plate 51), with its choppy waters, bobbing fishing boats and sailors in woollen caps, jerseys and top boots hauling on ropes and tackle, might recall a Turner picture of the sea; but only the subject matter links them. Though Constable, too, proved beyond imitation, Richard Parkes Bonington merits comparison with him. In freshness and their open-air feeling his views of the Normandy coast painted in the 1820s are outstanding. A delicacy of touch and feeling for colour imbue his small-scale history pictures (Plate 41) with a poetic life of a different order. The Romantic nostalgia for the past replaces the realistic vision of his landscapes, with, however, a grace of style that Victorian painters later lost sight of in their preoccupation with historical anecdote. In the historical subjects he shows a kinship with Delacroix, who admired him though not without some reservations on the score of Bonington's possibly too facile exercise of skill. These years of inspiration were cut short by Bonington's early death; to what heights he might otherwise have risen it is not easy to guess.

4 Late Romanticism and the early Victorian age

IT IS USUAL to draw a strong contrast at a certain characteristic level between the Regency and reign of George IV on the one hand and, on the other, the Victorian age. The former may be described as refined in taste, elegant in its productions, extravagant, free-thinking, free-living. The latter is grave, earnest, moralistic, severely disciplined and with various gaps and shortcomings in the attitude to and production of works of art. Such a generalization tends to overlook the niceties of transition from the one period to the other. To view the nineteenth century as a whole is to be reminded that its late Georgian beginning (if the reign of William IV is included) extends over more than a third of this period of a hundred years. Many a young Regency 'buck' must in due time have turned into a stern Victorian paterfamilias!

In architecture something of John Nash's Regency style remained in the work of his follower, Decimus Burton. The Regency style of furniture gradually thickened to accord with a growing love for the massive and solid. In some respects the story is sad. There is what may be called a Romantic twilight in which artists groped in baffled and disappointed fashion. The wonderful paintings and drawings of Samuel Palmer in the Shoreham period were the work of a young man between the age of twenty-two and twenty-six. It is a shock to recall that he lived to be seventy-six, until 1881; in this half-century, though he never wavered in his devotion to the memory of William Blake and produced respectable landscapes, the early rapture of colour and design in his Kentish 'nook of Paradise' was lost to him. Rome and Florence offered him no equivalent.

He was upset by the march of progress which, he declared as he watched the advance of villas at Redhill, 'is blasting the fairest regions of the earth'. Moving with its own irresistible force, the genius of Turner could survive transition with the utmost aplomb. He was able to paint a steamship or a locomotive with as much relish as he had earlier shown in painting Nelson's *Victory* or a horse-drawn coach, at the time when Palmer, frustrated by his own sensitiveness, was bemoaning the new applications of science.

The influence of that capable landscape and portrait painter John Linnell, whose daughter Palmer married in 1837, is also to be taken into account. Linnell presents a special instance of the period's change of mood. The bleak narrative of Samuel Palmer's son transforms Linnell from the able young man who took pleasure in helping Blake, into one hardened with the passage of time, turned into the domestic tyrant of a family colony at Redhill. If A. H. Palmer exaggerated the crushing effect of his father, this at all events was how he viewed Samuel Palmer's later life.

The Romantic spirit lived on in others, creating something of the pattern of imaginative fire and desperate ambition set by Haydon. The Scottish painter David Scott (1806–49), aware though he appears to have been of Haydon's weaknesses, likewise worked on a huge and unpractical scale and had a similar fondness for far-fetched subject matter. His *Fingal and the spirit of Lodi* incurred the criticism that he 'spoke a dead language' and the advice to 'shoot a lower aim'. Yet there are works by him such as his *Puck fleeing before the dawn* (Edinburgh, National Gallery of Scotland) in which an authentic flash of fancy appears; and *The Russians burying their dead* (Plate 44) captures something of the tragedy of Goya's immortal *Disasters of war* prints.

Strangely fated was the painter Richard Dadd (1817–86) who, in that overcast decade, the 1840s, shot his father for reasons that remain obscure, and was consigned to the old Bethlem Hospital as insane. The titles of a remarkable series of drawings preserved at the present Bethlem Hospital at Eden Park, bespeak the Romantic mind: *Grief and sorrow*, *Battle or vengeance* and *Agony-raving madness* (recalling the statues by Cibber, which had always made a deep impression on the artists who saw them over the gateway of the old 'Bedlam'). But in the lucid detail that elaborates eerie fancy in the *Fairy Feller's masterstroke* (Plate 113) there is a direct parallel with the realistic minuteness of the Pre-Raphaelites.

Transition in the work of Sir Edwin Landseer (1802–73) was from a Romantic brilliance to the humorous animal genre long regarded as the nadir of Victorian art. It would be hard to refute Ruskin's criticism that Landseer departed from 'the true nature of the animal for the sake of a pretty thought or a pleasant jest', but for a long time previously his work had been of a very different character. When the young Londoner visited Sir Walter Scott at Abbotsford in 1824, he responded to the grandeur of Scottish mountain scenery in a series of impressive landscapes painted in the later 1820s and the 1830s (Plate 59). The Romantic Landseer made many studies of animals and birds untouched by sentimentality or humanization (Plate 28), often displaying an interest in violence (Plate 43) like that of his French contemporary, Barye. The dogs that Scott admired as 'the most magnificent things I ever saw—leaping and bounding and grinning on the canvas' predated the canine bourgeoisie of the 1840s and 1850s with the flunkeys, philosophers and deserving characters that parodied human expression (Plate 68).

It would be unfair to regard Queen Victoria and the Prince Consort as a prime influence in encouraging this development, much as they admired Landseer's skill and welcome as he always was at Balmoral (Plate 62). In the reign of William IV,

Landseer had already made a hit with a representation of canine pomposity. A middle-class demand for this kind of pictorial entertainment was insistent enough to make him do more. Sir George Beaumont had bought a Landseer animal painting of an earlier and fiercer kind, the *Fighting dogs getting wind* (1818), but Sir George and Lord Mulgrave, admirers also of David Wilkie, belonged to a dwindling race of aristocratic patrons who were seriously interested in their artist contemporaries. The wealthy merchants had more liking for Landseer's comedy and pathos. They included John Sheepshanks, wealthy through the cloth trade; Jacob Bell, the pharmacist; Robert Vernon, the horsedealer; and Henry Tate, the sugar magnate. Landseer's *Uncle Tom and his wife for sale*, suggested by *Uncle Tom's Cabin* and depicting the grief of a bull-terrier couple soon to be parted and sold into slavery, was bought by Sir Henry Tate and was among the pictures that formed a nucleus for the Tate Gallery.

The taste for narrative, more especially in the form of anecdote—historical, sentimental or humorous—which was to remain strongly characteristic of the Victorian age throughout its long course, was already marked in the 1820s and 1830s, before the Queen's accession. The Romantic liking for the emotional side of history and the past finery of costume caused some painters to take their subjects from historical novels and other literary works. With themes from Scott, Sterne, Cervantes, Molière and Goldsmith, Charles Robert Leslie (1794–1859) signals the transition in the early Victorian period to a lesser aesthetic level than that of Bonington, the concern with subject being no longer so well balanced by design, colour and originality of personal style. Wanting in real substance, too, is the fictional illustration of William Powell Frith before he found his true *métier* in his great panoramas of contemporary life.

It is easy and to some extent justifiable to regard this liking for anecdote, which Roger Fry so severely castigated as a 'veritable debauch', as the bias of a public uninformed in matters of art and the easy route for painters to a profitable success in spite of the dangers of banality it entailed. But the painters of popular genre must be given the credit of a reaction of their own against the type of 'high art' that had lost its significance for them. Leslie, for instance, began with such themes as *Timon* and *The witch of Endor* before finding his mildly humorous level.

The early Victorian painters did not invent the picture with a story to tell or a moral to impart. They carried on the tradition of seventeenth-century Dutch and Flemish genre and also the 'improving' themes the eighteenth century had begun to cultivate. The links with Holland and Flanders can be seen in the work of David

Wilkie (Plate 17) and William Mulready (1786–1863; Plate 18). In a different style from that of Wilkie, though perhaps encouraged by his example, Mulready showed himself a conscientious observer of life in works of admirable quality.

Portraiture in the first half of the nineteenth century was a flourishing business—as always in Britain—dominated by a Romantic tradition that had its basis in the style of Thomas Lawrence. In one aspect the last of the great eighteenth-century school of portrait painters, with the work of Reynolds as a splendid basis on which to expand, Lawrence introduced a flexible and temperamental style that brought with it a psychological animation—sometimes radiant, sometimes tense—that set a new standard. The tension appears, for instance, in the great portrait of Pope Pius VII of 1819 (Plate 23), one of the mighty series of full-lengths celebrating the victory of 1815 in the Waterloo Chamber at Windsor Castle. The almost febrile effect is accentuated by the fitful play of light.

For painters otherwise involved in the complexities of subject composition, portraiture as Lawrence practised it was a delightful exercise of skill. His execution —in the admiring words of William Etty, Lawrence's pupil for a year—was '*perfect—playful* yet *precise*—elegant, yet *free;* it united in itself the extreme of possibilities'. Painstakingly, and not without difficulty, Etty set himself to attain a like result. He was eminently successful in the sparkling radiance of his female portraits (Plate 49) and in the Romantic sombreness with which he invested his own likeness.

What stimulus the work of Lawrence gave to the mature portraiture of Wilkie is evident in the masterly full-length of King William IV (London, Wellington Museum), painted in 1833, and the light and shade that give dramatic force to the study of Prince Charles of Leiningen, Queen Victoria's half-brother (Royal Collection). The combination of elegance and freedom such as Etty found in Lawrence is an admirable feature of the portrait of the Sultan of Turkey, Abdul Meedgid, painted by Wilkie for Queen Victoria in 1840 (Royal Collection), little noticed where it hung at Osborne until Wilkie's work began to have fresh assessment in the 1950s.

Landseer is said to have prided himself particularly on swiftness of execution. The freedom and spontaneity thus obtained contrast with the high degree of finish that the taste of the time tended to impose. His portrait of Georgiana, Duchess of Bedford (collection of the Duke of Abercorn), painted about 1830, and his oil sketch of Queen Victoria and the Duke of Wellington reviewing the Life Guards of 1839 (private collection), were full of temperament. His portrait of Sir Walter Scott

(London, National Portrait Gallery), with its suggestion of a slightly dishevelled greatness, is an image that seems as authentically personal as that of Dr Johnson by Sir Joshua Reynolds.

It was the Prince Consort's belief that art needed some form of public patronage of a better managed or more elevated order than private patronage in the 1840s was able to supply. The new Palace of Westminster, which arose by the Thames in 1840, replacing the old Houses of Parliament that had been destroyed by fire in 1834, seemed an admirable setting for his proposed encouragement of 'high art', in terms of mural decoration. That a competition was the best means of getting the desired result and that fresco—virtually unknown in Britain but revived in Germany by the Nazarenes, Cornelius and Overbeck and their followers—was the right medium to use, were both doubtful propositions.

The subjects intended to be painted directly on the walls were necessarily adjudged by designs submitted in the form of cartoons (a word to which satire in *Punch* gave the humorous association it has since retained). The hopes with which artists such as Haydon submitted their proposals were followed by disappointment at rejection that intensified the depression of the baffled Romantic. The struggles of those who were chosen were perhaps hardly less depressing to the artists themselves than a rejection would have been. Daniel Maclise (1806–70) offers the most striking instance. His was the heroic effort, which was made at his own request, to paint two huge epics in the Royal Gallery at Westminster: *The meeting of Wellington and Blücher* (Plate 109) and *The death of Nelson*. The technical difficulties were such that he would have withdrawn if the Prince Consort had not urged him to continue and go to Berlin to study the water-glass method of 'stereochromy' invented by Dr Fuchs of Munich. The work absorbed his energies until 1865, but the national enthusiasm aroused by the scheme had evaporated when the Prince Consort died in 1861. With deepening gloom, Maclise toiled on to find the completed paintings ignored or coldly treated by the critics except for Dante Gabriel Rossetti's words of poetic cheer in the *Academy*: 'they unite the value of almost contemporary record with that wild legendary fire and contagious heart-pulse of hero-worship which are essential for the transmission of epic events through art.'

A hostility that no one had bargained for was that of the corrosive atmosphere of nineteenth-century London. Maclise's frescoes have needed an immense amount of restoration. William Dyce (1806–64), who painted the *Baptism of Ethelbert* in the House of Lords in 1846 and frescoes of Arthurian themes in the Queen's Robing Room, was another contributor to the scheme whose work likewise suffered from

the chemically laden air, against which his close study of fresco painting in Italy was of little avail. The small-scale easel picture for the private patron was to remain the typical Victorian product: such as Dyce's own *Christ and the woman of Samaria* (Plate 112).

5 The Pre-Raphaelite revolt and its sequels

THE YEAR 1848 has been called the 'year of revolutions'. All over Europe there were riots and risings. In Britain 'the hungry forties' had reached the critical stage marked by Chartist processions and demonstrations. It was in this climate of unrest, and in the same year, that the Pre-Raphaelite Brotherhood came into being, a band of young men, with one exception (William Michael Rossetti) fresh from the study of art in the Royal Academy Schools. Even at the outset there appears a division in the swing between Romantic and Realist elements that produced extreme contrasts in British painting throughout the century. For a time there was an extraordinary fusion of the contrasting elements, leading Delacroix to remark in 1855 on 'the prodigious conscientiousness that these people bring even to objects of the imagination'.

In the initial revolt, Dante Gabriel Rossetti (1828–82) played a leading part. Essentially a poet, Rossetti had also the Romantic spirit in full measure. He was a rebel like Blake, whom he consciously imitated, against the academic establishment, the trivialities currently exhibited, the materialism of the time, to which he opposed his own imaginary world. Through Ford Madox Brown (1821–93) he was aware of the German *Nazarener* who, earlier in the century, had lived like a monastic community in Rome and sought to turn the clock back by emulating the purity of Italian religious painting, before the High Renaissance (as they thought) darkened ideals with worldly ambition and the display of mere skill.

The German Nazarenes had been nicknamed rather derisively Pre-Raphaelite— if they had not been so described it is difficult to imagine what the young English rebels would have called themselves. Their acquaintance with Italian art was of the slightest, and the engravings by Lasinio after the frescoes of the Campo Santo at Pisa, said to have been their source of inspiration, could give only the merest illusion of contact with Italian art. However, the point was made that art stood in need of ideals such as once prevailed, that the movement to that extent should look back to the past. It was the proposal of Rossetti that translated the idea of the quasi-monastic Nazarene community into English as a 'Brotherhood'.

The contribution of the other leading members of the group, William Holman Hunt (1827–1910) and John Everett Millais (1829–96), was the conception of 'truth to nature', acquired from John Ruskin's first volumes of *Modern Painters*, in which he gave a new application to the thought of Wordsworth. As Hunt and Millais understood the phrase it meant painting figures from life; open-air scenes in the open air, with a wealth of circumstantial detail; and colour that boldly discarded the brown tones and unnaturally dark shadows that still found popular

favour. Truth to nature combined with a 'Pre-Raphaelite' nostalgia made a curiously dynamic compound.

In subject matter the group did not greatly depart from the themes of a preceding Romantic generation except in dealing with contemporary life. They produced religious, historical and Shakespearian subjects. Into their (fewer) contemporary scenes they replaced humorous trivialities by emotional tension and, for a while, an earnest tendency to ventilate social problems (as in Hunt's *The awakening conscience* and Rossetti's *Found*). A startling change was that of technique. Hunt and Millais initiated a method of painting with fine brushes and fluid colour, on a prepared white ground when the latter was almost but not quite dry, that allowed them to work swiftly and minutely at the same time to obtain an effect of brilliant translucence. The realistic treatment that portrayed family and friends in the guise of imaginary characters and set them against backgrounds of imaginary scenes painted with minute fidelity from a real environment, was an innovation that had a magic of its own. This realistic fervour became a cause to which young painters rallied with enthusiasm. The Pre-Raphaelite manner was dominant in the Royal Academy exhibitions of the 1850s. A succession of little masterpieces by artists not of the Brotherhood but entirely Pre-Raphaelite in feeling—Walter Deverell (1827–54), Henry Wallis (1830–1916; Plate 106), John Brett (1830–1902), Arthur Hughes (1832–1915; Plate 102), W. S. Burton (1824–1916)—showed the extent and fruitfulness of the influence.

William Dyce and Ford Madox Brown, at first well-disposed spectators—it was Dyce who converted Ruskin to Pre-Raphaelite advocacy by forcing him to look at Millais's *Christ in the house of His Parents*—were in their own works no less susceptible than the younger painters to the altered key of colour and feeling. The triumphal progress of the decade was helped on by the turn in the national fortunes that, after the Great Exhibition of 1851, made London the centre of the world, brought growing prosperity and a new race of picture buyers, many with riches gained in the industrial midlands. Shipping magnates, stockbrokers, manufacturers and bankers delighted both in detail and in the romance of pictorial narrative.

The Brotherhood (or even a feeling of fraternity) did not survive the 1850s. After a series of very beautiful pictures—including *The return of the dove to the ark* (1851; Plate 76), *Ophelia* (1852; London, Tate Gallery) and *The blind girl* (1856; Birmingham, City Museum and Art Gallery), awarded in that year the annual prize of the Liverpool Academy—Millais turned to a broader style, less exacting and more adapted to the sentimental subject matter he took to in aiming at wider popularity.

Holman Hunt displayed a splendid mastery in works of which *The hireling shepherd* of 1851 (Plates 96–8) represents a peak. Later in the 1850s he set off to Palestine (as Wilkie had planned to do) to paint religious events where they actually happened; he again produced an astonishing picture in *The scapegoat* of 1856 (Port Sunlight, Lady Lever Art Gallery), though the logic of the enterprise afterwards assumed an extreme form, in which he was mentally and physically isolated from the ideas and company of contemporary artists.

Rossetti had only theoretically subscribed to the idea of 'truth to nature'. He had no such regard for professional skill of execution in an imitative sense as Hunt and Millais possessed. An allergy to criticism prevented him from public exhibition after his early religious painting, *Ecce Ancilla Domini* (Plate 75), had been badly received. The Royal Academy, so essentially a part of Millais's life, was entirely outside Rossetti's. The Romantic element, belated in the realist mid-century, appears in the escapes to the past represented by his efforts (like those of Blake) to interpret Dante and by the excursion into the fabulous realm of Sir Thomas Malory's *Morte d'Arthur*, a never-never land of British history occupied by King Arthur and his knights at some unstated time. Rossetti's evolution as a painter was marked by several phases. His first two paintings in oil, *The girlhood of Mary Virgin* (1849; London, Tate Gallery) and *Ecce Ancilla Domini*, which he termed his 'white paintings', were distinguished by the simplicity of their form and the restraint of their colour, though replete with Anglo-Catholic symbolism. Afterwards, in the 1850s, he worked in watercolour, elaborating subjects taken from Dante, Shakespeare and Browning with a medieval glow of colour. After the death of his wife in 1862 a mystical element appeared in the oil painting *Beata Beatrix* (London, Tate Gallery), in which he symbolically identified Elizabeth Siddal with the Beatrice of Dante. He resumed oil painting after 1862 but in an altered and more sensuous key, portraying beautiful women rapt in luxurious daydreams (Plates 121 and 139). In his later years he developed a form of allegorical portraiture with the suggestion of mystery and melancholy that appears in his pictures of Jane Morris in various ideal roles.

Rossetti's magnetic personality enabled him virtually to construct a second Pre-Raphaelite movement with the aid of Edward Burne-Jones (1833–98) and William Morris (1834–96), though with Morris it took an altered direction towards the design of objects of use. Morris painted only one easel picture but Burne-Jones, though an ally of Morris in various forms of design, remained primarily a picture painter. From Rossetti, Burne-Jones acquired an abiding affection for the dream

world of Arthurian romance (Plate 162) and something also of his melancholy, though without Rossetti's mystical passion. Visits to Italy and acquaintance with the work of Botticelli and Michelangelo also influenced him—he was the one Pre-Raphaelite to take any notice of Italian art (Plate 141). The Rossetti tradition as modified by Burne-Jones was continued by a number of painters, including Spencer Stanhope (1829–1908; Plate 140), Charles Fairfax Murray (1849–1919), J. M. Strudwick (1849–1935), Maria Stillman (1844–1927) and Evelyn de Morgan (1855–1919). With them the militant realism of Pre-Raphaelitism in the 1850s had turned into the wish to evoke what Burne-Jones called 'a beautiful romantic dream of something that never was, never will be'.

Advocates of realism, pointing to this as a languid conclusion to the stirring episode of Pre-Raphaelitism, have not failed to draw an unfavourable comparison with the course of events in France where, unhindered by lingering Romantic ideas, 'truth to nature' came to splendid flower in Impressionism. Such criticism has not allowed sufficiently for the place of imagination in art. There is a broader view in the remark of so fastidious a twentieth-century Frenchman as Marcel Duchamp, that the Pre-Raphaelites 'lit a small flame which is still burning despite everything'. Surrealists certainly have not hesitated to apply the early Pre-Raphaelite minuteness of detail to an imaginative purpose of their own. As a movement directed in every phase against what was banal or ugly, Pre-Raphaelitism occupied a place of central importance in the Victorian age.

6 Victorian realism

IN SOME RESPECTS the Pre-Raphaelites may be considered anti-Victorian. The realistic element in their paintings in the 1850s, which involved not only working direct from nature but a special technique with a quality of its own, was different from the realism of others, who applied themselves to giving a social picture of the age. Typical of the latter was William Powell Frith (1819–1909), solidly pro-Victorian and highly critical of Pre-Raphaelitism as a craze and affectation. For a long time he followed the tradition of literary illustration, not altogether avoiding the triteness that resulted from a second-hand version of the humours of Goldsmith and Sterne, of the comedy of Cervantes and Molière.

His *Dolly Varden*, commissioned by Charles Dickens in 1842, has been accounted a step towards his debut in social history, though in this picture there was still the artificiality of a character that the author of *Barnaby Rudge* himself had made more sentimental than life. The origin of Frith's mature and best achievement may be found in the pleasant interlude of middle-class Victorian life, the seaside holiday. His summer holiday at Ramsgate in 1851 suggested the picture of Ramsgate Sands which, under the title of *Life at the seaside*, was a sensation at the Academy of 1854. The objective delight in the social scene had full expression in the panorama of *Derby Day* (1856–8; Plates 93 and 103). The problem of weaving the complexity of different incidents, each with its own story to tell, into a coherent composition was solved with consummate skill. The self-contained stories combined into a vivid picture of Victorian life at a number of levels. He used a similar narrative principle in *The railway station* of 1862 (London, Royal Holloway College).

Such massive assemblages of character and happening took years to compile—as the intervals between them suggest. A rough general outline on the spot was followed by many carefully detailed studies and these in turn by trial oil sketches to decide on the most suitable disposition of the groups on canvas, before work began on the finished picture. Frith had no hesitation in making use of photographs to ensure accuracy in such detail as the grandstand at Epsom or the arcading of Paddington Station; but the quality of painting remained of a kind that even so prejudiced a critic as Whistler could admit to being equal, in certain passages, to that of Manet.

Frith maintained a high level of execution in the course of his long life. His realism was tempered by an undertone of satire in *The private view at the Royal Academy* of 1881 (Plates 144 and 145) and he gave to *The road to ruin*, a series with a moral on somewhat Hogarthian lines, a spice of the melodrama the Victorians so enjoyed in the theatre. This appears also in other painters who may be grouped

with him. Though Robert Braithwaite Martineau (1826–69) was the pupil of Holman Hunt, there was little of the Pre-Raphaelite in his principal work, *The last day in the old home*, which could be 'read' almost like a Victorian novel. A similar effect is given by three pictures by Augustus Egg (1816–63) on the theme of sin and punishment, *Past and Present* (London, Tate Gallery). There is an affecting picture by Alfred Elmore (1815–81), *On the brink* (private collection), of a girl in despair having staked all and lost on the gaming table. But a majority was content with more amiable portrayal of character, dress and environment. J. J. J. Tissot (1836–1902), the French-born painter who identified himself so closely with London in the 1870s and early 1880s, added a foreign charm of style to paintings with a certain exaggeration of English types and fashions, often with a setting overlooking the Thames (Plates 128 and 130). A number of minor artists made much of the delicacies of courtship, the pleasures of social and family life (Plate 146), the appeal of childhood (Plate 147), the humours of the city street. But the 1870s produced a distinct departure from the engaging industry of Arthur Boyd Houghton (1836–75), A. E. Mulready (documented 1863–80, died 1886), G. E. Hicks (1824–1914) and others who provided a view of an equable middle-class existence. The departure is indicated by the term 'social realism'.

In a general sense all the social observers of the age, including Frith, might be said to come under this heading. It gained a special meaning as the effort to bring the miseries and misfortunes of the poor to 'the notice of Mayfair', in the phrase of Frank Holl (1845–88), for a time prominent in the genre. What alleviation of misery they led to is less clear than the fact that pictures so inspired were immensely popular. Luke Fildes (1844–1927) became famous at the age of thirty for his *Applicants for admission to a casual ward* (London, Royal Holloway College), exhibited at the Academy with marked effect in 1874 and reproduced in the first number of *The Graphic*, a particular policy of which was to expose conditions in the social depths.

Fildes's painting of a row of shivering outcasts was followed by other scenes of pathos, culminating in *The doctor* of 1891 (London, Tate Gallery). The humble cottage in which the doctor watched at the bedside of a sick child was reconstructed in a corner of the artist's Kensington studio so that he could do justice to its sombreness. Frank Holl, before turning to portraiture, devoted himself to 'starvation, coffins and the dock'; *No tidings from the sea* (Plate 125) was a title that explained the misery of a group huddled in a wretched hovel. *Newgate: committed for trial* (Plate 126) was another of his themes. Hubert von Herkomer (1849–1914), an

immigrant from Bavaria who studied under Luke Fildes and drew for *The Graphic*, could be described as a social realist by reason of such a picture as his *On strike* (1891; London, Royal Academy); the sullen workman and his wife, whose pinched features convey suffering, were characters almost photographically portrayed.

A compensatory drama, drawing attention to the miseries of the rich, had example in the work of William Quiller Orchardson (1832–1910). Orchardson, whose work considered purely as painting has been somewhat overpraised, was varied in output from 'costume pieces', recalling the social graces of the eighteenth century, to the anecdotal history, pictured as it might have been, of *Napoleon on board the 'Bellerophon'*. In addition he portrayed depression in evening dress in such a work as his *Mariage de convenance* (Plate 142), where a psychological distance between the couple is emphasized by the length of the dinner-table.

Such paintings had the shortcoming of distracting attention from such aesthetic quality as they might possess to what might be surmised from the title and worked out in the spectator's mind. They were of little importance when the psychology was superficial or negligible. But in social realism there was the element of concern with the people's lot that so deeply impressed Van Gogh. The pair of old boots of which he made an effective picture might have been discarded by one of Luke Fildes's waifs and strays.

THERE WERE TWO ALTERNATIVES to the anecdotal pictures of contemporary everyday life that entertained the Victorian middle class: the Romantic and the Classical. In so far as both looked to the past, they could be regarded as two aspects of the same wishful thought. The Pre-Raphaelites had their vision of the Middle Ages, a separate group looked back to ancient Greece and Rome. They shared an aversion from Victorian fashions or at least from painting the bustle or the frock coat. The extraordinary contrasts with which the nineteenth century is fissured were numerous in the second half of the century when, regularly in the Royal Academy exhibitions, classical fable alternated with scenes of marital discord in the upper walks of Victorian society, happy days at the seaside of the middle level, and many hopeless dawns in the lower.

There were clear distinctions between the Pre-Raphaelites and classicists in spite of the general interest they shared in the past. Classicism had always been much concerned with an ideal perfection of the nude human figure, Pre-Raphaelitism hardly at all, Burne-Jones making only a mild exception to this almost medieval indifference to the body. Figure drawing as a preliminary to paintings of the nude or partly nude had been the essential study of academies (Plate 32) and it is not surprising that the Royal Academy should favour a classicist trend.

In contrast, the Pre-Raphaelites retained something of the movement's early militancy, held aloof from the Academy and, as far as their later course is charted by William Morris, saw the future in broader terms of design than any form of easel picture represented. Classical revivals in the past had followed each fresh discovery of antique remains. The decorations of Nero's 'Golden House' had stimulated Raphael and his collaborators. The Neoclassicism of the late eighteenth and early nineteenth centuries followed discoveries at Pompeii and Herculaneum. The instalment in the British Museum of the Elgin Marbles in 1816 created a fresh source of influence--and, moreover, on home ground; they were to have a great effect on the outlook and work of Frederic Leighton (1830–96; Plate 163), G. F. Watts (1817–1904; Plate 150) and Albert Moore (1841–93; Plate 136).

The interest of Leighton was first drawn to the Parthenon sculptures by the passionate enthusiasm expressed in Haydon's *Autobiography and Journals*, published in 1853. It was not, however, until he had completed a comprehensive course of study and travel that ranged from Rome and Florence to Paris and Frankfurt and as far east as Damascus, that the classical leaven began to work in earnest. The vast studio of the house in Kensington, built to his requirements by his friend George Aitchison in 1866, had a copy of the Parthenon frieze as its wall decoration. His

first inclination to Italian subject matter, as in his *Cimabue's Madonna carried in procession through the streets of Florence* (bought by Queen Victoria), remained in *The industrial arts of war* (1872–85), one of his frescoes in a spirit medium for the South Kensington Museum; but Italian setting and costume of the fourteenth century gave place in the companion work, *The industrial arts of peace*, to a scene in ancient Greece. Over the years he painted many a beautiful woman from Greek history and legend, many a scene of mythical happenings. The graceful folds of drapery in his paintings were like those of the Phidian sculptors and were the material that he converted into a likeness to the Hellenic ideal.

It was an aim he shared with his friend, George Frederic Watts. On Watts's studio mantelpiece stood casts of the *Theseus* and *Ilissus* from the Parthenon pediment, a sign of his devotion to the Elgin Marbles, though he combined with this ideal a great regard for the Venetian masters of the sixteenth century. Leighton and Watts, though highly gifted, were not immune from some of the traps into which the idealist was liable to fall. Leighton, so intent on perfection, gave an impression of coldness, even when he used warm colours, an impersonal conscientiousness that relates him rather to the German Nazarenes, with whom he was long associated in his early years of study, than to his classical exemplars.

There was much feeling for beauty in Watts's female portraits (Plate 116), a sense of majesty in his portraits of eminent Victorians such as Cardinal Manning (Plate 151), but in his allegorical subjects a Victorian proneness to point a moral that eventually became oppressive. This didactic tendency, scarcely in accord with figures decked out in Parthenaic draperies, acquired an unusual and impressive force when he came to paint his minotaur-like *Mammon* (Plate 150). In various ways an unclassical spirit crept into the classical theme. Edward John Poynter (1836–1919) effected withdrawal from the industrial, commercial and heavily clothed century into a playful dreamland (Plate 171). To a similar Utopian conception Lawrence Alma-Tadema (1836–1912) added the titillation of anecdote (Plate 137). There was a likeness in the handsome young patricians he depicted in the setting of ancient Greece or Rome to those who might be encountered in the Bond Street of the 1880s. He induced the feeling that good looks and sentimental situations were much the same at all times and his paintings, thin though they might be aesthetically, were none the less popular for their suggestion that an easy transposition could be made between a golden classical age and late Victorian England. In effect, though a learned archaeologist, Alma-Tadema was in no way classically minded; he was really a genre painter in disguise.

Albert Moore, as much influenced by the masterpieces of the Parthenon as Leighton or Watts, was an artist apart. He painted no *Return of Persephone*, no *Helen of Troy* like Leighton; he attempted no reconstruction of ancient history and architecture. To point a moral like Watts was entirely beyond him. He painted beautiful girls with the composed and regular features that foreign visitors such as Taine and Stendhal admired in the English upper class as the classical type in real life; and he invested their dress with abstract harmonies of fold and patterns.

The idea of a purely aesthetic beauty that seems to have been taking shape untheoretically in Albert Moore's mind found verbal expression even in the high noon of illustration and the story picture, the 1860s. Swinburne, receptive to the French doctrine of *l'art pour l'art*, could write of a painting by Moore in the Academy of 1868: 'His painting is to artists what the verse of Théophile Gautier is to poets: the faultless and secure expression of an exclusive worship of things formally beautiful.' In Moore's *Azaleas*, 'The melody of colour, the symphony of form is complete: one more beautiful thing is achieved, one more delight is born into the world; and its meaning is beauty; and its reason for being is to be.'

The most extraordinary instance of the Victorian desire to place art on a lofty plane is afforded by the isolated genius of Alfred Stevens (1817–75), whose inspiration was neither medieval nor Hellenic but the grand manner of the Italian Renaissance and especially of Michelangelo. The realistic century had its own way of making its presence known in the work of those dreaming of the ideal. Stevens can be admired in contrasting roles. There is the artist of great Italianate conceptions born out of his time, powerful but frustrated, and on the other hand the portrait painter who could put aside the 'great style' to give a sensitive interpretation of individual character in works that stand out as portrait masterpieces of the mid-century (Plate 86).

ALBERT MOORE AND JAMES MCNEILL WHISTLER (1834–1903) may be considered together for a time as representing, in their close accord, a significant aspect of the 'aesthetic' current of the 1870s and 1880s. The word 'aesthetic', in its Greek origin meaning 'things perceptible to the senses', was much used in the speculations of German philosophers in the early nineteenth century. It was revived as the conviction gained ground that the beauty of art had been lost sight of in the developments of the age, that it needed to be coaxed back and given a renewed respect and place of honour.

Walter Pater, the great literary expositor of a beauty independent of a meaning or message, set out a criterion in his essay 'The School of Giorgione' with its two pregnant statements. 'In its primary aspect a great picture has no more definite message for us than an accidental play of sunlight and shadow for a few moments on the wall or floor: is itself in truth, a space of such fallen light, caught as the colours are in an Eastern carpet, but refined upon, and dealt with more subtly and exquisitely than by nature itself.' The other, often quoted, statement of the aesthetic attitude was that 'All the arts aspire to the condition of music.'

This was written in 1877 and taken in conjunction with certain works of visual art shows that the writer and artist were thinking along the same lines, though not necessarily that the work of literature was the one source of the idea. It could be traced back to Dante Gabriel Rossetti, in several respects a precursor of the aesthetic period. Watercolours of the 1850s such as *The blue closet* and *The tune of the seven towers* (London, Tate Gallery) not only pictured the playing of musical instruments, but in colour and rhythm imparted the feeling of music with what Pater was to refer to in the German term *Andersstreben* as an art's 'partial alienation from its own limitations'. The echo of music as interpreted by Rossetti lingered in the compositions of Burne-Jones. Whistler, with no particular love of music, seems to have thought of it as providing an analogy with his canon of painting to the excision of any literary admixture in thought, sentiment or descriptive matter.

Whistler's development as an artist was complicated in several respects. As an early friend and follower of Courbet—to the extent shown in *Au piano* of 1859, exhibited and even praised in the Academy of 1860—he could have been expected to follow a realistic course, possibly in a way similar to that of the Impressionists. But he later repudiated realism and the influence of Courbet with considerable vigour. The change in the 1860s to London and Rossetti's Pre-Raphaelite circle produced both pictures of the Thames and female studies distantly related in dress and contemplative pose to those of Rossetti at that period.

Between 1865 and 1870 he was close to Albert Moore and an interchange of style and motif appears. The reclining pose of the Parthenon frieze so often used by Moore was adopted by Whistler in, for instance, *Symphony in white, no. 3*. Moore, reciprocally, was so far affected by Whistler's taste for Japanese prints as to attempt their colour scale and to introduce Japanese fans into his backgrounds. But Whistler gives the first serious intimation of the American link with the Far East (Plate 114) as well as Europe in art. He was not deeply concerned with classical ideals in a sense reminiscent of antiquity. He had as little appreciation as Mark Twain of the Middle Ages, beloved of the Pre-Raphaelites. After his renunciation of Courbet and realism, he retained no vital connection with French art. What was left was an abstract simplification, a final outcome of his Oriental tastes, in pursuit of which he produced in the 1870s some of the most beautiful and original paintings of his time.

The musical analogy was now stressed. 'Nocturne', a word with a musical past used by Haydn and Chopin, perhaps suggested to Whistler by his patron, F. R. Leyland, replaced 'Moonlight' as the title of his Thames night scenes. By significant chance, his *Nocturne in blue and gold: Old Battersea Bridge* (Plate 135) was exhibited at the Grosvenor Gallery, the new centre of aesthetic trends in 1877, the year in which Pater's dictum on the aspiration to music appeared in print. 'Symphony', 'Harmony', 'Variations' (of colour) were other titles of musical suggestion. Even portraits became 'Arrangements', the likeness professedly secondary to the design (Plate 133).

The evidence given in the libel action of 1878 against Ruskin, following the latter's intemperate criticism of Whistler's *Nocturne in black and gold: the falling rocket*, and the verdict of a farthing damages, revealed an absence of sympathy or understanding that the painters called to give evidence shared with the jurymen. Only Albert Moore came forward to testify on Whistler's behalf. The bolts of sarcastic criticism, vindictive wit and scathingly lucid exposition (in the Ten o'clock Lecture) that Whistler continued to fire until the 1890s at critics, aesthetes and the academic purveyors of pictures with a story or a moral, had no obvious effect in changing insular opinion.

The resistance to ideas from abroad, one aspect of a general insular prejudice, was especially marked in the 'seventies and 'eighties. Academicians grew rich as never before in ministering to the requirements of an art-conscious public at home with whose tastes they were entirely in accord. This situation produced the exclusiveness that the French critic Ernest Chesneau likened to enclosure behind a sort of 'great wall of China'. His assertion that to British painters 'European art was a

sealed book' might be supported by the cold reception of Claude Monet and Camille Pissarro when they came to London in the period of the Franco-Prussian War, 1870–1.

The attempt of the dealer Durand-Ruel at that time to establish an Impressionist gallery in Bond Street was unsuccessful. A gradual infiltration followed towards the end of the century, but British painters never entirely assimilated the Impressionist analysis and use of colour. The influence of Whistler may be discerned in the cultivation of tone rather than colour, though his two principal disciples, Walter Greaves (1846–1930) and Walter Sickert (1860–1942), show a marked divergence. Greaves, member of a boatbuilding family and essentially a character of the Chelsea riverside, displayed an interest in his Chelsea subjects of a kind that made his work clearly distinct even when he sought to imitate Whistler (Plate 134). He naïvely indicated the difference between them in saying, 'To Mr Whistler a boat was a tone, but to us [i.e. Walter and his brother Henry Greaves] it was always a boat.'

Sickert, who greatly admired Greaves's natural gift of expression, also had an interest in subject that distinguishes him from Whistler. Sickert is outstanding among the artists who sought to re-establish links between England and France. Though he worked with Whistler for some time he was more deeply influenced by Degas, whom he first went to see in Paris in the 1880s and whose friend he remained until the outbreak of war in 1914. From Degas he gained an appetite for the urban subject, the street, the theatre, the music-hall (Plates 167 and 168). From Whistler he acquired the practice of working from memory with the aid of sketches, but Degas opened up a wider prospect in showing how the spontaneity of a sketch might be preserved in a composition carefully worked out. If Impressionism is to be rigidly defined as the habit of painting direct from nature with colours more or less corresponding to those of the spectrum, then the method Sickert learned from Degas would scarcely come under that heading. It was obvious, however, that a London music-hall performance could not be painted on the spot any more than Degas's ballet dancers; and dusky tones were probably best suited to convey its atmosphere. Such works as *The mammoth comique* (Plate 167) and *Bonnet et Claque* (Ada Lundberg at the Marylebone Music-hall singing 'It all comes from sticking to a soldier') were unique in their pictorial savour and the feeling they gave of the 'nineties'.

In a sense, the Victorian age ended about the year 1890 although the Queen lived on until 1901. M. Chesneau's 'great wall' of isolation was at last breached in

several places. Painters trained in Paris, a growing number, were apt to be out of accord with the standards of the Royal Academy. They looked for alternative places of exhibition, the appearance of which disturbed the Academy's long hegemony. As early as 1876 the Grosvenor Gallery had become the exhibition centre for such non-academic personalities as Burne-Jones and Whistler. The New English Art Club, founded in 1886, was expressly intended to further the Anglo-French tendencies of the younger generation. In intention at least the New English Art Club was Impressionist. It had a minor offshoot in the Newlyn School of open-air painting headed by Stanhope Forbes (1857–1947), influenced more by the popularizer of French Impressionism, Bastien Lepage, than by the great artists of the movement. But the principal members of the New English Art Club were the outstanding artists of the time. They included Walter Sickert, John Singer Sargent (1856–1925) and Philip Wilson Steer (1860–1942), as well as such painters of the so-called 'Glasgow School' (united in admiration of Whistler) as James Guthrie (1859–1930) and John Lavery (1856–1941).

Sargent was the friend of Claude Monet and at least sympathetic to Impressionism in the open-air landscape that gave him a pleasurable relief from portrait painting (Plate 138). But it is in portraiture that he stands out as a brilliant observer of English and American society and a technician who had profited by the study of Velazquez, Hals and Manet (Plates 155 and 170). Steer in the 1890s showed an awareness of new values of colour in French art that produced the triumphant freshness of his landscapes at Walberswick and Cowes. It is evident that he must have studied Seurat's 'Neo-Impressionism' to good purpose if not in a very scientific way. *Nude sitting on a bed* (Plate 164) is partly a conscious act of homage to Manet's *Olympia*, which had promoted a great scandal. The difference between this straightforwardly painted figure of a naked model and Leighton's *Bath of Psyche* (Plate 163) is that of a new candour as compared with the disguises of classical setting and accessories that had made nudity in painting acceptable to a Victorian public.

From a present-day point of view it is strange that Impressionism should still have appeared in the 1890s as suspect from a moral and ethical point of view. Degas's *Au café* (Paris, Louvre), exhibited in London in 1893 as *L'absinthe*, a picture of restful contemplation on a café terrace, was regarded with horror as 'a study of degradation, male and female'. The habit of looking for a story or reading one into a painting died hard. Yet change in this remarkable century was again at work. Its end was brilliant—a final flare and transformation of the illustrative genius in the

art of Aubrey Beardsley (1872–98; Plate 166), a sophisticated elegance in the paintings of Charles Conder (1868–1909). Through them—Beardsley in particular—and their fellow members of the New English Art Club, Sickert and Steer, abetting the efforts of the younger writers that included the sparkling gift of Max Beerbohm as an essayist, *The Yellow Book*, first published in April, 1894, issued its challenge to the old order. The *fin de siècle* was not simply an end but the beginning of a quest for the new.

List of plates

The plates

1 PHILIP JAMES DE LOUTHERBOURG (1740–1812):
Detail from *The battle of the Nile* (Plate 2)

Events of the Napoleonic Wars added the incitation
of fact to the surge of violent feeling that was one
feature of Romanticism. De Loutherbourg
displayed this feeling with effect in his pictorial
celebration of Nelson's victory over the French in
the battle of the Nile, fought in 1798 in Aboukir Bay.

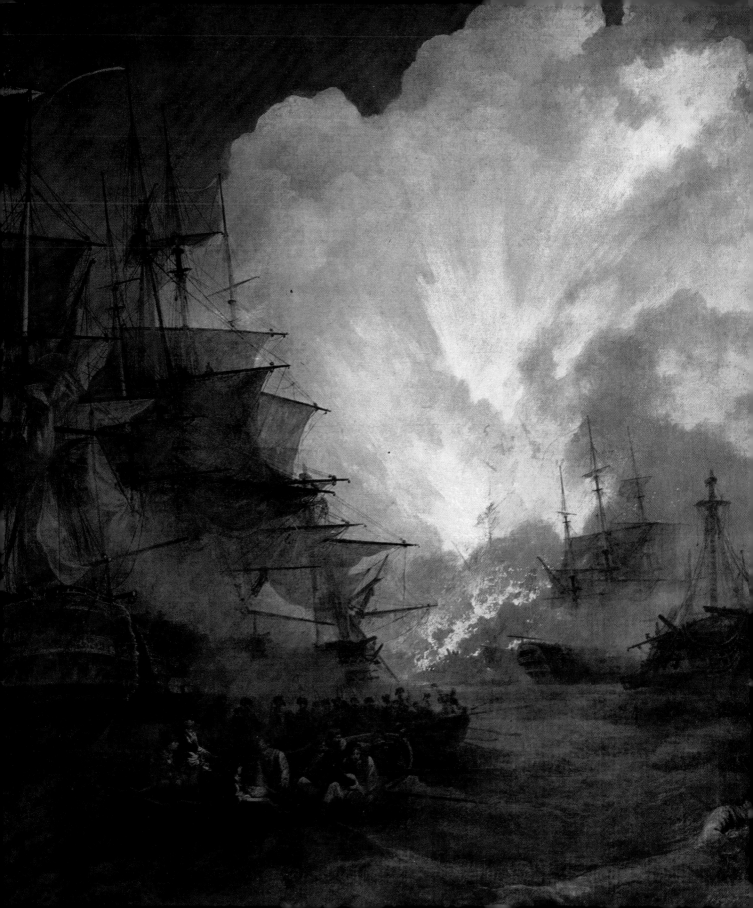

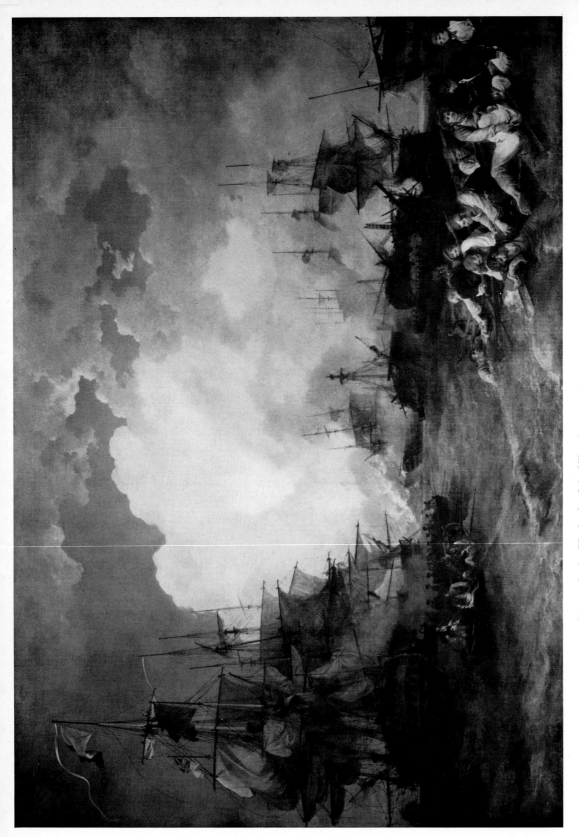

2 PHILIP JAMES DE LOUTHERBOURG (1740–1812): *The battle of the Nile.* 1800.
Canvas, 60 × 84¼ in. London, Tate Gallery

As a composition full of restless movement and the expression of dynamic energy,
de Loutherbourg's battle piece may be contrasted with the comparatively static pictures of
naval engagements produced in the seventeenth and earlier eighteenth centuries. A new
emotional tide was breaking down conventions of style and making for the effort to come
closer to the actual sensation of the depicted events. De Loutherbourg's work represents a
tendency in common with the sea pieces of Turner.

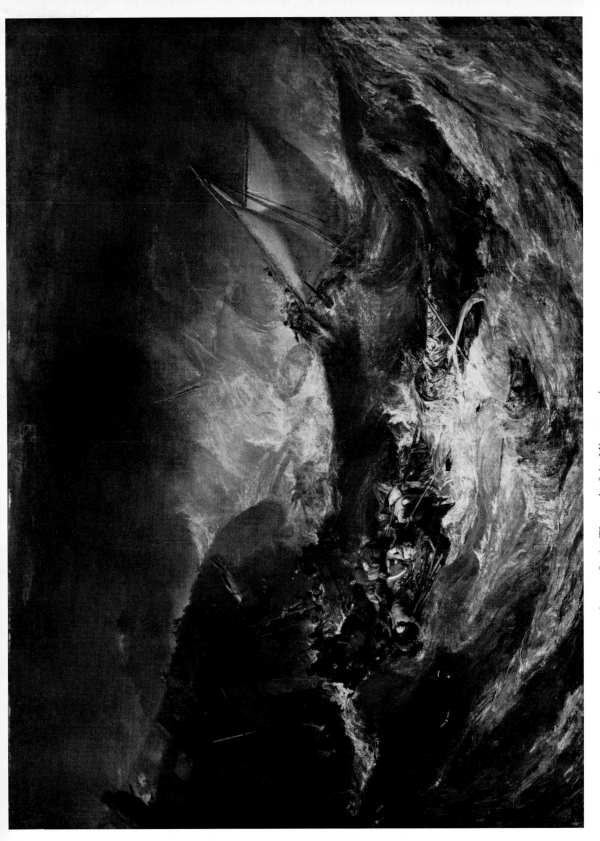

3 JOSEPH MALLORD WILLIAM TURNER (1775–1851): *The wreck of the Minotaur on the Haak Sands*. About 1810. Canvas, 68×95 in. Lisbon, Gulbenkian Foundation

For Turner the elements themselves were a continued battle scene in which man was perpetually engaged in a losing encounter with the storms of nature. The theme of his romantically pessimistic *Fallacies of Hope* here has one of many examples. The picture was vividly described by John Burnet about 1850 as 'like a great boiling cauldron, with boats, men and boxes floating about in every direction, realizing the description given by Macbeth—''the yeasty waves confounding and swallowing navigation up'''

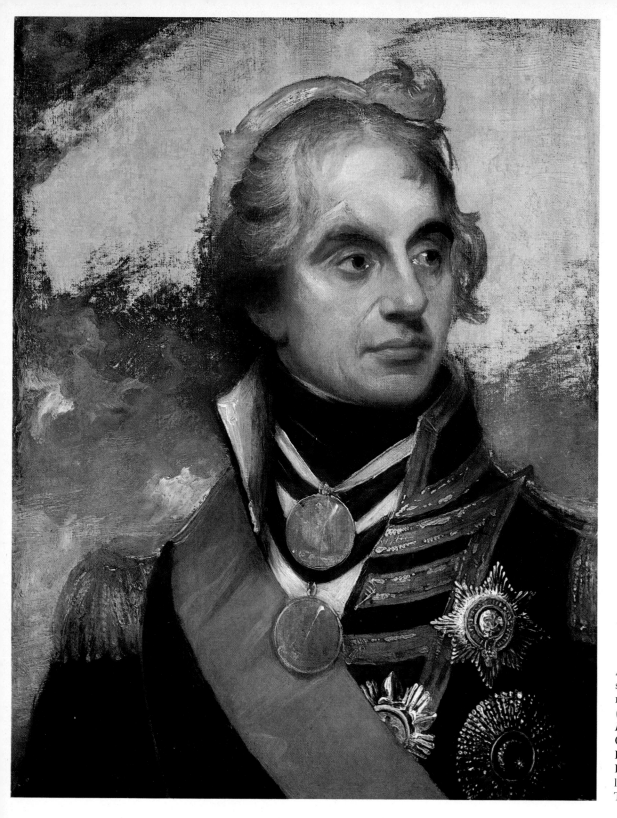

4
<small>SIR WILLIAM
BEECHEY</small>
(1753–1839): *Horatio
Lord Nelson*. 1800–1.
Canvas, 24¼ × 19 in.
London, National
Portrait Gallery (on
loan from the Leggatt
Trustees)

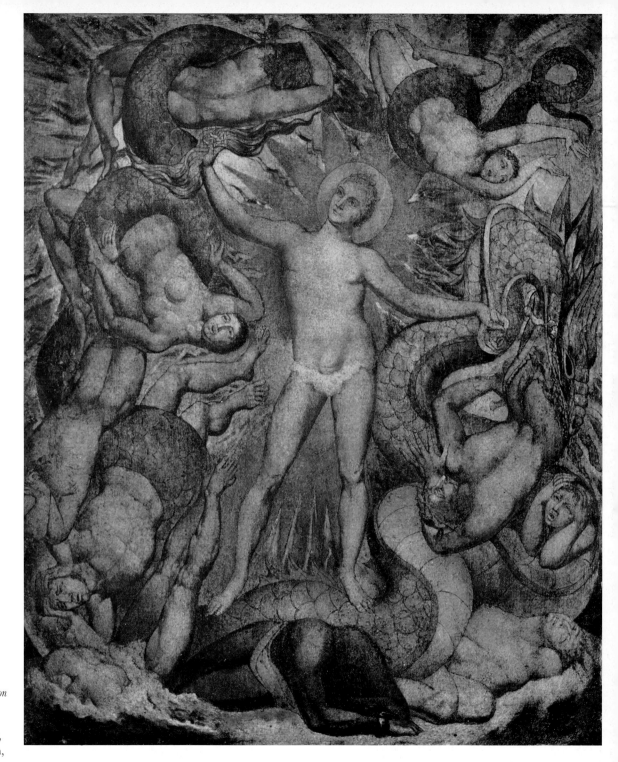

5
WILLIAM BLAKE
(1757–1827): *The
spiritual form of Nelson
guiding Leviathan.*
Exhibited 1807.
Tempera on canvas,
30 × 24⅝ in. London,
Tate Gallery

The period of the Napoleonic Wars, naturally not without effect on the work and attitude of artists, could produce such a remarkable contrast as appears in the realistic iconography of Sir William Beechey compared with Blake's magnificent creation of a mythological hero. Beechey shows us the careworn victor of the Nile at a time when much involved with Lady Hamilton, but shortly to win fresh laurels in the attack on Copenhagen. Blake's Nelson—like the companion 'spiritual form' of Pitt—was, as Blake explained, an apotheosis on an ancient model. 'Clearness and precision' had been his aim in using 'fresco' (his version of tempera) instead of oil.

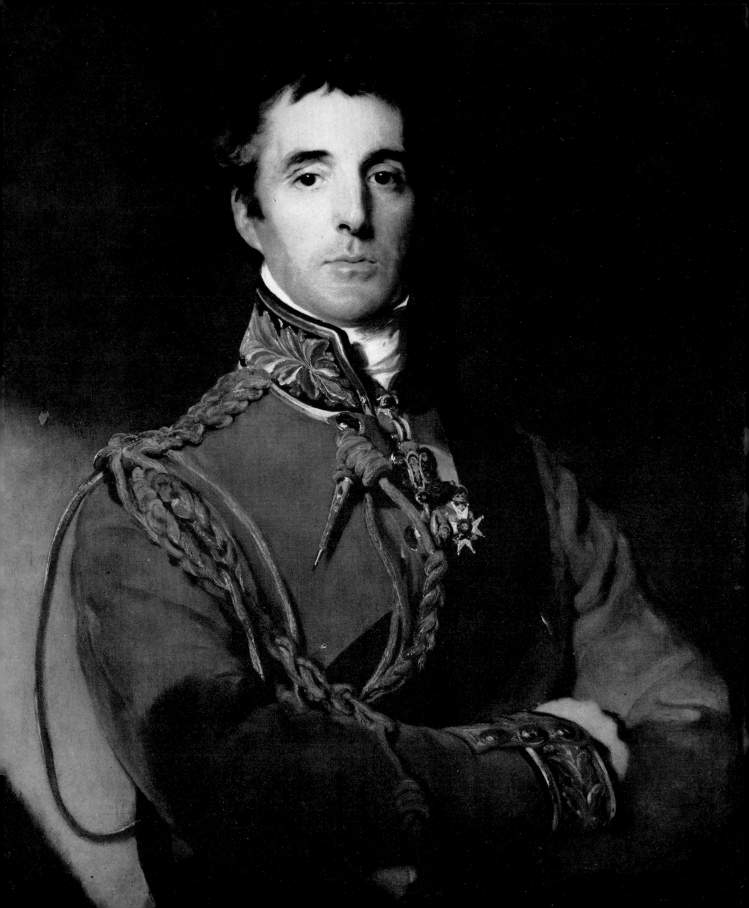

6 (*opposite*)
SIR THOMAS LAWRENCE
(1769–1830): Detail from
*Arthur Wellesley, first Duke of
Wellington.* 1814. Canvas,
36 × 28 in. London,
Wellington Museum

7
SIR THOMAS LAWRENCE:
*Charles Philip, Prince
Schwarzenberg.* 1819. Canvas,
123½ × 95¼ in. Royal
Collection. Reproduced by
gracious permission of Her
Majesty The Queen

Lawrence's ability to impart
dignity to his sitter without
resort to obvious flattery is
well exemplified in the
portrait of the Duke of
Wellington as he appeared at
the time of the first overthrow
of Napoleon. In the Striped
Drawing Room of Apsley
House (Wellington Museum)
the portrait is appropriately
accompanied by those of his
generals as well as other
celebrities of the war period.
In Lawrence's subsequent
triumphal European journey
to paint rulers and leaders in
the euphoria of final victory
he went from Aix-la-Chapelle
to Vienna to paint his
impressive portrait of Prince
Schwarzenberg and other
Imperial generals.

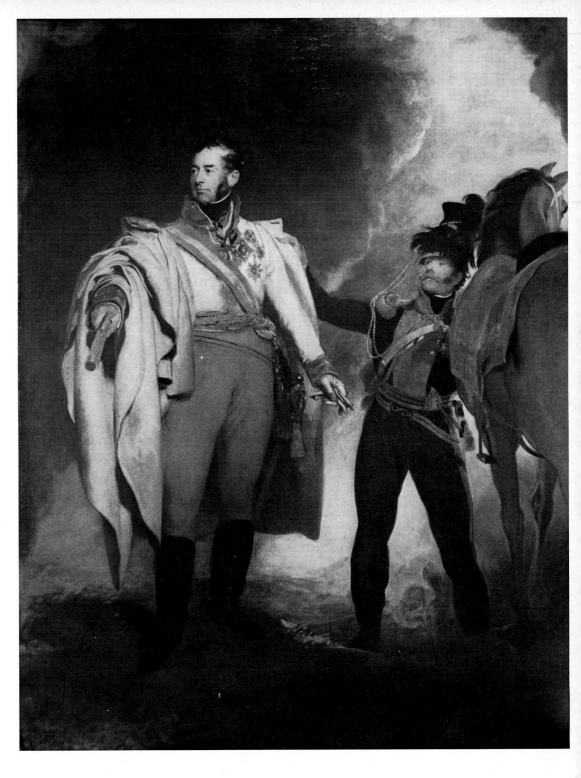

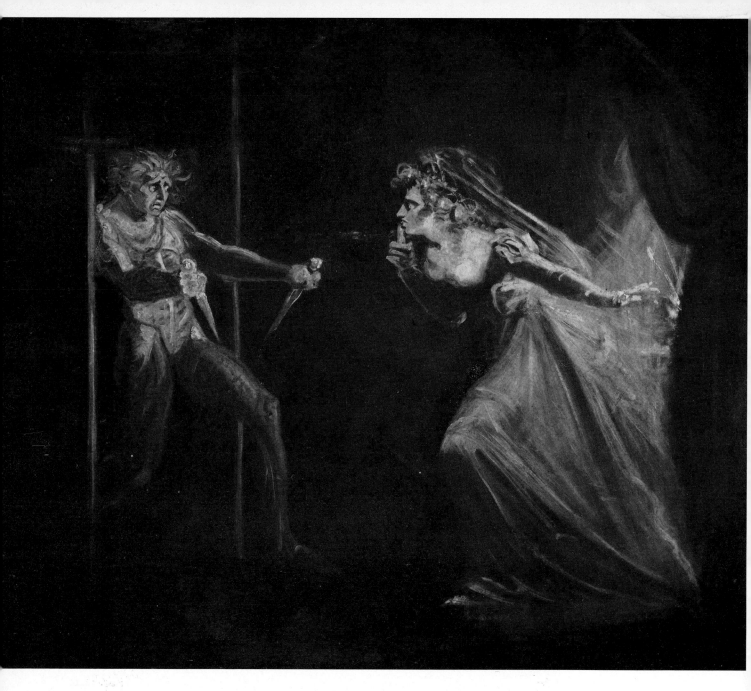

8 HENRY FUSELI (1741–1825): *Lady Macbeth seizing the daggers*. Exhibited 1812.
Canvas, 40×50 in. London, Tate Gallery

Though Lady Macbeth is not actually seizing the daggers, as the title states, this picture
evokes more vividly than any other of Fuseli's Shakespearian scenes the horror of the moment
and the will to violence. A shudder of dread seems to pervade the work and the impression
is heightened by the livid near-monochrome. The painting is a striking instance of the
Romantic association of the terrible and the sublime. It is probable that the composition
was inspired by the acting of Mrs Siddons, who made Lady Macbeth one of her most
celebrated roles and chose the part for her farewell performance in 1812, about the time the
picture was painted. Fuseli, however, did not portray her or give the effect of a stage—
instead he projects a psychological dimension.

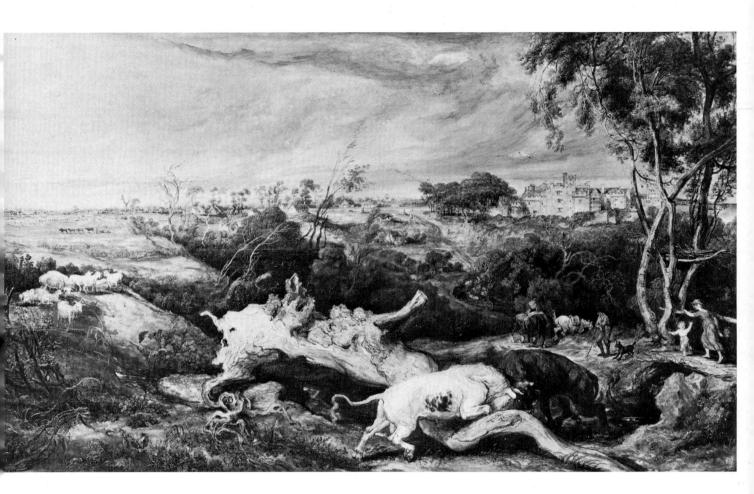

9 JAMES WARD (1769–1859): *Bulls fighting*. 1804. Panel, 51¾×89½ in. London, Victoria and Albert Museum

It was Ward's ambition to excel in a loftier style of painting than that of his brother-in-law, George Morland, and in this effort he opposed violent action to the placidity of Morland. One of his most impressive works of this kind is his *Bulls fighting*. It is evident he had Rubens much in mind as a model to follow though he was far from being merely imitative. Every detail of the scene seems to contribute to its force, which is no more a realistic illustration than a Rubens copy. Unlike though his subject is to Fuseli's scene from *Macbeth* it is possible to discern some underlying affinity in the artists who both give personal feeling an objective shape.

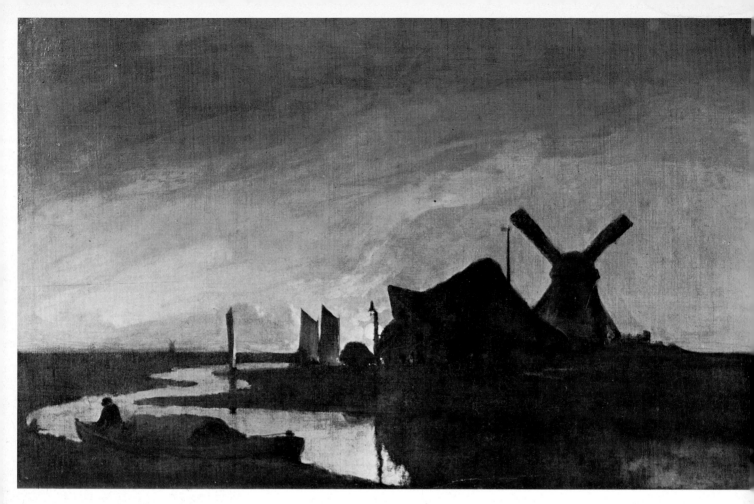

10 JOHN CROME (1768–1821): *Moonrise on the Yare*. About 1808. Canvas, $28 \times 43\frac{3}{4}$ in.
London, Tate Gallery

In John Crome there is an instance of a great artist who was little affected by the march of
events and change of mood in the world generally, bringing a serenity of style and outlook
into an unquiet age. His affinities were with the seventeenth-century Dutch landscape
painters and his English predecessors of the eighteenth century, Wilson, Gainsborough and
Morland. Breadth and dignity, the qualities he prized, are well exemplified in *Moonrise on
the Yare*, a mature work painted when he was about forty years of age. If Aert van der
Neer's 'Moonlights' come to mind as the Dutch prototype, it is the more apparent that
Crome excelled in the arrangement of large masses into a coherent grandeur of design.
The local collector, Dawson Turner of Yarmouth, who bought the painting from
Crome, placed the scene between Norwich and Yarmouth, near the junction of the Yare
and the Waveney. The exact locale has been debated by others but there is no reason to
suppose that Crome felt bound by topography in a work so poetically conceived.

11 JOHN CROME (1768–1821): *Slate quarries*. About 1804–6. Canvas, $48\frac{3}{4} \times 62\frac{1}{2}$ in. London, Tate Gallery

Crome was in general so consistently a painter of the flat East Anglian lands, that mountains in a picture by him come as a surprise, though it is to be recalled that his infrequent excursions away from Norfolk included visits to Cumberland. In this early masterpiece it can be seen how little affected he was by the Romantic tendency to exaggerate or lay especial stress on heights and depths. There is a massive calm and completeness of harmony between level and rising ground and the clouds that make their olympian circle round the higher slopes. The colour is an unobtrusive but corresponding harmony of silver green and greys with light earth tones.

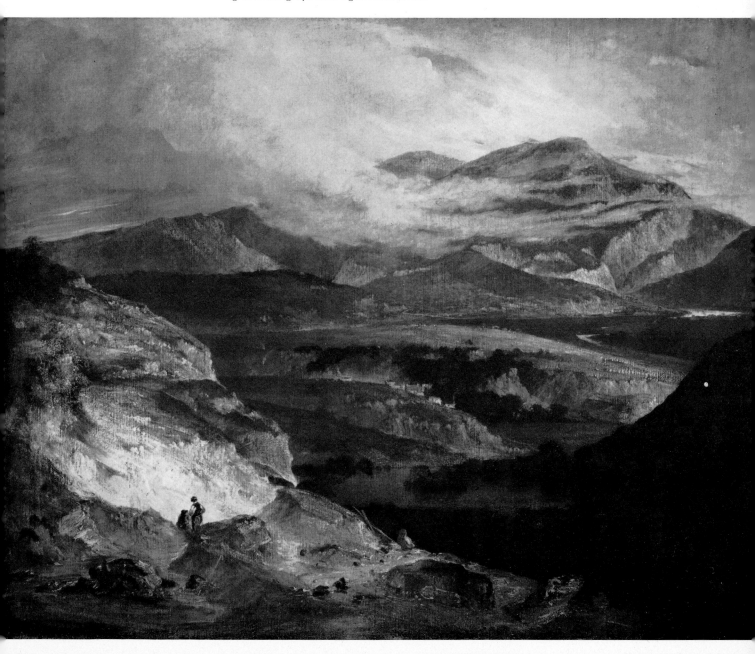

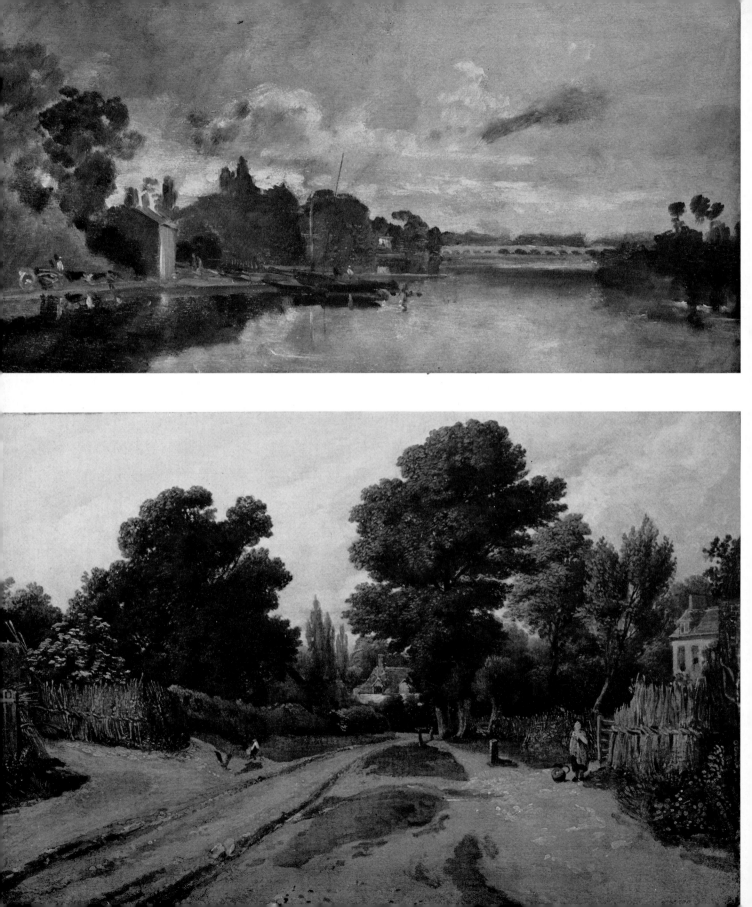

12 (*opposite, above*)
JOSEPH MALLORD WILLIAM
TURNER (1775–1851): *The Thames near Walton Bridges*.
About 1807. Wood, $14\frac{5}{8} \times 29$ in.
London, Tate Gallery

13 (*opposite, below*)
WILLIAM DELAMOTTE
(1775–1863): *Waterperry, Oxfordshire*. 1803. Board,
$12\frac{3}{4} \times 19\frac{1}{4}$ in.
London, Tate Gallery

The intimate aspect of landscape was sought rather by the Realist than the Romantic and perhaps for this reason landscapes of the intimate kind such as *The Thames near Walton Bridges* are rare in Turner's work. The picture belongs to a series painted direct from nature between about 1805 and 1810. In these years he occupied a house at Hammersmith Mall with a garden that ran down to the river, a convenient starting point for painting expeditions by boat. Though a lesser painter, William Delamotte showed a like intimacy of feeling for landscape in the first decade of the century.

14 JOHN CROME (1768–1821): *Study of a burdock*. About 1813.
Panel, $21\frac{1}{2} \times 16\frac{1}{2}$ in. Norwich, Castle Museum

A study such as this could be regarded as a rustic equivalent of the ornate flower and still-life paintings of the Netherlands. More than an examination of detail for some further use, it became, as Crome painted it, a composition with its own completeness and a wealth of delightful colour and brushwork. Crome's breadth of style remained even at such close quarters with nature.

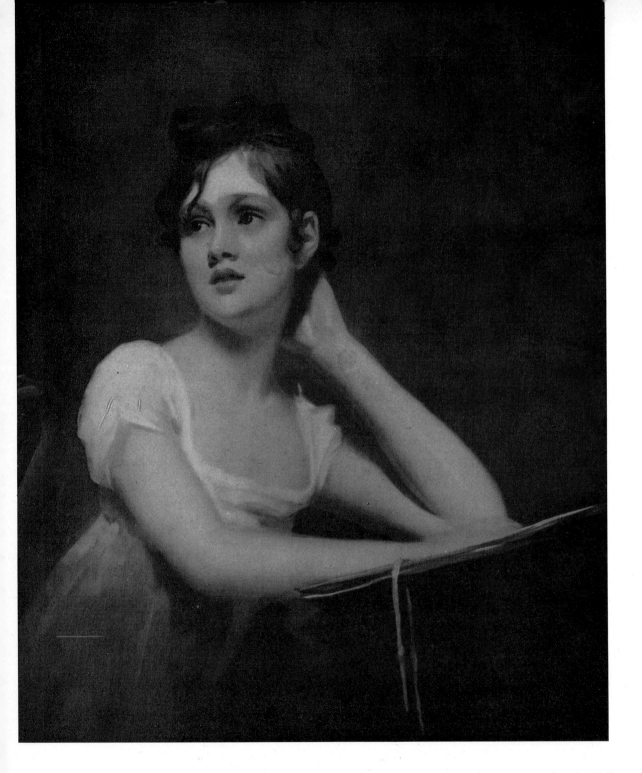

15 SIR HENRY RAEBURN (1756–1823): *Girl sketching*. About 1814. Canvas, 30 × 25 in. Liverpool, Sudley Art Gallery and Museum

It was long a criticism of Raeburn that while his boldness of style was well suited to represent men of intellect and vigorous character it was less adapted to convey the charm and delicacy that Lawrence was so well able to render in his female portraits. While he was certainly equipped to do full justice to a Lord Eldon, a James Watt, a John Rennie, this painting shows that Raeburn could well adapt himself to the portrayal of either sex.

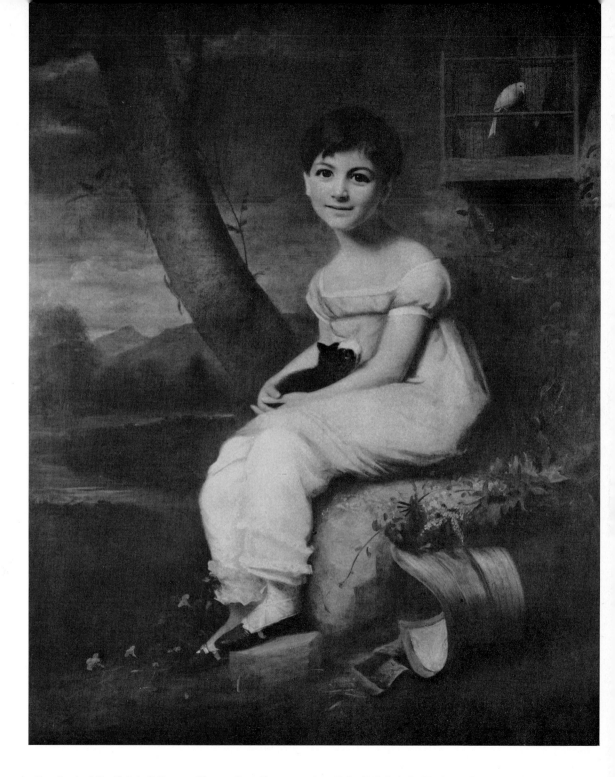

16 GEORGE WATSON (1767–1837): *Miss Zoë de Bellecourt*. About 1825. Canvas, 50¾ × 38¾ in. Edinburgh, National Gallery of Scotland
Raeburn's influence on George Watson is evident in this charming portrait of Zoë Bellecourt, later Mrs Stafford.

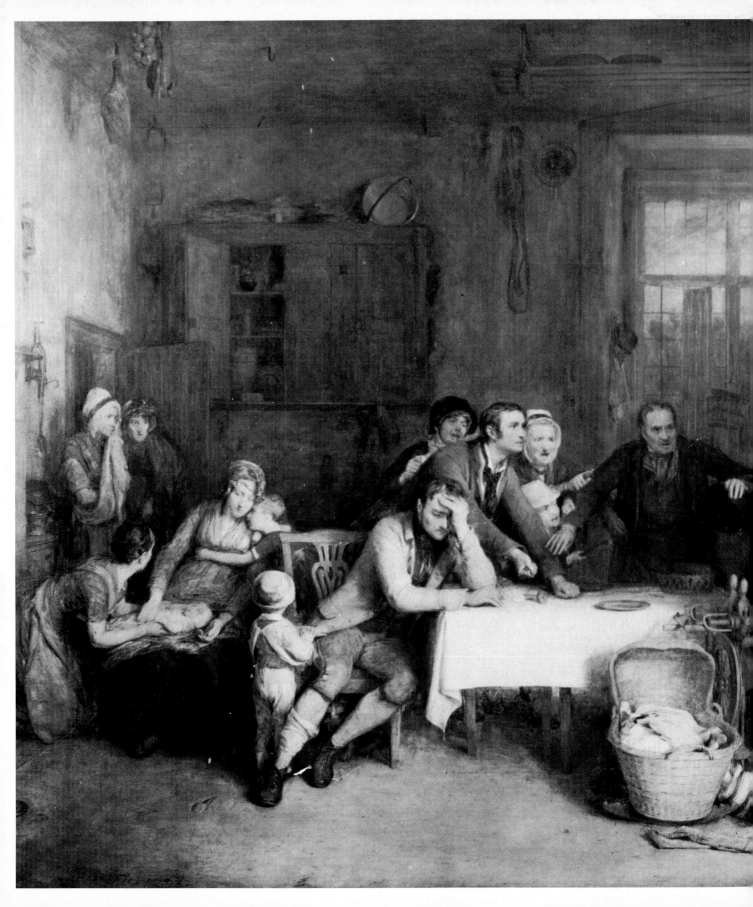

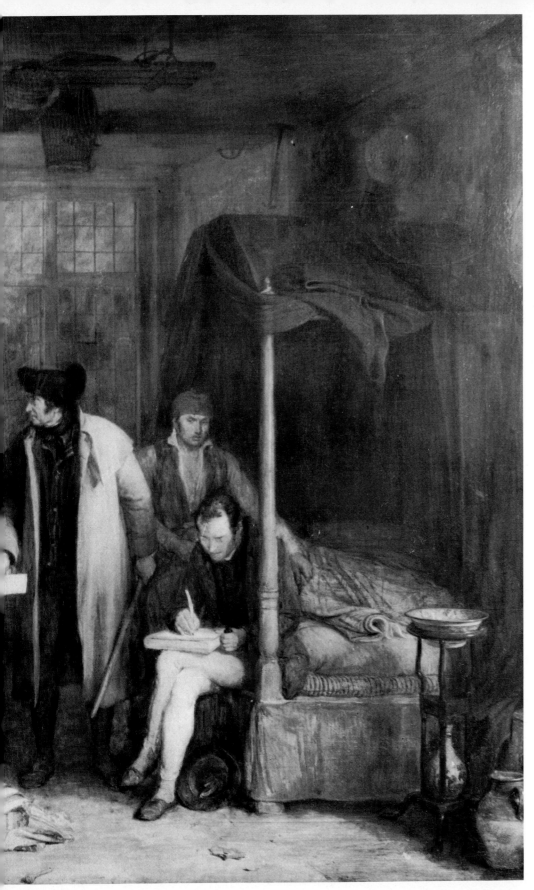

17

SIR DAVID WILKIE (1785–1841):
Distraining for rent. 1815.
Panel, 32 × 48 in.
Edinburgh, National Gallery of
Scotland.

In this picture Wilkie seems on
the verge of the social realism that
was to be a much later feature of
the century. The subject itself
made for more serious treatment
than the horseplay of his *Blind
man's buff* of three years before.
Lady Eastlake in 1846 gave it
intelligent appreciation, regarding
it as 'truly matchless, every figure
appropriate and telling, not an
over-acted expression—mere quiet
sorrow and loud indignation'. One
of Wilkie's own paintings had been
seized at his exhibition in Pall Mall
for rent due from a former tenant;
this may have added veracity of
feeling to his painting. Purchased
by the directors of the British
Institution for £600, the picture
was sold to A. Raimbach, whose
published engraving of the picture,
presumably because of the subject,
was not a great success.

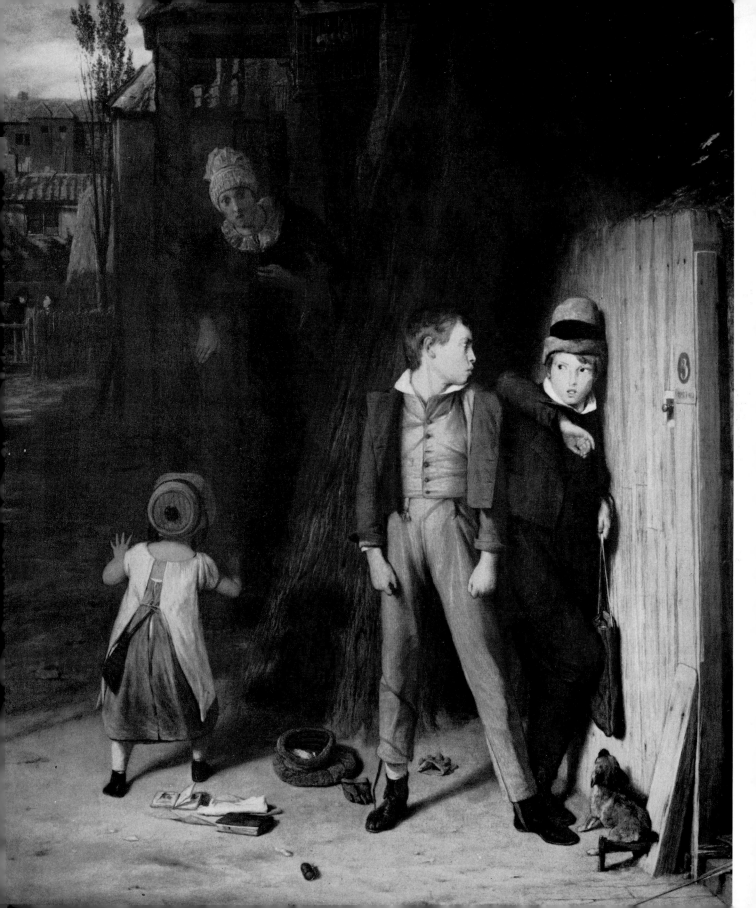

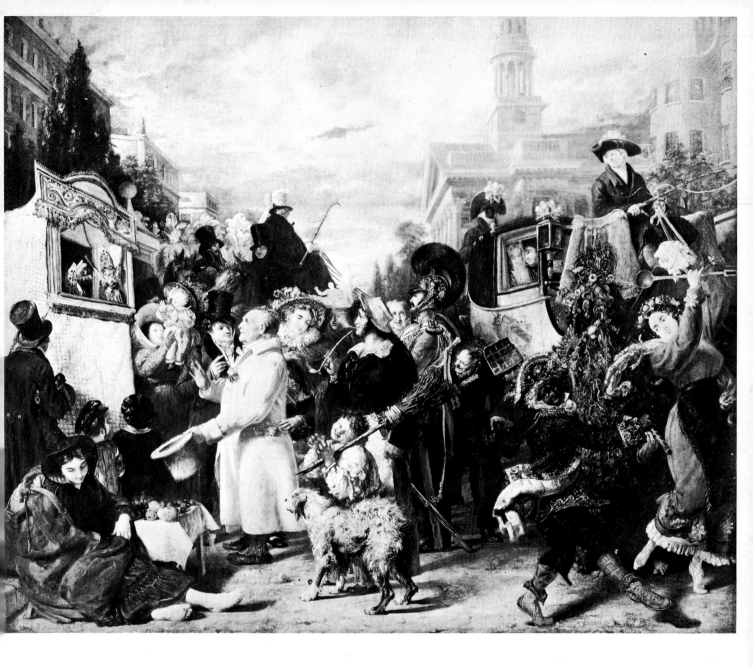

18 (*opposite*) WILLIAM MULREADY (1786–1863): *The wolf and the lamb*. Exhibited 1820. Panel, $23\frac{5}{8} \times 20\frac{1}{8}$ in. Royal Collection. Reproduced by gracious permission of Her Majesty The Queen

It was the view of Mulready, as recorded in one of his notes, that 'in the present state of the art almost any subject matter may be raised into importance by truth and beauty of light and shade and colour and with an unostentatious mastery of execution'. This sensible remark provided a theoretic basis for a work such as this.

19 BENJAMIN ROBERT HAYDON (1786–1846): *Punch or May Day*. 1829. Canvas, $59\frac{1}{4} \times 72\frac{1}{8}$ in. London, Tate Gallery

In William Powell Frith's *Autobiography* there is the dictum that 'Historical painting in England, from the contemporaries of Reynolds down to Haydon and Hilton, has been disastrous to its professors.' When Haydon was compelled by circumstances to attempt to live *by* painting instead of *for* painting he had to abandon his lofty ambitions and turn to the genre picture of everyday life that answered to the taste of the time.

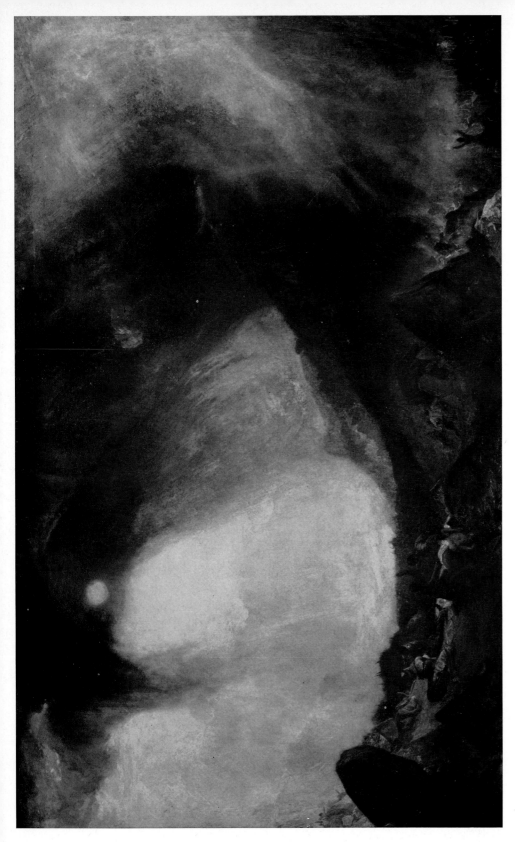

20 JOSEPH MALLORD WILLIAM TURNER (1775–1851) : *Hannibal and his army crossing the Alps*. Exhibited 1812. Canvas, 57 × 93 in. London, Tate Gallery

This tremendous vortex of storm, with human figures dwarfed in comparison to the giant effects of elemental rage, was a masterpiece to which Turner first appended a quotation from his *Fallacies of Hope*: 'In vain each pass ensanguined deep with dead, Or rocky fragments, wide destruction rolled.' The effect of storm was observed in reality on one of Turner's visits to Farnley. His patron's son, Hawksworth Fawkes, watched him making notes of the storm's progress over the Yorkshire hills. 'There, Hawkey,' said Turner, 'in two years you will see this again and call it Hannibal crossing the Alps.' Contemporary opinion was favourable. Crabb Robinson admired the picture in the Academy of 1812 as the most marvellous landscape he had ever seen.

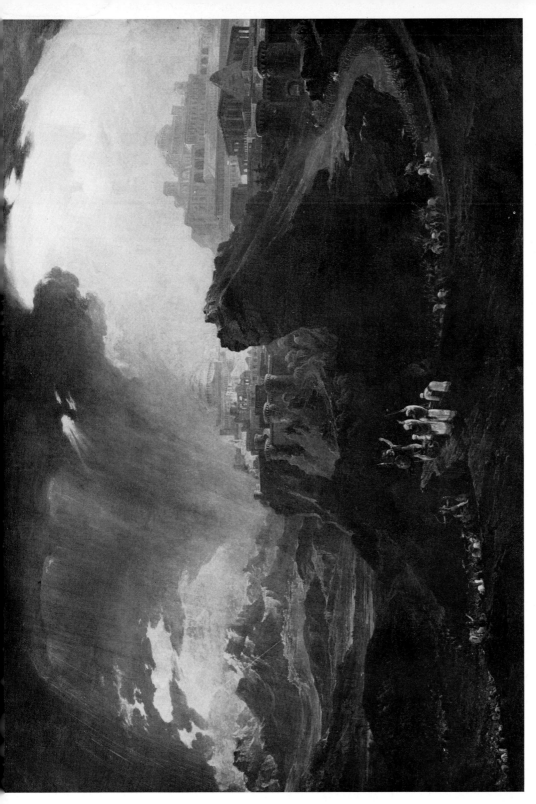

21 JOHN MARTIN (1789–1854): *Joshua commanding the sun to stand still upon Gibeon*. Exhibited 1816. Canvas, 59 × 91 in. London, United Grand Lodge Museum

There is a superficial likeness between Turner's *Hannibal* and this work by John Martin though a difference soon appears between natural phenomena carefully but imaginatively observed and supernatural melodrama. Ruskin denounced Martin's works of this kind as a 'reckless accumulation of false magnitude' but they can more fairly be appreciated as fantasy; their being, as the critic maintained, 'allied to nightmare', makes them none the less of interest. The Academy accepted *Joshua* in 1816 but according to Martin 'hid it' in the Ante-room— which did not prevent its becoming the picture of the year. Martin gained a confidence from its reception that enabled him to embark on other vast panoramas seen in an unearthly light.

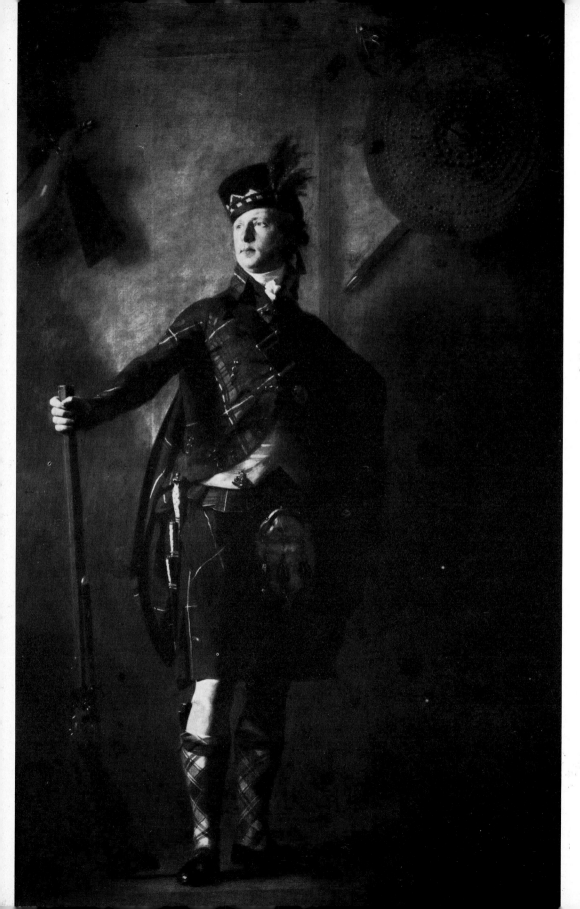

22
SIR HENRY RAEBURN
(1756–1823): *Colonel Alastair
Macdonell of Glengarry*.
Exhibited 1812. Canvas,
95 × 59 in. Edinburgh,
National Gallery of Scotland

Dramatic shadow, a martial
stance and many details
suggesting a proud, warlike
tradition, give Raeburn's
portrait of the Chief of the
Macdonells of Glengarry a
robustly Romantic character.
The plaid and kilt of the
Macdonell tartan, the
plumed bonnet, the musket
and broadsword all
contribute to this effect.
Highland history has its
mementoes on the wall in the
crossed swords behind a
round targe and the horn and
crossbow at the left.

23

SIR THOMAS
LAWRENCE
(1769–1830): *Pope
Pius VII.* 1819.
Canvas, 106 × 70 in.
Royal Collection.
Reproduced by
gracious permission
of Her Majesty The
Queen

Pius VII figured
among the sitters for
Lawrence in the
series of portraits
painted after
Waterloo as the
opponent of
Napoleon, whom he
had excommunicated
and who had
imprisoned him at
Fontainebleau. The
painter's style was at
his most
romantically
temperamental in the
portrait painted in
the Vatican, with its
shifting lights and
shadows. Though
nearly eighty,
the Pope looks
younger in the
painting—'through
all the storms of the
past', the artist
noted, 'he retains
the jet black of
his hair.'

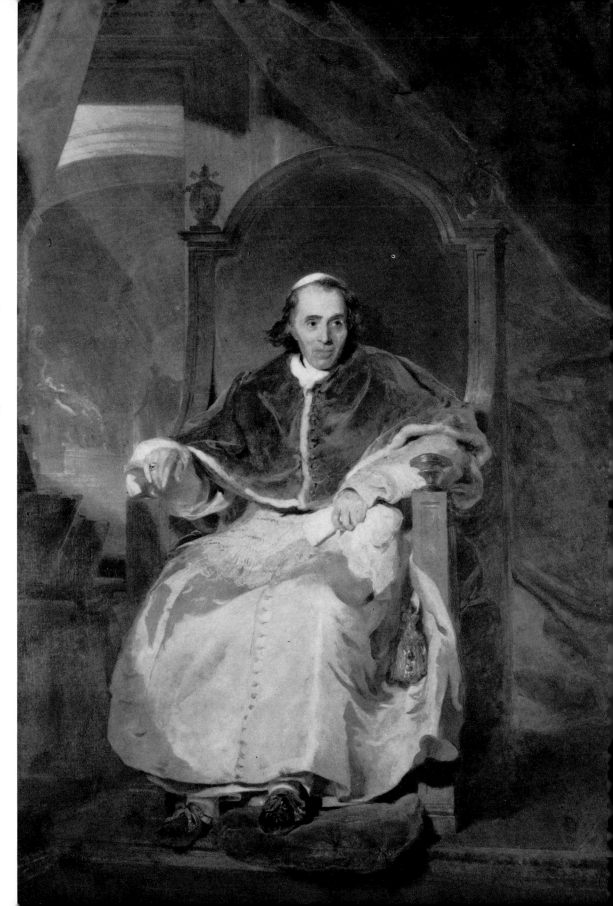

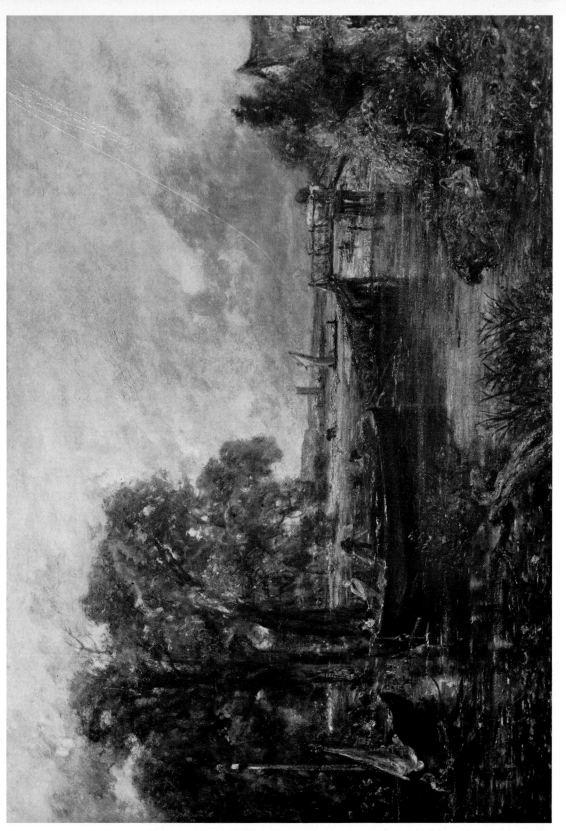

24 JOHN CONSTABLE (1776–1837) : Oil sketch for *View on the Stour near Dedham*. 1822. Canvas, 51 × 73 in. London, Royal Holloway College

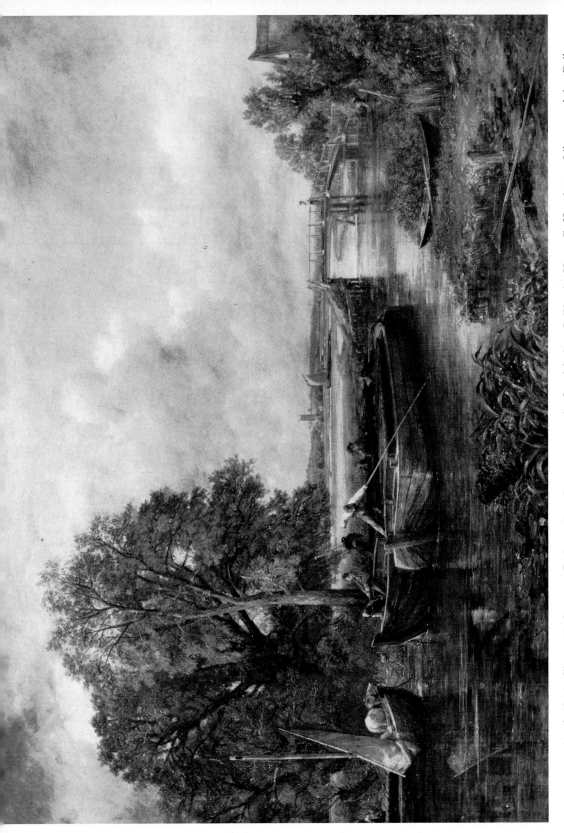

25 JOHN CONSTABLE (1776–1837): *View on the Stour near Dedham*. 1822. Canvas, 51 × 74 in. San Marino, California, Henry E. Huntington Library and Art Gallery

How Constable translated the oil study into the finished work can be well appreciated in a comparison of the study and completed painting of *View on the Stour*. There is no reason to suppose that Constable valued the freedom of the study more than the final exhibited picture; on the contrary, the study or sketch was a step towards the objective. He was able to a surprising degree to retain the first freshness of the idea in its subsequent elaboration. A modern suspicion of 'finish' has perhaps tended to overlook this essential connection and process of development. To the sparkle of paint in itself Constable contrived to add much that in the *View on the Stour* enables the spectator to share his affection for the waterways and meadows of his native region.

26 SIR AUGUSTUS WALL CALLCOTT (1779–1844): *Diana at the chase*. Canvas, $61\frac{1}{2} \times 85$ in.
Bury, Public Library and Art Gallery

Although Callcott was a pupil of Hoppner, he was soon convinced that he was not cut out to
be a portrait painter. His work consisted mainly of landscapes into which he sometimes
introduced groups of figures, until the last years of his life, when he attempted 'history'. This
picture is a very good example of the 'classical' landscape style, going back to Claude and
Poussin, which was still considered the finest possible achievement in landscape painting in
the first half of the nineteenth century. The date of this painting is unknown; it was
discovered under another canvas by Callcott's nephew after the artist's death.

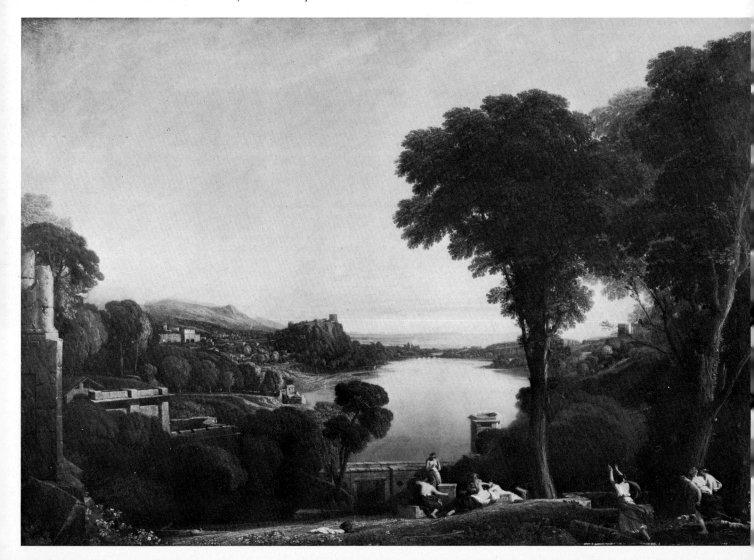

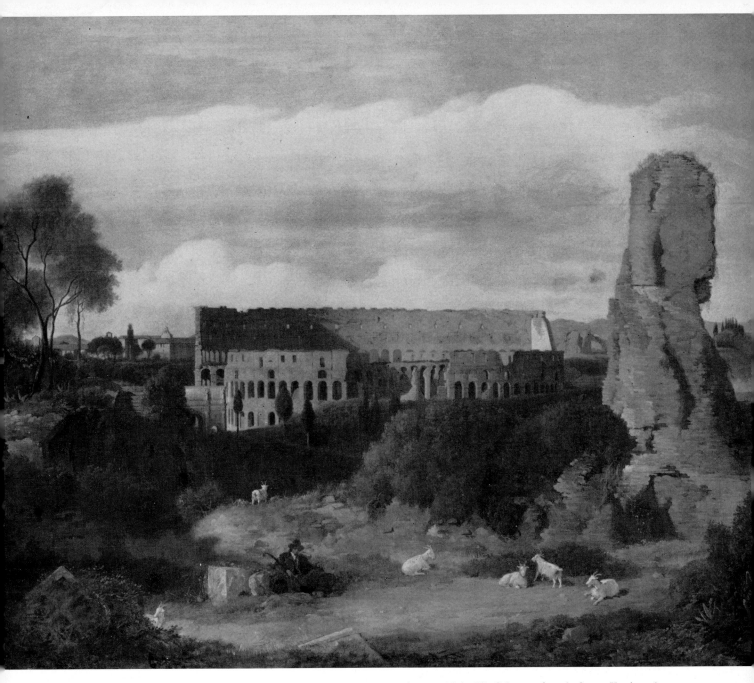

27 SIR CHARLES LOCK EASTLAKE (1793–1865): *The Colosseum from the Campo Vaccino*. 1822. Canvas, 20¾×25½ in. London, Tate Gallery

The abilities of Sir Charles Eastlake are seen to excellent advantage in this view of the Colosseum with its picturesquely rural surroundings, an elegant sequel to the views so popular with visiting artists in Rome in the seventeenth century. It was one of several paintings showing the Colosseum made by the artist in 1821 and 1822 which, according to Lady Eastlake, had a considerable influence on other landscape painters. The view was taken from the Palatine Hill which, together with the Forum, was traditionally known as the Campo Vaccino, an enclosure for cattle.

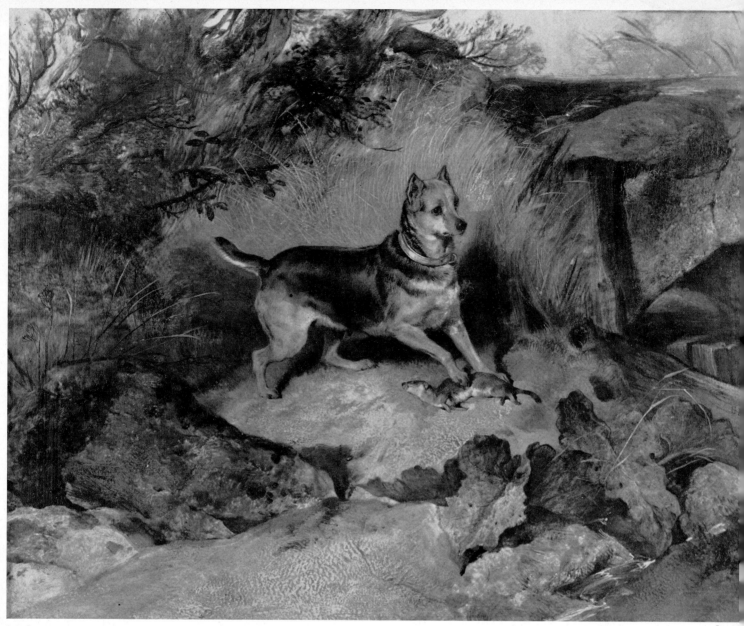

28

28 SIR EDWIN HENRY LANDSEER (1802–73): *Zippin, a dog*. 1826. Panel, 14 × 18 in.
Collection of the Duke of Sutherland

29 JOHN CONSTABLE
(1776–1837): *Willy Lott's house*.
About 1810–15. Paper,
9½ × 7½ in. London, Victoria and
Albert Museum

Landseer prided himself on his ability to work swiftly and spontaneously; it was only in
deference to the taste of the time that he provided a glossy finish. This dog study shows his more
spontaneous quality of handling and is comparatively free from the suggestion of human
characteristics that became an intrusive element in his work.

The enchanting sketch (opposite) by Constable shows the harmony that results in the work
of a great artist from a swift and summary treatment of his subject. The colour arrives at its
own plan, everything falls instantaneously into place. Willy Lott's house was the small
farmhouse close to Flatford Mill that appeared in a number of Constable's landscapes. It was
called after its owner, who was said to have lived there for eighty years without being more
than four days away.

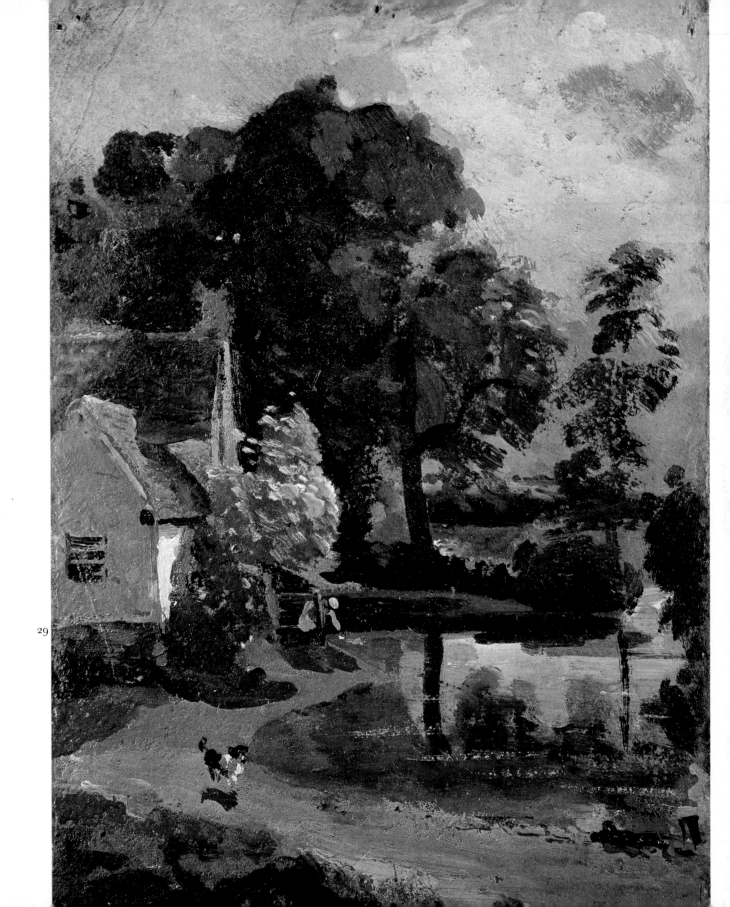

29

30 JOHN CONSTABLE
(1776–1837):
*Study of two
ploughs.* 1814.
Paper, $6\frac{3}{4} \times 10\frac{1}{4}$ in.
London, Victoria
and Albert Museum

Constable is often
surprising in the
attention he paid to
detail and the
patient labour he
devoted to sketches
and studies.
The two oil studies
reproduced here
were made by
Constable during a
visit (30 July to
4 November 1814)
to his parents' house
in East Bergholt.

31 JOHN CONSTABLE
(1776–1837):
*Study of a cart and
horses, with a carter
and dog.* 1814.
Paper, $6\frac{1}{2} \times 9\frac{3}{8}$ in.
London, Victoria
and Albert Museum

This sketch was
used for the cart,
horses and dog in
his painting *Stour
Valley and Dedham
Village* (Boston,
Museum of Fine
Arts).

32 WILLIAM ETTY (1787–1849): *Standard bearer.* About 1843. Panel, $16\frac{3}{4} \times 13\frac{1}{4}$ in. Anglesey Abbey
(The National Trust, Fairhaven Collection)

Although many of Etty's preliminary oil studies, like this one, were intended as no more than the
basis for more elaborate compositions, they have a force and vitality that make them—at least to
modern eyes—often more attractive than the ambitious pictures for which they were made.

33 JOHN CONSTABLE (1776–1837): *Flatford Mill, on the River Stour*. 1817. Canvas, 40 × 50 in. London, Tate Gallery

This was the first of the series of large compositions exhibited by Constable at the Royal Academy and a beautifully composed work including typical elements of cumulus cloud, riches of foliage and riverside incident. The landscape of the region was to be a theme on which he worked many variations. His biographer, C. R. Leslie, said of Constable's works painted in the years 1817–21: 'Constable's art was never more perfect, perhaps never so perfect as at this period of his life.'

34 WILLIAM COLLINS (1788–1847): *Borrowdale, Cumberland, with children playing by the banks of a brook.* 1823. Canvas, 34 × 44 in. London, Royal Holloway College

William Collins, like Constable, concentrated on what may be called 'domestic nature', in contrast to Turner. Borrowdale, a discovery of the Romantic artists, inspired Collins to paint a quiet, gentle domestic scene, including the children who were the usual accessories of his landscapes.

36 HENRY PETHER (active 1828–65): *Lake with ruined church by moonlight*. Canvas, $26\frac{1}{2} \times 33\frac{1}{2}$ in. Anglesey Abbey (The National Trust, Fairhaven Collection)

The word 'Gothic' has various connotations in the history of English art from the eighteenth century onwards; the suggestion of the weird and mysterious; the picturesqueness of pre-Reformation ruin; and the learned architectural revival of the Victorian age. Bonington, in his picture of Saint Bertin Abbey—a picture unusual for him—shows an appreciation of original beauties of linear design that survived dilapidation. In contrast, Pether's *Lake with ruined church* creates the atmosphere of the 'Gothic' novel, a delight in the eeriness of the nocturnal scene.

35 (*opposite*) RICHARD PARKES BONINGTON (1802–28): Detail from *Saint Bertin, near Saint Omer—transept of the abbey*. About 1823. Canvas, $24 \times 19\frac{1}{2}$ in. Nottingham, Castle Museum and Art Gallery

37 SAMUEL PALMER (1805–81): *The Rest on the Flight*. About 1824–5. Panel, $12\frac{1}{4} \times 15\frac{1}{2}$ in. Oxford, Ashmolean Museum

Two masterpieces of Samuel Palmer's early period, these paintings, executed in oil and tempera, have—to use a phrase of Palmer's own—'a mystical and spiritual more than a material light'. *The Rest on the Flight* contains one of Palmer's few borrowings from William Blake in the donkey that appears in Blake's *Flight into Egypt*. The work may have been completed before they met but Palmer already knew Blake's work through John Linnell. There is at the same time an individual quality quite distinct and peculiar to Palmer. All his feeling for Gothic can be appreciated in the *Coming from evening church*. The church spire, lit by a full moon, becomes a symbol of magic and wonder.

38
SAMUEL PALMER
(1805–81):
*Coming from evening
church*. 1830?
Tempera on canvas,
$11\frac{7}{8} \times 7\frac{7}{8}$ in. London,
Tate Gallery

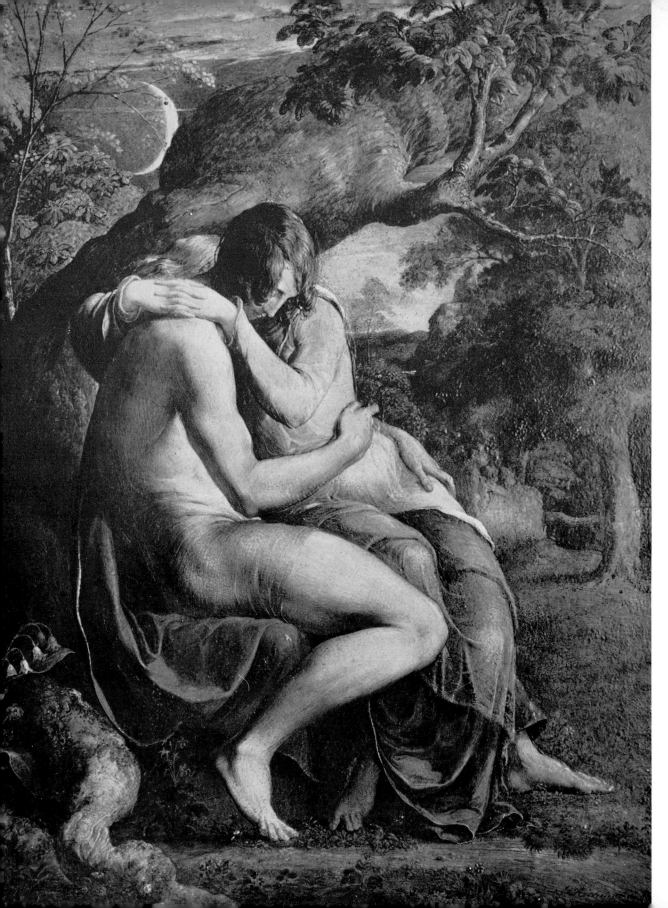

39
GEORGE
RICHMOND
(1809–96):
'*The eve of
separation*'.
1830. Panel,
$19\frac{3}{8} \times 14\frac{1}{4}$ in.
Oxford,
Ashmolean
Museum

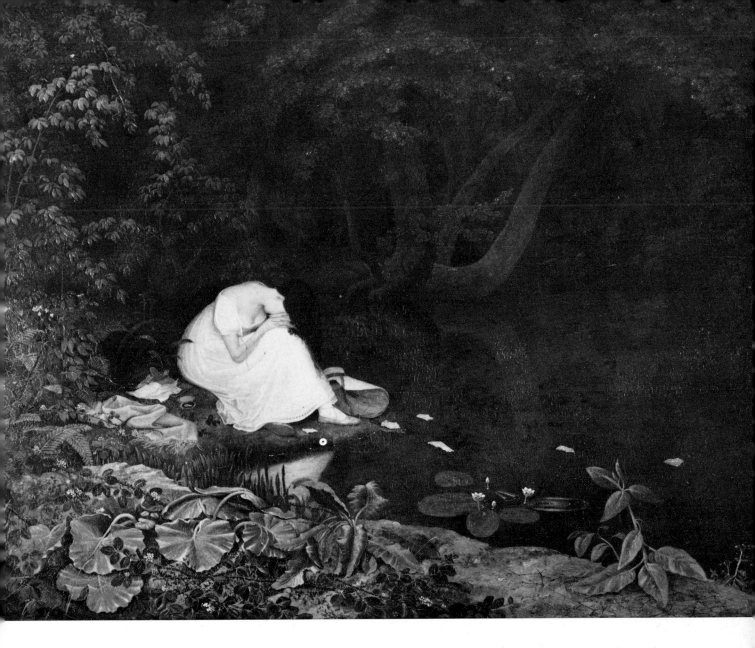

40 FRANCIS DANBY (1793–1861): *Disappointed love*. Exhibited 1821. Canvas, $24\frac{3}{4} \times 31\frac{7}{8}$ in. London, Victoria and Albert Museum

The inspiration that Blake gave to the group of young enthusiasts known as 'the Ancients' was transmitted to George Richmond in the same way as to Samuel Palmer, partly by actual encounter and acquaintance with his remarkable character and partly by the woodcuts that Blake made for Thornton to decorate his course of Virgil readings. They idyllically anticipated the pastoral delights of the Kentish village of Shoreham, where Richmond recalled 'they often spent the night-time under the open sky drinking in the exquisite beauty of the scented silence'. Although the figures in '*The eve of separation*' are academically conceived there is the Blakean moon that 'bathed the still world in mystery', and the background suggests the 'valley of vision'.

In *Disappointed love*, the painting by which Danby first became celebrated, the melancholy of Romanticism, rather than its ecstasies, finds expression.

41

RICHARD
PARKES
BONINGTON
(1802–28): *Amy
Robsart and the
Earl of Leicester*.
1827. Canvas,
$13\frac{3}{4} \times 10\frac{5}{8}$ in.
Oxford,
Ashmolean
Museum

The parting of the
ways that
so frequently
confronted the
nineteenth-century
artist with a
difficult choice is
manifest in the
work of Bonington.
In landscape and
seascape he was as
much concerned
with sky and space
as Constable but
this did not
prevent his being
affected by the
Romantic
nostalgia for the
past that called for
'costume pieces'
and the portrayal
of historical
personages in
imagined
conversation.

42

WILLIAM ETTY
(1787–1849): *Mars,
Venus and attendant.*
Exhibited 1840. Canvas,
36½ × 25 in. Anglesey
Abbey (The National
Trust, Fairhaven
Collection)

One of Etty's favourite
subjects was that of Mars
and Venus, a variant on
the theme being his
painting exhibited in the
Academy in 1840 under
the title *Mars, Venus and
attendant disrobing her
mistress for the bath.* The
formula was repeated
with practised ability
though Etty at the age of
fifty-three had lost some of
the urge to produce
finished compositions
especially intended for
exhibition.

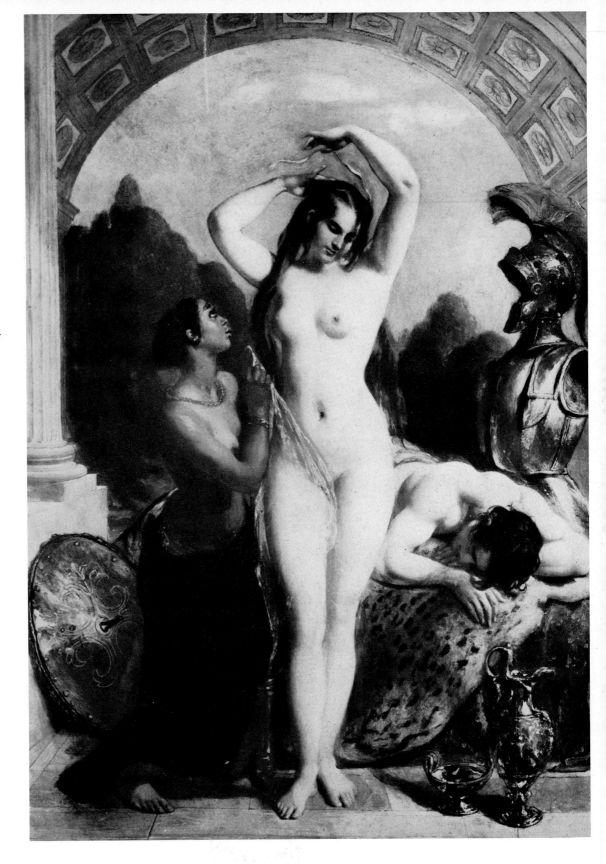

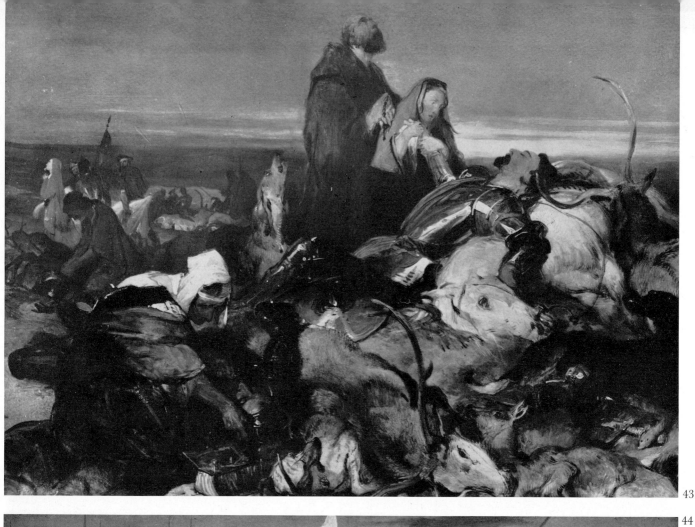

43

44

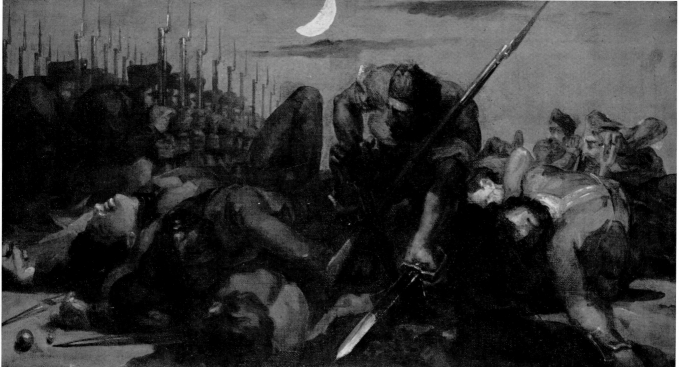

43
SIR EDWIN
HENRY
LANDSEER
(1802–73):
*The battle of
Chevy Chase*.
About 1825.
Panel,
19 × 25 in.
Sheffield,
Graves Art
Gallery

44
DAVID SCOTT
(1806–49):
*Russians
burying their
dead*. 1832.
Canvas,
19¼ × 35⅞ in.
Glasgow,
The
Hunterian
Museum,
University of
Glasgow

45
WILLIAM ETTY (1787–1849): *Benaiah slaying two lionlike men of Moab*. Exhibited 1829.
Canvas, 120 × 157 in. Edinburgh, National Gallery of Scotland

The three works here reproduced are representative in their several ways of what may be
called the 'grand manner' of the Romantic 1820s and 1830s. *Chevy Chase*, painted when
Landseer was about twenty-three, is dramatically rich in composition and colour; it is close
enough to Delacroix's *Massacre of Chios* (1822) as to suggest that Delacroix's work was known
to the English painter.

The intensity of David Scott's imagination had powerful expression in *Russians burying
their dead*, exhibited at the Scottish Academy in 1832, though like the other works he exhibited
at that time, it was returned unsold. In characteristically Romantic despair he observed:
'Everything I have yet attempted has been unsuccessful; so many disappointments make effort
seem vain.'

Etty's avowed purpose in history painting was 'to paint some great moral on the heart', and
his *Benaiah* fitted into this scheme of elevated sentiment as emblematic of valour. The picture
was a variation on the theme of *Combat*, painted some four years earlier. Valour was expressed
in terms of vigorous action, in which the artist's anatomical skill was prominently displayed.

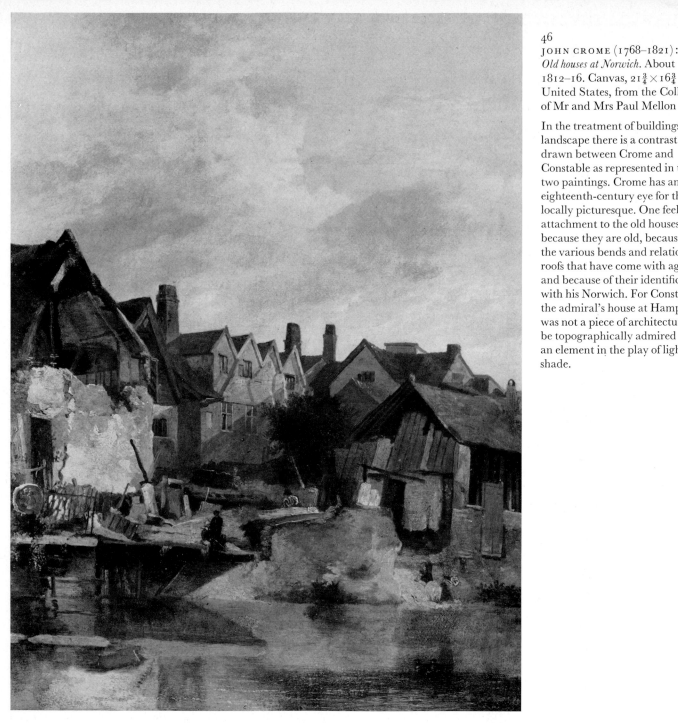

46
JOHN CROME (1768–1821):
Old houses at Norwich. About
1812–16. Canvas, 21¾ × 16¾ in.
United States, from the Collection
of Mr and Mrs Paul Mellon

In the treatment of buildings in
landscape there is a contrast to be
drawn between Crome and
Constable as represented in these
two paintings. Crome has an
eighteenth-century eye for the
locally picturesque. One feels his
attachment to the old houses
because they are old, because of
the various bends and relations of
roofs that have come with age,
and because of their identification
with his Norwich. For Constable,
the admiral's house at Hampstead
was not a piece of architecture to
be topographically admired but
an element in the play of light and
shade.

47 JOHN CONSTABLE (1776–1837): *The Grove, Hampstead* (*the
admiral's house*). About 1832. Canvas, 14 × 11¾ in. London,
Tate Gallery

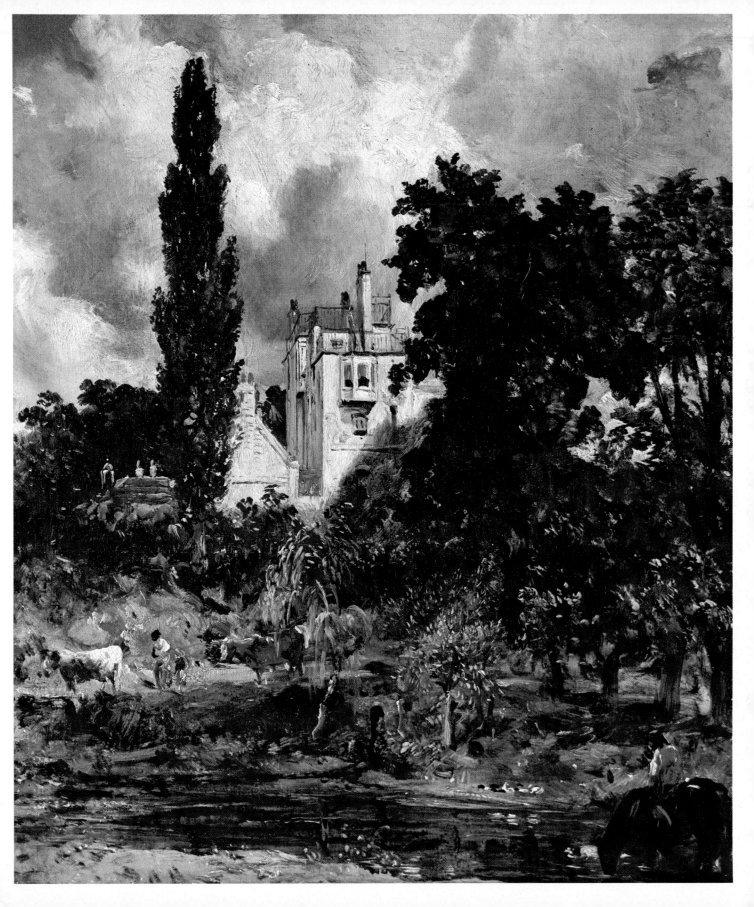

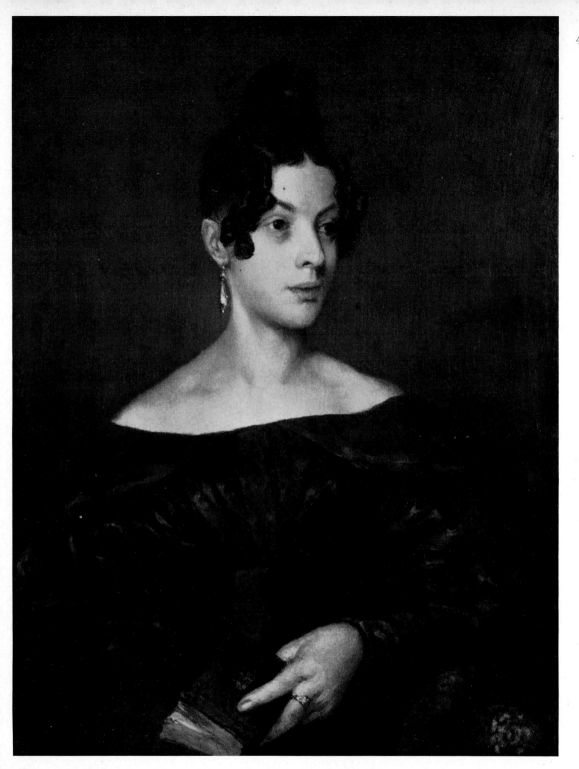

WILLIAM ETTY
(1787–1849): *Mrs
Vaughan*. About
1835–40. Canvas,
30 × 25 in. Cardiff,
National Museum of
Wales

Etty's portrait of Mrs
Vaughan (mother of
Cardinal Herbert
Vaughan) brings to
mind the work of
Lawrence, with whom
Etty studied for a short
time. What mainly
distinguishes it,
however, is a
psychological aspect of
Romantic portraiture,
the glamorous element
being secondary to the
wistful and introspective
mood suggested.

48 ALFRED STEVENS (1817–75): *Emma Pegler*. About 1833. Canvas, 11¾ × 9¼ in. Liverpool, Walker Art Gallery

The name of Alfred Stevens is usually associated with sculpture of grand aims of a neo-Renaissance kind, to such an extent that his brilliant portraits are sometimes overlooked. *Emma Pegler* has the charm and quiet intimacy that are also found in the portraits of Corot.

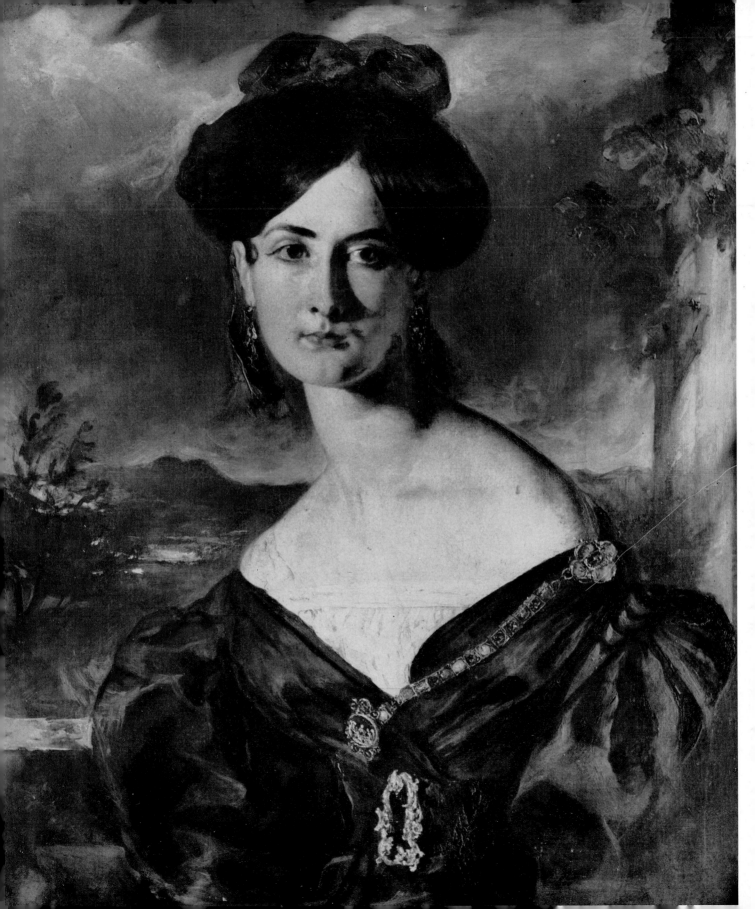

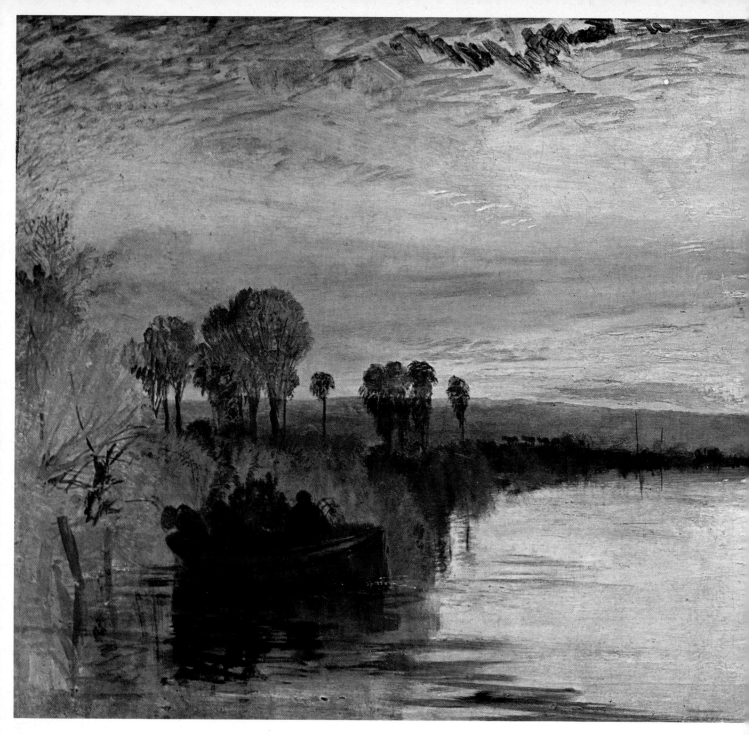

50 JOSEPH MALLORD WILLIAM TURNER (1775–1851): *Chichester Canal.*
About 1830–1. Canvas, 25 × 52¾ in. London, Tate Gallery

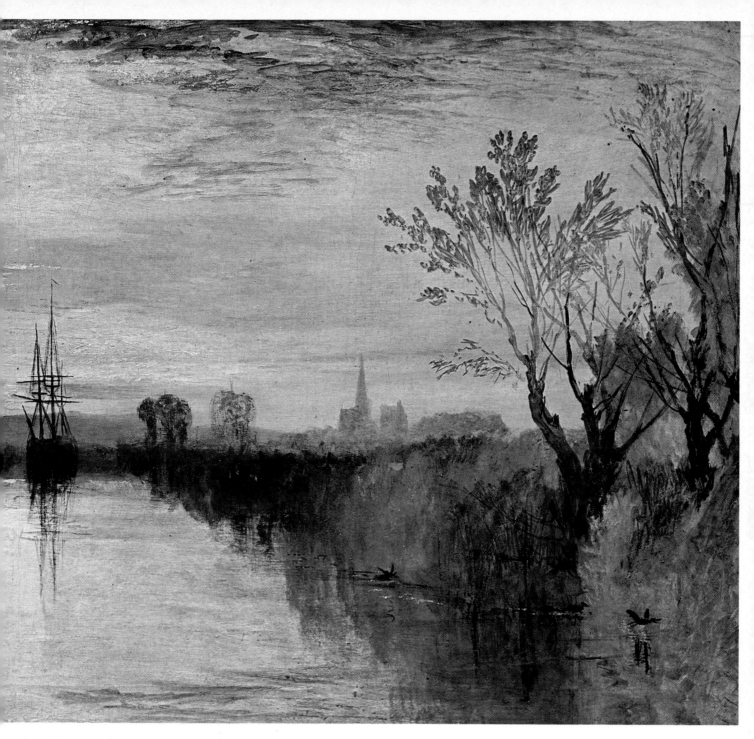

One of the works intended for fitting in panels in the dining room of Petworth House, *Chichester Canal* was a partner in purpose and size to Turner's view of the setting sun at Petworth Park and his combination of sails and metallic outline in his *Chain Pier, Brighton*. The picture was painted not long after the death of Turner's father, when the loneliness of the London studio-house in Queen Anne Street became oppressive. It was a welcome change to stay at Petworth in Sussex, where Turner was always a favoured guest of George Wyndham, third Earl of Egremont.

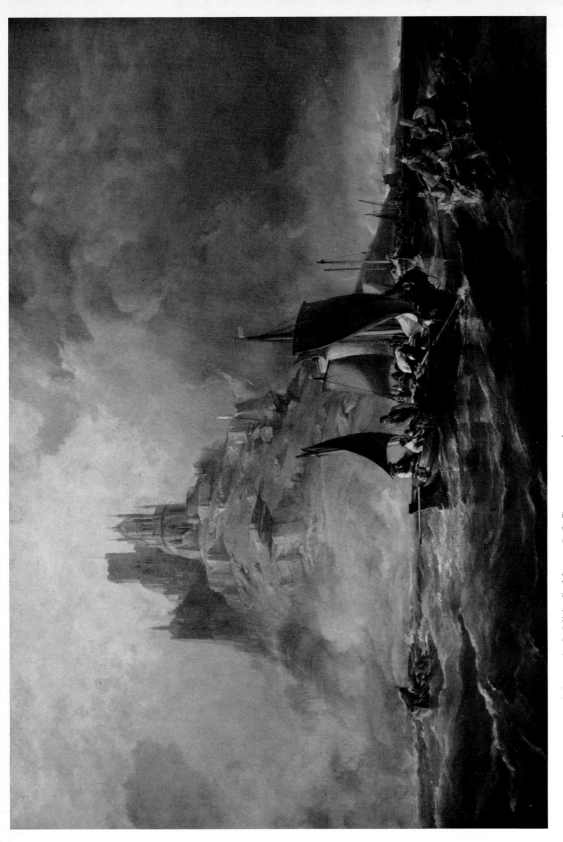

51 GEORGE CHAMBERS (1803–40): *St Michael's Mount.* 1836. Canvas, 49 × 71 in. Bury, Public Library and Art Gallery

George Chambers, a painter whose knowledge of the sea was gained from early experience on shipboard and whose sense of the dramatic was encouraged by later employment as scene painter, makes an effective *coup de théâtre* in his painting of St Michael's Mount that has a faintly perceptible echo of Turner's Romantic imagination.

52 JOSEPH MALLORD WILLIAM TURNER (1775–1851) : *Ulysses deriding Polyphemus.*
Exhibited 1829. Canvas, 52¼×80 in. London, National Gallery

This masterpiece, probably painted on Turner's return from Rome in 1828, is a landmark in
his work in the translation of everything into terms of pure colour, ranging from those hot
reds and golden yellows of which he was so fond, to cool and delicately opalescent tints in the
morning sky— perhaps the most splendid of all Turner's skies. To indicate further that it was
morning he faintly outlined the horses of Apollo. The stricken cyclopean giant is half hidden in the
morning mists, in no way detracting from the mountainous grandeur of the setting. Ruskin
found more to say in praise of the landscape than of the human and naval aspect of the painting:
'a composition of the Lord Mayor's procession with a piece of ballet scenery'. But the galleys
and their colour beautifully offset the sky and promontory behind.

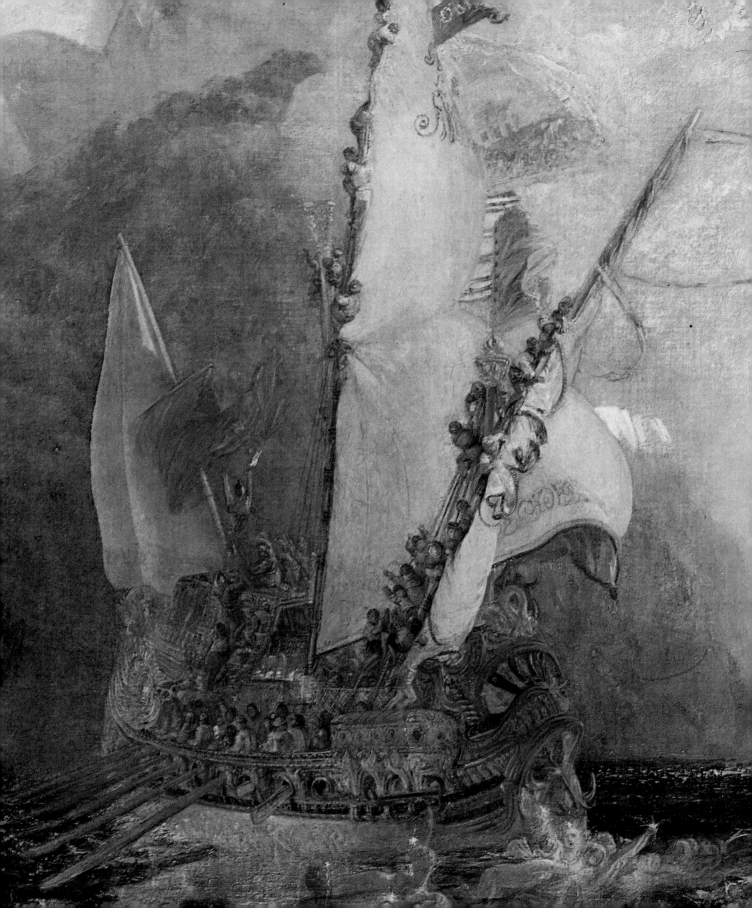

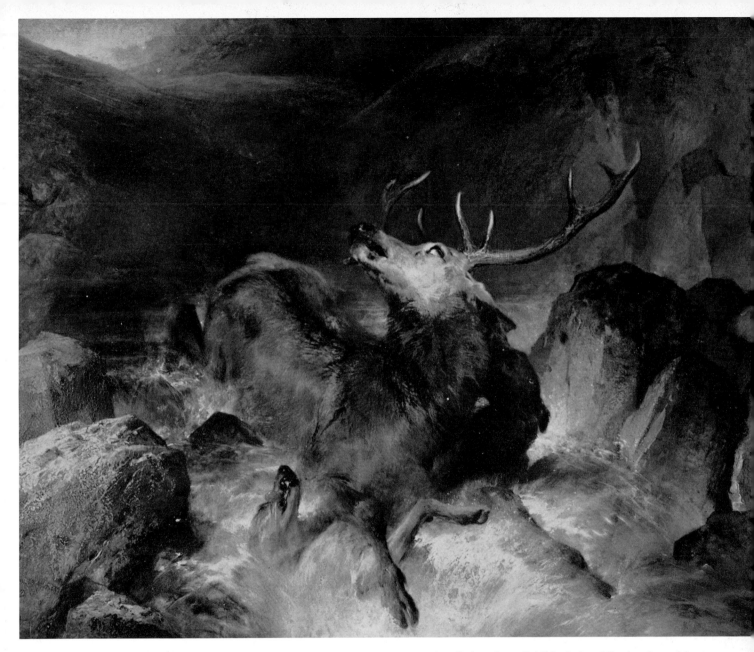

54 SIR EDWIN HENRY LANDSEER (1802–73): *The hunted stag*. Exhibited 1833. Wood, $27\frac{3}{4} \times 35\frac{3}{4}$ in. London, Tate Gallery

In an era of the narrative picture both tragedy and comedy had their place in art, sometimes presenting the artist with a difficult choice of direction. Landseer's humorous animal subjects have been often enough reprehended yet he never altogether lost sight of the tragic side of nature or that Romantic awareness of violence and cruelty that was also vividly illustrated in France by such contemporaries as Delacroix and Barye. *The hunted stag* is far from being simply a 'sporting picture' and is none the less moving for being a dispassionate portrayal of the scene.

53 (*opposite*) JOSEPH MALLORD WILLIAM TURNER (1775–1851): Detail from *Ulysses deriding Polyphemus* (Plate 52)

55 (*opposite*) JAMES HOLLAND
(1800–70): Detail from *Piazza dei
Signori, Verona*. 1844. Canvas,
40 × 30 in. London, Royal
Holloway College

56 WILLIAM JAMES MÜLLER (1812–45): *The carpet bazaar, Cairo* (*detail*). 1843.
Panel, 24½ × 29½ in. Bristol, City Art Gallery

As travellers, British artists of the nineteenth century supplied records of places and peoples in
a way for which there is hardly an equivalent in the art of other countries. The habit first
formed by the 'discovery' of Britain extended in the course of time abroad. Artists went far
afield as tourism grew more adventurous, creating the demand for pictorial souvenirs; also in
the wake of the archaeologists as the field of research that had opened in the eighteenth century
became wider. James Holland was a regular Continental tourist, whose views of towns ranged
from Holland to Portugal. He painted many Italian subjects and his view of Verona well
illustrates his vigour of style. William James Müller added to European journeys travel in
Egypt, one result of this being his vivid impression of a Cairene bazaar. His expedition to
Asia Minor (1843–4) was also fruitful.

57 DAVID COX (1783–1859): *A windy day*. 1850. Canvas, $10\frac{1}{2} \times 14\frac{1}{8}$ in. London, Tate Gallery

An admirer described David Cox as 'painter of the wind' and so he appears in this picture, where the brisk movement of air is made perceptible by the lone countrywoman bent against its force and by the broken touches of paint that set up a suggestion of movement of their own. There is something to recall Boudin in his suggestion of breezy weather and, in respect of technique, a slight intimation of Impressionism to come. What Ruskin termed his 'impatient breadth' was a development of his later years.

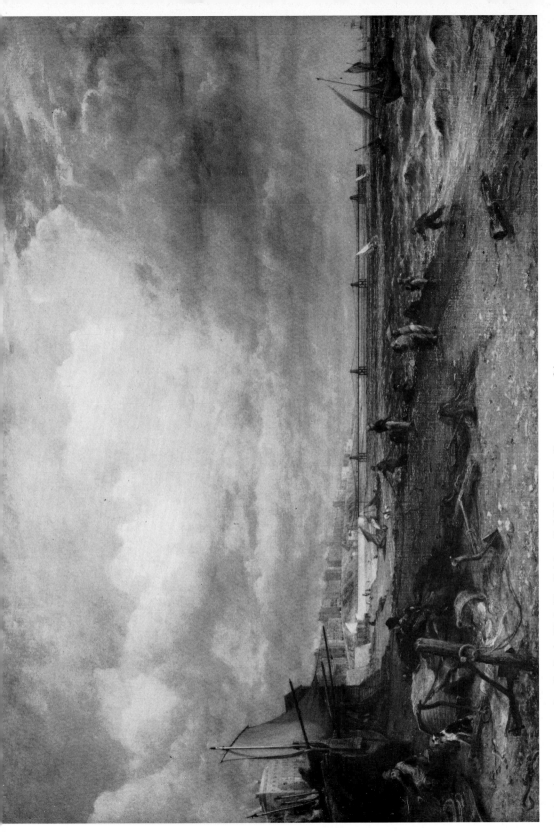

58 JOHN CONSTABLE (1776–1837): *Chain Pier, Brighton.* Exhibited 1827. Canvas 50 × 72¾ in. London, Tate Gallery

With a much greater elaboration than Cox and with, for him, an unusual complication of incidental detail, Constable contrived in this picture to convey a seaside freshness of air. Again, perhaps, a thought of Boudin may come to the spectator's mind. The boats, anchors, nets, baulks of timber, seashore figures and the delicate metallic tracery of the pier give the greater emphasis to the grand space of sky, the 'natural history' which Constable so well understood.

59 SIR EDWIN HENRY LANDSEER (1802–73): *Loch Avon and the Cairngorm Mountains*. About 1833. Wood, $13\frac{7}{8} \times 17\frac{1}{2}$ in. London, Tate Gallery

The Highland landscapes of Landseer were a part of his work that was long disregarded, so completely had he become associated with the humorous paintings of dogs. Their merits were brought to light again in the exhibition at the Royal Academy in 1961. For those who had not sought it out in the storerooms of the Tate Gallery, the *Loch Avon* was in itself a revelation. Simple and direct in execution, without irrelevance of detail, the painting conveys an immediate sense of natural truth and of the artist's enthusiasm for the scene. His visits to the Highlands began in 1824, when he stayed with Sir Walter Scott at Abbotsford and also visited Glenfeshie in Inverness-shire, then rented by his friend, the Duchess of Bedford. Some of his best landscapes, among them *Loch Avon*, were of subjects from the Cairngorms.

60 JOHN CONSTABLE (1776–1837): *Salisbury Cathedral from the meadows*. 1831. Canvas, 59¾ × 74¾ in. Collection of Lord Ashton of Hyde

Certainly one of Constable's greatest paintings, the superb *Salisbury* was also one that he himself valued most highly. As his biographer, C. R. Leslie, puts it: 'This was a picture which he felt would probably in future be considered his greatest; for if among his smaller works there were many of more perfection of finish, this he considered as conveying the fullest impression of the compass of his art.' Sky and rainbow, trees, water and meadows all convey a tremulous beauty of moist atmosphere. The grand design of nature in the rainbow enhances the effect of the cathedral spire as an exquisite work of art. The engraver Lucas, urged on by Constable, surpassed himself in the mezzotint engraving from the picture, but the original found no buyer. When Constable's friend, William Purton of Hampstead, proposed after the artist's death that one of his works should be purchased by subscription and presented to the nation, his suggested choice was the *Salisbury*. Constable's bold originality of treatment at no time found ready acceptance and in this instance the majority demurred, selecting *The cornfield* instead.

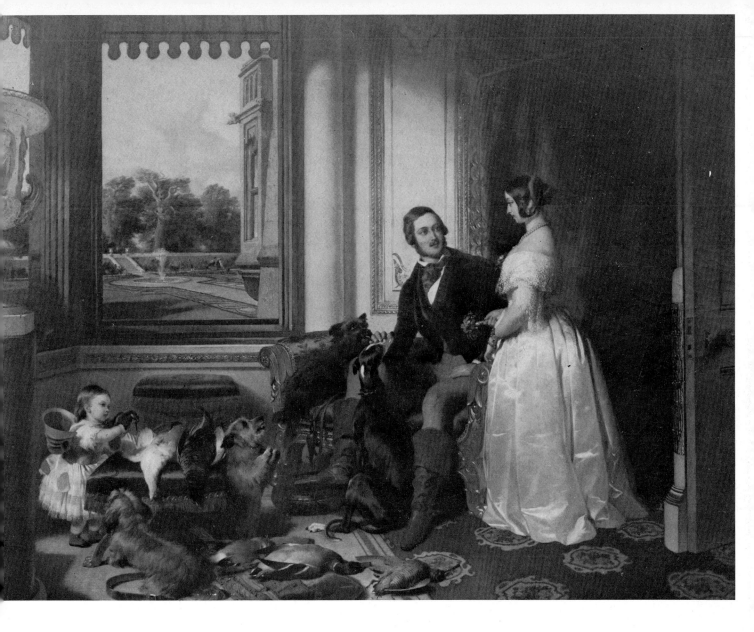

61 DANIEL MACLISE
(1806–70):
Charles Dickens. 1839.
Canvas, 36 × 28⅛ in.
London, National
Portrait Gallery
(on loan from The
Tate Gallery)

62 SIR EDWIN HENRY LANDSEER (1802–73): *Queen Victoria, the Prince Consort and the Princess Royal at Windsor*. 1840–3. Canvas, 44½ × 56½ in. Royal Collection. Reproduced by gracious permission of Her Majesty The Queen

Maclise painted the portrait of Dickens—who was to become a close friend—in 1839, when the novelist was twenty-seven. The painting was exhibited at the Academy in 1840 and engraved as a frontispiece for an edition of *Nicholas Nickleby*. Thackeray thought it an amazing likeness: 'We have here', he said, 'the real identical man, Dickens, the inward as well as the outward of him.' It is the masterpiece of Maclise's portraits, conveying the imagination and magnetism of the young Dickens.

Elaborately finished, no doubt in deference to the Prince Consort's taste, is Landseer's intensely Victorian conversation piece of the Queen, Prince Consort and Princess Royal in the Green Drawing Room at Windsor. The Queen's mother, the Duchess of Kent, can be seen in her bath chair through the window. The royal pets add informality to the scene. The effect was, the Queen noted in her diary, 'altogether very cheerful and pleasing'.

Mary Augusta Lady Holland by Watts

63
GEORGE
FREDERIC WATTS
(1817–1904): *Lady
Holland*. About
1843. Canvas,
31¾ × 25 in. Royal
Collection.
Reproduced by
gracious permission
of Her Majesty The
Queen

Victorian portrait
painting followed no
one consistent
course. Watts had
surprises to give, as
in his portrait of
Lady Holland,
painted at the Casa
Feroni in Florence,
where Lord Holland
was British
Minister. Lady
Holland's Riviera
hat contributes to
the originality of
design without
distracting attention
from the sharply
intelligent glance
levelled directly at
the spectator. Lady
Holland (Mary
Augusta), daughter
of the eighth Earl of
Coventry, was born
in 1812 and married
the fourth Baron
Holland in 1833.

64

SIR EDWIN HENRY
LANDSEER (1802–73)
John Gibson. 1844 or
1850. Canvas,
35 × 27 in. London,
Royal Academy of
Arts

Landseer's portrait of
the sculptor, John
Gibson, was
presumably painted in
1844 or 1850, when
Gibson—who had
lived in Rome since
1817—paid his only
two visits to London.
He is described as
having 'a peculiarly
grave, immovable
expression of
countenance'. The
likeness is probably
accurate but the air of
dignity that the image
suggests must also be
related to the actual
style of the painting,
with its loose,
generalized modelling
and avoidance of
niggling detail.

65 FRANCIS DANBY (1793–1861): *The Deluge*. About 1840. Canvas, 112 × 178 in. London, Tate Gallery

Though Turner painted many pictures of catastrophe, he did not imply that these were acts of vengeance and retribution visited on the human race by an angry supernatural power and in that respect was different from John Martin and Francis Danby. The difference can be appreciated by a comparison of Danby's conception of the Biblical Deluge and Turner's snowstorm at sea (*opposite*). There was the difference also of capacity. As the critic M. W. Bürger remarked when writing on the English school in 1863, apropos of Danby: it took genius to attain the heights at which he aimed.

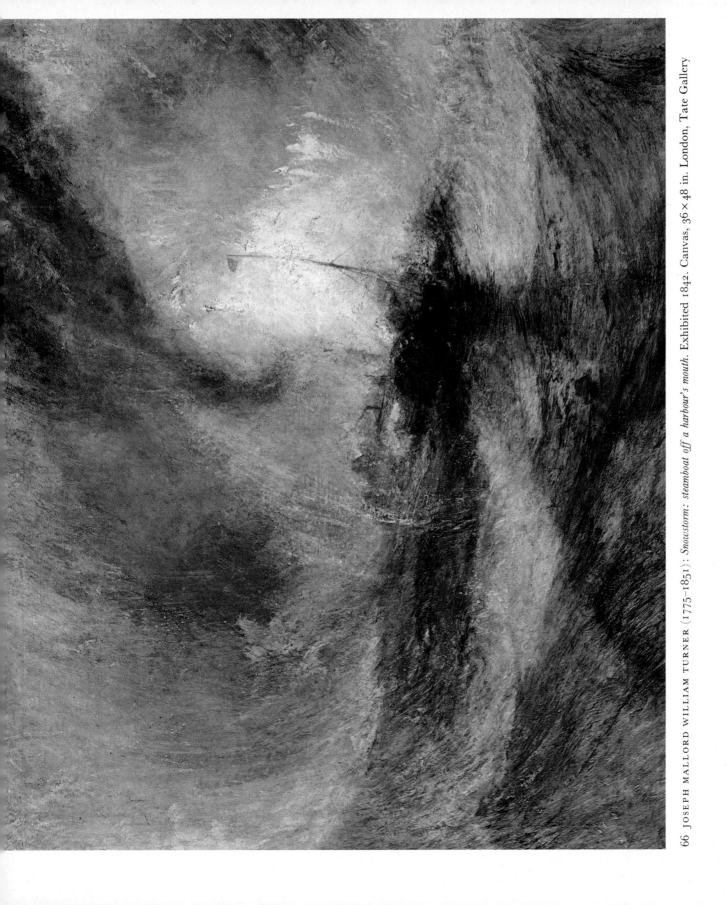

66 JOSEPH MALLORD WILLIAM TURNER (1775–1851): *Snowstorm: steamboat off a harbour's mouth.* Exhibited 1842. Canvas, 36 × 48 in. London, Tate Gallery

67 WILLIAM MULREADY (1786–1863): *The seven ages*. Exhibited 1838. Canvas, 35½×45 in.
London, Victoria and Albert Museum

Mulready's most ambitious painting, *The seven ages*, was originally drawn on wood to serve as
frontispiece to J. van Voorst's edition of *Illustrations of Shakespeare's Seven Ages*. It depicts 'All
the world's a stage' from *As You Like It*, Act II, Scene 7. Painted for Mr Sheepshanks in 1837, it
was exhibited in the Academy the following year. It differed from Mulready's other works in
being more complex in theme and without his usual richness of colour. A controversial question
was whether the seven ages could be successfully brought together on one canvas. Ruskin flatly
denied that the subject could be painted, because in the picture the various stages of life had all
to appear at the same time. Even the sensible Mulready in some degree shared the restless wish
to excel in an 'elevated' theme, not entirely suited to his capacity.

68 SIR EDWIN HENRY LANDSEER (1802–73): '*There's no place like home*'. 1842. Canvas, $29\frac{1}{2} \times 25\frac{1}{4}$ in. London, Victoria and Albert Museum

Landseer's dogs, however strongly it may be felt that the humorous roles he gave them were an aberration, were nearly always well painted and '*There's no place like home*' was no exception. The picture may come near to the brink of humour but this is mainly by reason of its title. It is otherwise a straightforward study painted with certainty of skill.

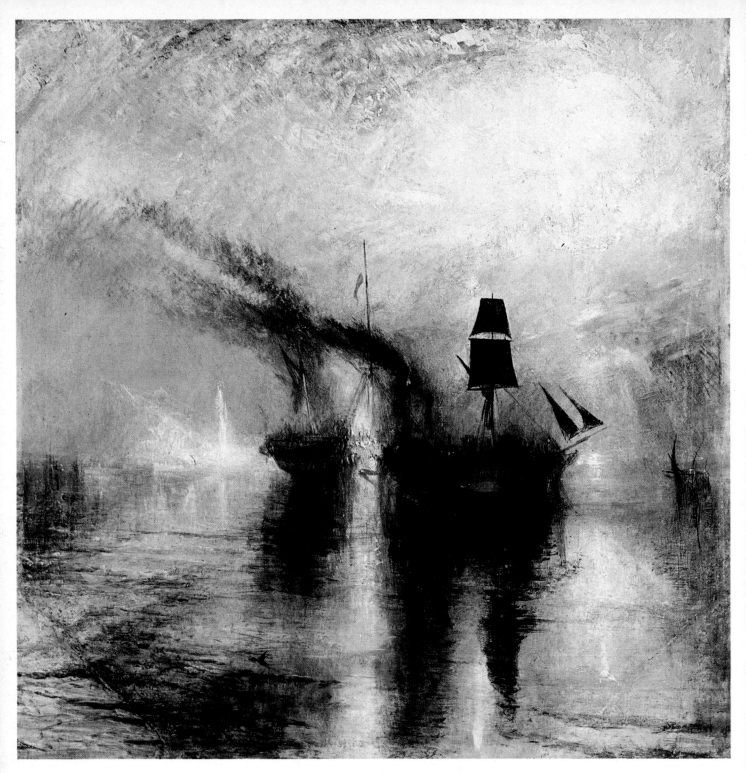

69 JOSEPH MALLORD WILLIAM TURNER (1775–1851): *Peace: burial at sea*. Exhibited 1842. Canvas, 34¼ × 34⅛ in. London, Tate Gallery

Turner represented the funeral of Wilkie at sea (quarantine regulations having forbidden the landing of the body at Gibraltar) as the scene must have appeared off the coast. The result was this sombrely magnificent canvas which, however, shared the hostile criticism of the *Snowstorm* (Plate 66) in the Academy of 1842. According to George Jones, Clarkson Stanfield complained to Turner that the blackness of the sails was unnatural in effect. Turner's answer was 'I only wish I had any colour to make them blacker.'

70 THOMAS CRESWICK (1811–69): *A summer's afternoon.* 1844. Canvas, 40 × 50 in.
London, Victoria and Albert Museum

In contrast with the expressionist force of Turner was the landscape art of Thomas Creswick.
'In all his works', remarked William Sandby in his account of the Royal Academy, 'there is a
thoroughly English character in the scenery and a natural truthfulness derived from his
practice of painting the scenes he depicts in the open air as he sees them before him.'

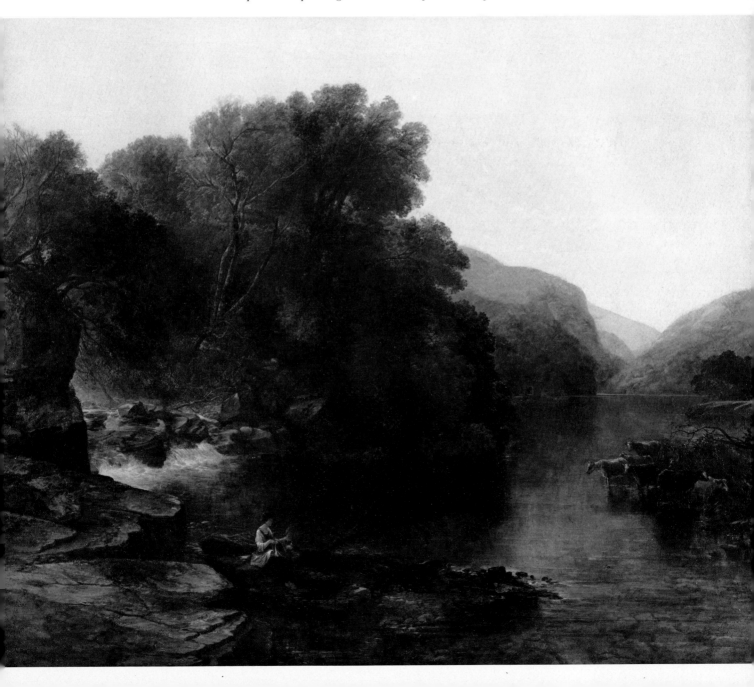

71 WILLIAM ETTY (1787–1849): *The destruction of the temple of vice*. Exhibited 1832.
Canvas, 36 × 46 in. Manchester, City Art Gallery

Reminiscent of Delacroix as a composition on a grand scale with a fiery Romantic element, this work by Etty does not carry with it such force as the French master's *Death of Sardanapalus*, the groups of figures tending to look diffused and chaotic, though a sensation of energy remains. In the Academy exhibition of 1832 Etty gave the painting the title *The destroying angel and daemons of evil interrupting the orgies of the vicious and intemperate*. To contemporaries the conception was not altogether clear; it was speculative why the 'daemons of evil' apparently joined with the destroying angel in interrupting an orgy they could have been supposed to encourage. It was not made clearer by the artist's explanation that the work belonged to 'that class of compositions called by the Romans "Visions", not having their origin in history and poetry'. A contemporary critic of *The Times* failed to understand what this class might be and, heavily humorous, thought the demons looked 'angry at the ladies for having stayed out so long' and had 'come to fetch them home accordingly'.

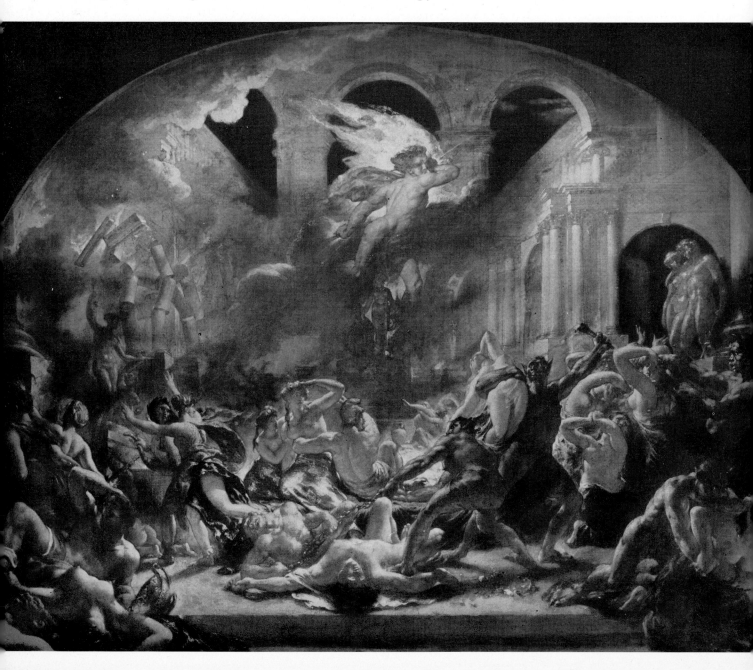

72
JOHN PHILLIP
(1817–67):
Gypsy sisters of Seville.
1854. Canvas,
28 × 22⅛ in. Liverpool,
Walker Art Gallery

John Phillip presents some parallel
with Wilkie in the great impression
that was made on him by Spain. He first
visited Spain for the sake of his health when
he was thirty-four, not only benefiting physi-
cally but gaining a new sense of colour and appreci-
ation of forceful light and shade. Though some deplored
Wilkie's alteration of style after visiting Spain, it was generally
considered that Phillip, after his stay in Seville in 1851–2, had taken a long stride forward.

73 JOHN PHILLIP (1817–67): *Drawing for the militia*. 1849. Canvas, 48 × 73 in.
Bury, Public Library and Art Gallery

This picture belongs to the first period of Phillip's work, before he had visited Seville and
become celebrated as 'Phillip of Spain'. After studying at the Academy with the aid of Lord
Panmure from 1837 to 1839, he had gone back to his native Aberdeen for a while and
painted portraits. But in 1841 he settled in London and devoted himself in the ensuing decade
to scenes of everyday life in Scotland. *Drawing for the militia* was one of the paintings by which
he was beginning to be known before the illness that was followed by convalescence in Spain
and a change of style.

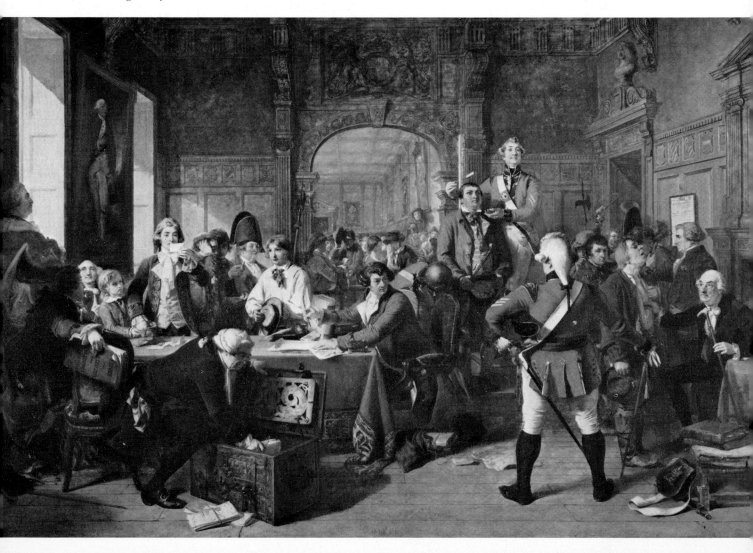

74 WILLIAM HOLMAN HUNT (1827–1910): *Rienzi*. 1849. Canvas, 34 × 48 in. Private Collection

The full title of this early Pre-Raphaelite painting by Holman Hunt, exhibited at the Royal
Academy in 1849, was *Rienzi vowing to obtain justice for the death of his young brother, slain in a
skirmish between the Colonna and the Orsini factions*. (The catalogue also contained a quotation
from *Rienzi, the Last of the Tribunes*, the novel by Bulwer Lytton.) Some influence of the cartoons
exhibited in Westminster Hall in the Parliamentary competition may be discerned, but many
particulars indicate the young artist's determination to go direct to nature. The fig tree was
painted straight on to the canvas ('its leaves and branches in full sunlight') from the tree in
the garden in Lambeth of Mr Stephens, father of Hunt's fellow Pre-Raphaelite, F. G. Stephens.
The background and faces were painted at Hampstead. 'They were done', Hunt wrote, 'thus
directly and frankly, not merely for the charm of minute finish, but as a means of studying more
deeply Nature's principles of design, and to escape the conventional treatment of landscape
background.' Rossetti was the model for Rienzi, and Millais for the knight on the left, Adrian.

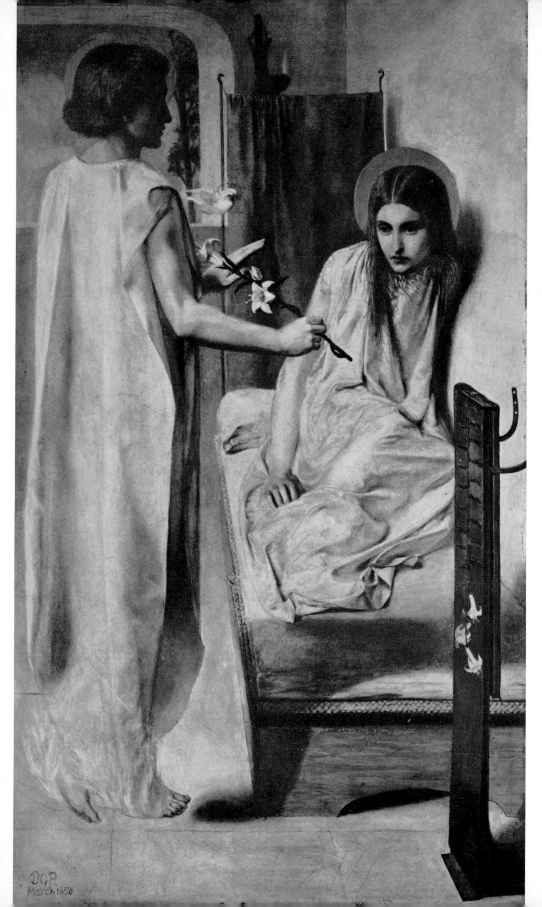

75

DANTE GABRIEL ROSSETTI
(1828–82): *Ecce Ancilla Domini*
(*The Annunciation*). 1849–50.
Canvas, 28½ × 16½ in. London,
Tate Gallery

The second of Rossetti's two
early religious subjects, designed
to indicate a return to the purity
of Pre-Renaissance art by its
austere simplicity, *Ecce Ancilla
Domini* was also Anglo-Catholic in
symbolism. The Archangel
Gabriel offers a lily to the Virgin;
the Holy Ghost descends in the
form of a dove. The picture was
exhibited at the Portland Gallery
in London but the severe criticism
it received caused Rossetti to
renounce public exhibition.

76

SIR JOHN EVERETT
MILLAIS (1829–96): *The
return of the dove to the ark.*
1851. Canvas, $34\frac{1}{2} \times 21\frac{1}{2}$ in.
Oxford, Ashmolean
Museum

One of the most beautiful of
early Pre-Raphaelite
pictures in simplicity of
design and richness of
colour, *The return of the dove*
was painted for Mr and
Mrs Combe of Oxford and
exhibited at the Royal
Academy in 1851. It was
part of Mrs Combe's
bequest to the Ashmolean
Museum in 1894. The work
attracted special notice
when shown at the Paris
Exhibition in 1855 and was
the subject of an article by
Théophile Gautier. Seen in
the window of James Wyatt,
the frame-maker in the
High Street, Oxford, it first
aroused Pre-Raphaelite
enthusiasm in William
Morris and Burne-Jones.

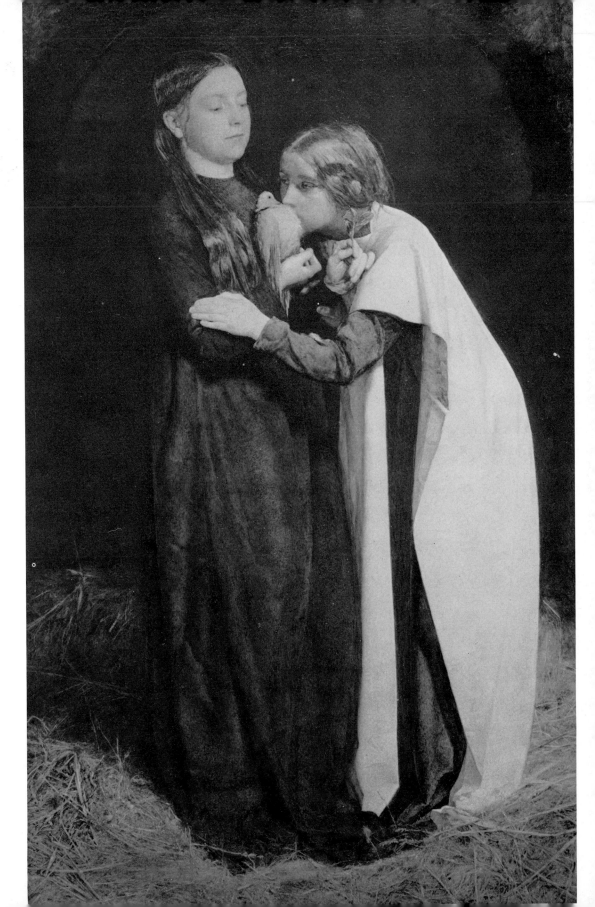

77

SIR JOHN
EVERETT
MILLAIS
(1829–96): *The
escape of a heretic*.
Exhibited 1857.
Canvas,
42 × 30 in.
Ponce, Puerto
Rico, Ponce Art
Museum

One of the best
examples of
Millais in an
historical vein is
this companion
piece to his
Huguenot,
suggested by a
series of old
woodcuts illustra-
ting the Duke of
Alva's persecu-
tion in the
Netherlands. The
'San Benito' gown
of sacking painted
yellow with
designs of devils
burning
unbelievers,
which the heretic
was compelled to
don, is worn by
the girl aided in
escape by her
lover.

JOHN ROGERS HERBERT
(1810–90): '*Cordelia
disinherited*'. 1850.
Canvas, 39½ × 24 in. Preston,
Harris Museum and Art
Gallery

Simplicity and earnestness of
feeling, in some measure
deriving from the German
Nazarenes, distinguished the
work of Herbert, as in this
Academy version of the
subject he was commissioned
to paint in fresco in the House
of Lords. A later *Cordelia* in
the Academy of 1855 was
unfortunate enough to arrest
the attention of Ruskin in
captious mood, who singled
it out as an example of the
'passively bad'.

79 WILLIAM CLARKSON STANFIELD (1793–1867): *The battle of Roveredo, 1796.* 1851. Canvas, 72 × 108 in.
London, Royal Holloway College

Though Clarkson Stanfield is perhaps best known for his marine paintings, he undertook a wide
variety of subjects, including reminiscences of the Napoleonic War period, which he had known
as a young man. He carried out ambitious projects with an easy confidence derived from his work
as a scene painter. *The battle of Roveredo* (or Rovereto), one of the long series of spirited works
he produced between 1845 and 1866, reflects both the pleasure he took in Italian scenery and
his conception of the engagement in which Napoleon had defeated the Austrians in 1796.

80 JOHN WILLIAM
INCHBOLD (1830–88):
In early spring. Exhibited
1871. Canvas, 20 × 13¾
in. Oxford, Ashmolean
Museum

Inchbold was one of the
few painters inspired by
Pre-Raphaelite ideas
who devoted themselves
to landscape without an
admixture of story or
action. Through Ruskin,
who greatly admired his
work, he became
associated with the
Pre-Raphaelites in the
1850s. *In early spring*
well illustrates the fine
quality of line and colour
that he attained. The
contrast with Stanfield's
picture emphasizes the
lyrical delight in
natural detail that
marked the
Pre-Raphaelite approach
to landscape.

82 WALTER HOWELL DEVERELL (1827–54): *Twelfth Night*. About 1850. Canvas, $40\frac{1}{4} \times 52\frac{1}{2}$ in. London, Tate Gallery (on loan from a private collection)

Paton's picture (*opposite*) is a particularly vivid example of the Germanic influence of the Nazarenes that by various channels found its way into Britain in the mid-century. It appears in the precision of design and hardness of outline.

Deverell's picture, painted with youthful enthusiasm for Pre-Raphaelite ideas, exemplifies the practice of the Brotherhood and their friends of using each other as models in their subject pictures. Elizabeth Siddal, whom Deverell introduced into the circle and who was in general demand as model, here posed for Viola, and D. G. Rossetti was the model for the Fool.

81 (*opposite*) SIR JOSEPH NOEL PATON (1821–1901): *Dante's dream*. 1852. Canvas, 40×37 in. Bury, Public Library and Art Gallery

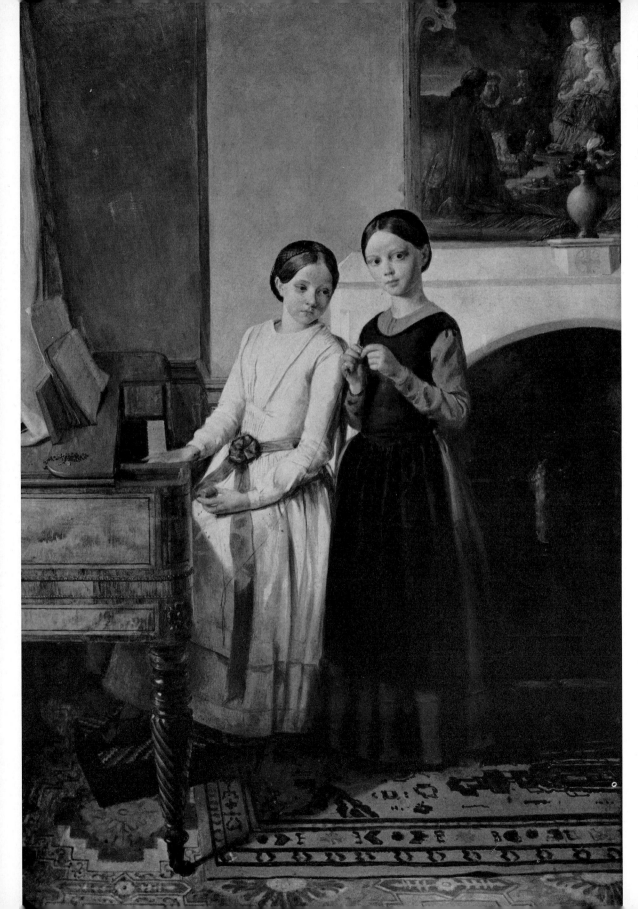

83
JOHN ROGERS
HERBERT
(1810–90): *Children
of the painter*. 1850.
Canvas,
31 × 21 in.
Private Collection

This picture well
exemplifies the
distinction of style
of which Herbert
was capable.
Refinement and
dignity of
execution and a
rejection of
unnecessary
auxiliaries make
the work
outstanding.

84 (*opposite*)
SIR JOHN
EVERETT
MILLAIS
(1829–96): *Thomas
Combe*. 1850.
Panel, 13 × 10⅞ in.
Oxford,
Ashmolean
Museum

Millais's portrait
of Thomas
Combe, director of
the Clarendon
Press and his early
patron at Oxford,
displays the
remarkable skill
and sense of
character and
detail that
animated his early
Pre-Raphaelite
works. Combe
gave Millais the
commission for
*The return of the
dove to the ark*
(Plate 76).

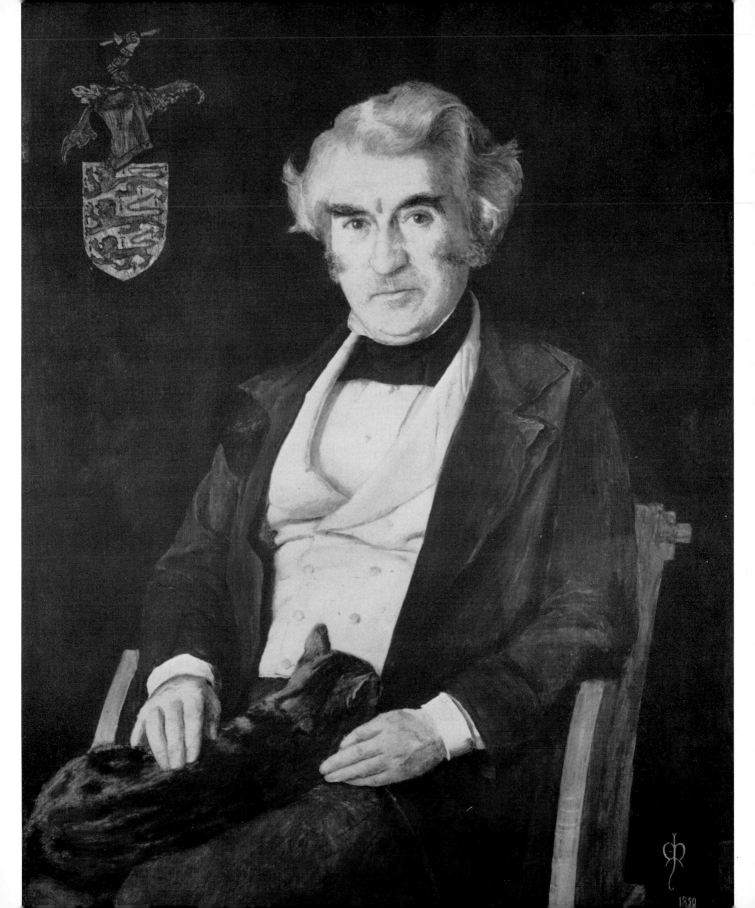

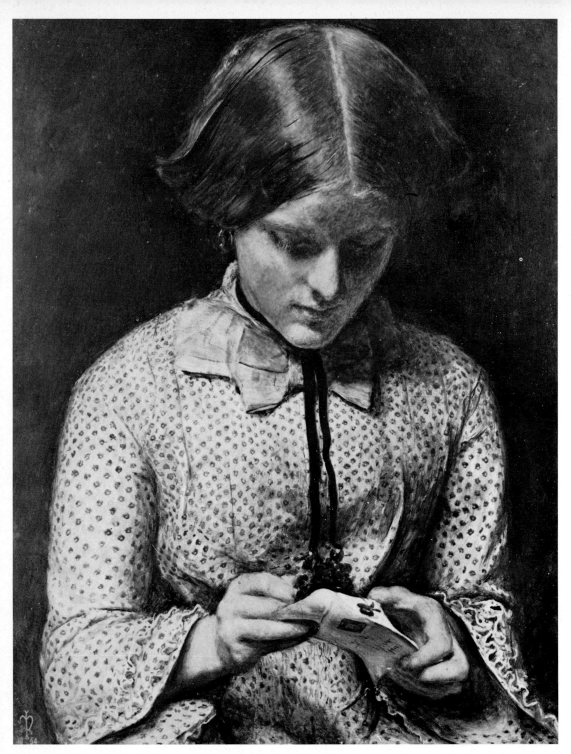

85 SIR JOHN EVERETT MILLAIS (1829–96): *The violet's message.* 1854. Panel, $10 \times 7\frac{3}{4}$ in. Trustees of Sir Colin and Lady Anderson

The violet's message is one of Millais's most enchanting works. Without the demands imposed by elaborate historical subjects, Millais was able to concentrate on what he was always to do best: the careful rendering of exactly what was in front of his eyes. The motif of the violets introduces a note of sentimental genre into an otherwise straightforward portrait study.

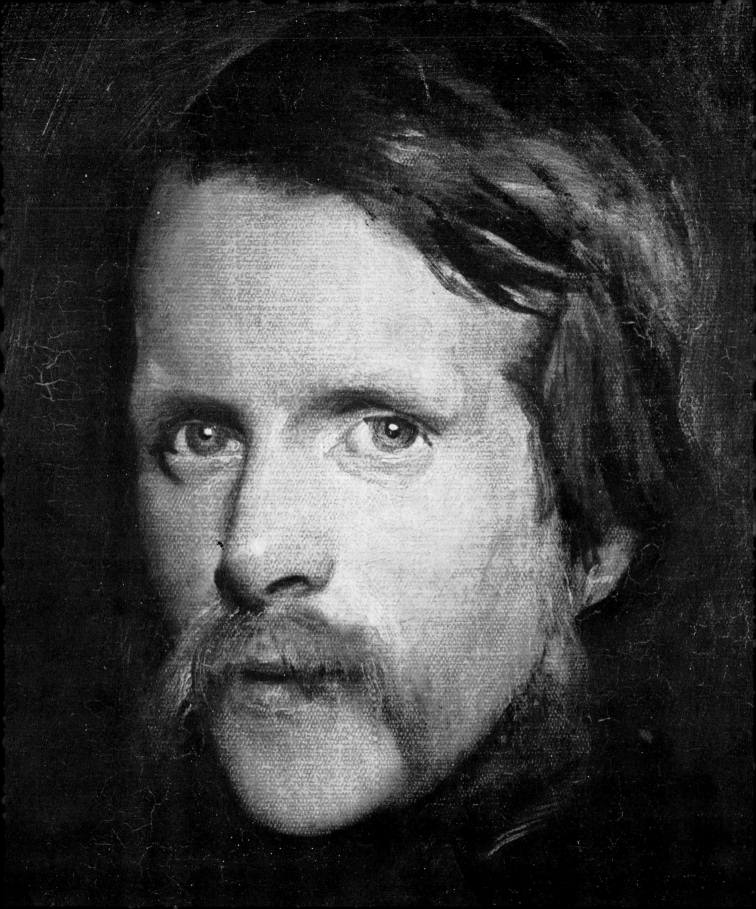

87 PAUL FALCONER POOLE (1807–79): *The Goths in Italy*. 1853. Canvas, 55½ × 84 in. Manchester, City Art Gallery

This picture impressively continues the old tradition of history painting, in which the theme was of the kind that allowed for the free exercise of the imagination. The placing of the figures in the foreground, the treatment of light and shade and the relation of man and architecture are brought into a vigorous unity of composition. It is possible to form an idea of the work on these grounds before considering such contrast between barbarian invaders and Roman civilization as the artist had in mind. The contrast is effectively made. Poole's style, with its rich but rather sombre colouring, may serve to emphasize the fact that many artists continued to paint in a traditional way, entirely uninfluenced by the Pre-Raphaelites.

88 FREDERICK GOODALL (1822–1904): *The happier days of Charles I*. Exhibited 1855.
Canvas, 38 × 59½ in. Bury, Public Library and Art Gallery

The change from history painting to works in which known historical persons figured, usually on some informal occasion, was a feature of Victorian art that could be described as one more anecdotal genre in opposition to the 'great style'. Pictures of this kind, realistically treated in likeness, expression and detail, were a speculation on how a given scene and group of characters might have looked, though with no assurance that they had so appeared in actuality. The possible confusion between historical fact and fiction may be held against Frederick Goodall's attempt to humanize history in this view of Charles I and his family as they might have been in their happier days; but as an illustration of Victorian taste it is an enlightening and entertaining document.

89
THOMAS
FALCON
MARSHALL
(1818–78):
*The
return to
health.*
Canvas,
$17\frac{3}{4} \times 27\frac{1}{2}$ in.
Private
Collection

90
WILLIAM
GALE
(1823–1909):
*The
convalescent.*
About
1862.
Canvas,
$12 \times 18\frac{1}{2}$ in.
Private
Collection

91 WILLIAM H. HOPKINS (documented 1853–90) and EDMUND HAVELL (1819–94): *Weston Sands in 1864*. 1864. Canvas, 24¼ × 38½ in. Bristol, City Art Gallery

Life at the seaside, William Powell Frith's celebrated painting of Ramsgate Sands, exhibited at the Royal Academy in 1854, marked the beginning of a new kind of realism and a vogue for the painting of groups of holiday-makers by the sea that lasted through the 1860s and 1870s. Though artists made much of the pleasant spectacle of children playing on a beach, not all the scenes they painted were necessarily cheerful. *The return to health* and *The convalescent* reflect the anxieties of a society that had not yet developed a full armoury of preventive medicine but had a firm belief in the curative properties of sea air.

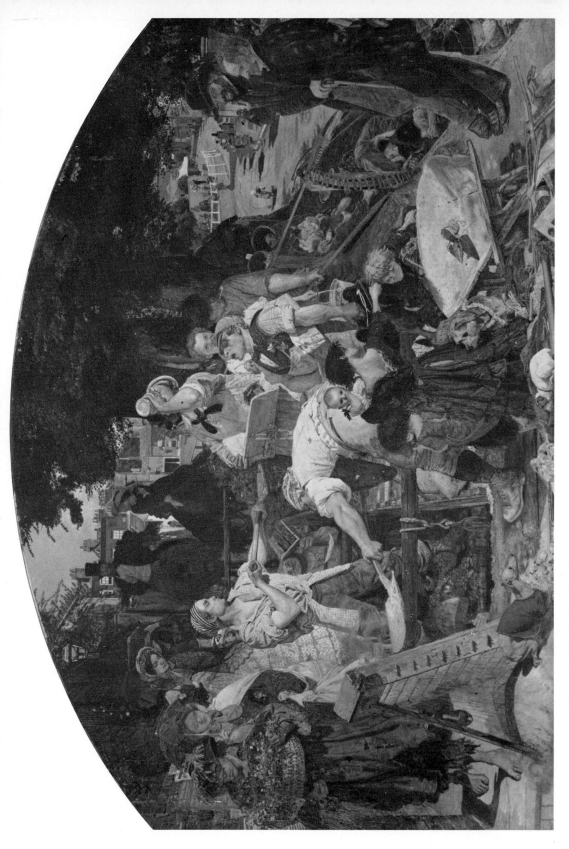

92 FORD MADOX BROWN (1821–93) : *Work*. 1852–65. Canvas, 53 × 77⅛ in. Manchester, City Art Gallery

Work was a Victorian watchword and Ford Madox Brown here gave an allegorical representation of it, though in Pre-Raphaelite fashion he ignored the work of factory and machine and concentrated on manual labour. The picture might be appreciated as a beautifully painted scene of a summer afternoon at Heath Street, Hampstead; but brainwork is represented by Thomas Carlyle and the apostle of Christian Socialism, the Reverend Denison Maurice. Other types include the idle rich, the unemployed and the unemployable. The allegory is of less moment than the realistic rendering of the Victorian scene.

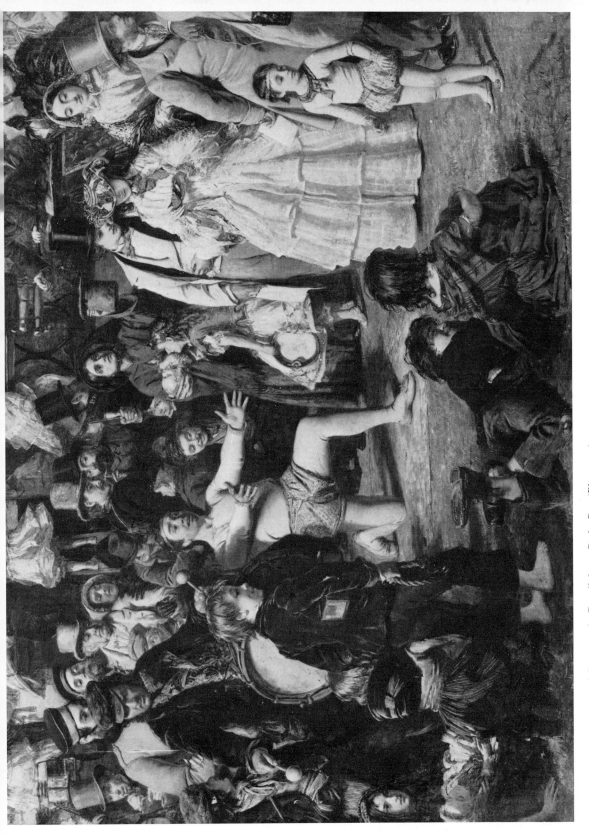

93 WILLIAM POWELL FRITH (1819–1909): Detail from *Derby Day* (Plate 103)

When Frith's *Derby Day* is studied in detail, the vivacity of gesture and accuracy of characterization in each individual group become apparent. His keen eye for type made exact note of the 'swells' in their carriage with a groom to unload the hamper of champagne and comestibles, and equally of the humble musicians and mountebanks in their effort to entertain the crowd. The effect of animation is the more surprising when the long gestation of the picture is considered—the process occupies a whole chapter in Frith's *Autobiography*. He made a first rough sketch after going to the Derby in 1856. He followed this with numerous figure studies, a small oil sketch, a large sketch and a further sketch (London, Bethnal Green Museum), trying out an altered arrangement of the principal group. In addition he made use of studies of race-horses by the sporting painter, J. F. Herring, and photographs of the scene by a photographer, Robert Howlett. All his references were assimilated with entirely satisfactory completeness.

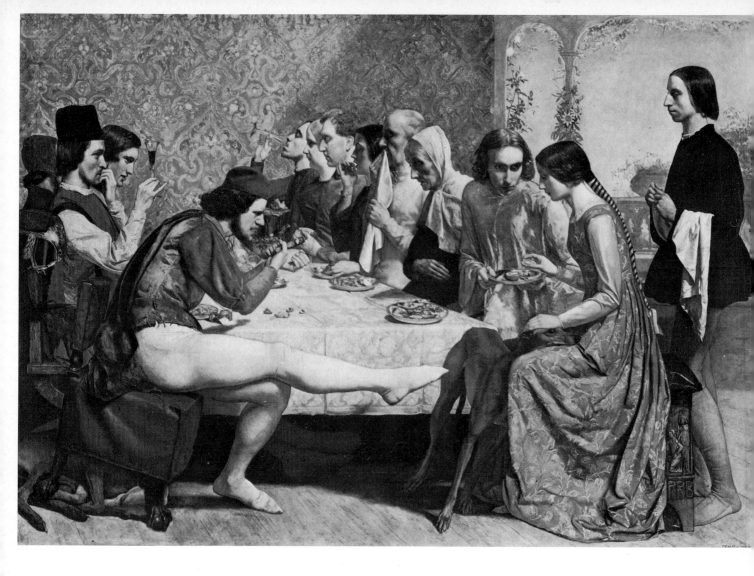

94 & 95 SIR JOHN EVERETT MILLAIS (1829–96): *Lorenzo and Isabella*. 1849. Canvas, 40½ × 56¼ in. Liverpool, Walker Art Gallery

One of Millais's most remarkable early feats of skill in combining detailed realism with poetic subject is his *Lorenzo and Isabella*, inspired by Keats's *Isabella or the Pot of Basil*. Friends and relatives were the models for the twelve characters at the table. Lorenzo was Walter Deverell, offering an orange to Isabella, portrayed from Mrs Hodgkinson, Millais's stepsister-in-law. Millais's father posed for the elderly gentleman politely touching a napkin to his lips. Dante Gabriel Rossetti is at the end of the table draining his glass. Of the three brothers angered by Lorenzo's courtship, F. G. Stephens is possibly the figure at the end of the table on the left, William Michael Rossetti next to him in sombre meditation, and the brother aiming a kick at Isabella's greyhound was another friend, John Harris.

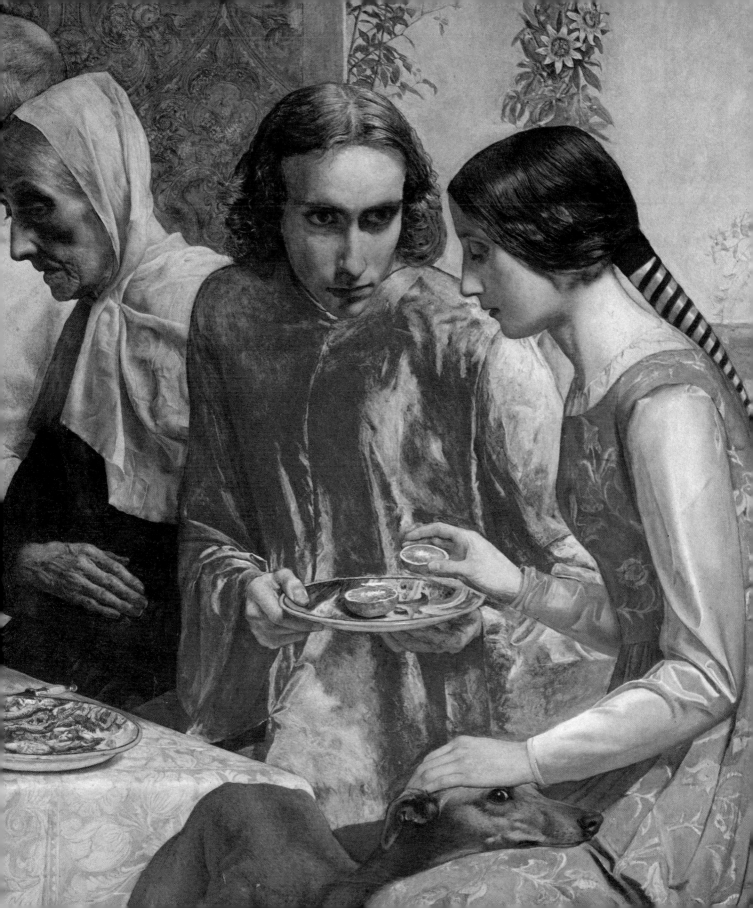

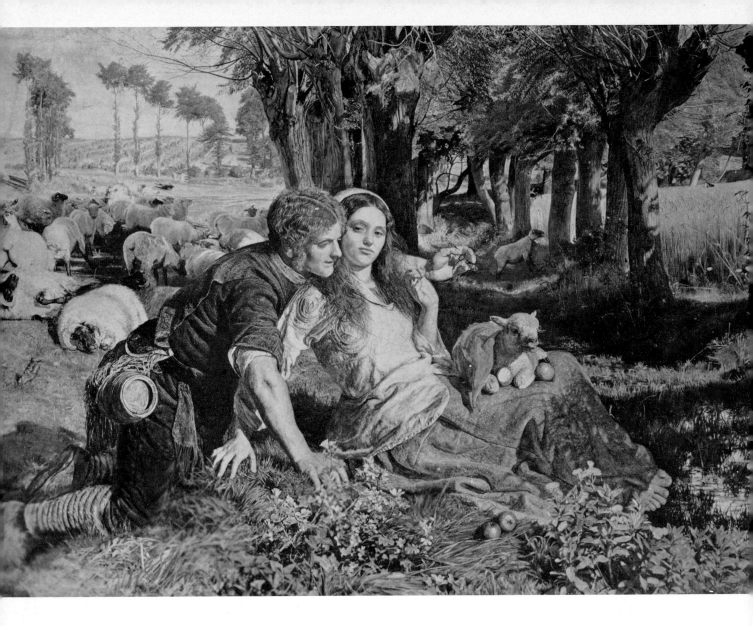

96 & 97 WILLIAM HOLMAN HUNT (1827–1910): *The hireling shepherd*. 1851. Canvas, 30 × 42½ in.
Manchester, City Art Gallery

The aim of 'truth to nature' led Holman Hunt to paint the background of this splendid picture in
the open air, mainly at Ewell in Surrey but apparently with the addition of some detail at
Godstow near Oxford. It is remarkable not only in the wealth of detail but for the effect of sunlight
courageously set down in terms of colour. In this respect Pre-Raphaelite 'truth' for a moment
seems to anticipate that of French Impressionism. There are some passages of the landscape
distance that bring Claude Monet to mind. The theme appears ostensibly to be a pastoral idyll
(the model for the girl was a fieldhand on the estate of Sir George Glynn at Ewell, nicknamed
'the Coptic' by Rossetti). But Hunt had a moral in reserve: that the 'jolly shepherd' of
Edgar's catch in *King Lear* was the type of idle pastor who was concerned with irrelevancies
and allowed his flock to stray. The surrealists of the 1930s saw not a moral but a sinister
element in the Death's Head moth in the shepherd's grasp, a detail reproduced with approval
in the *avant-garde* magazine *Minotaure*.

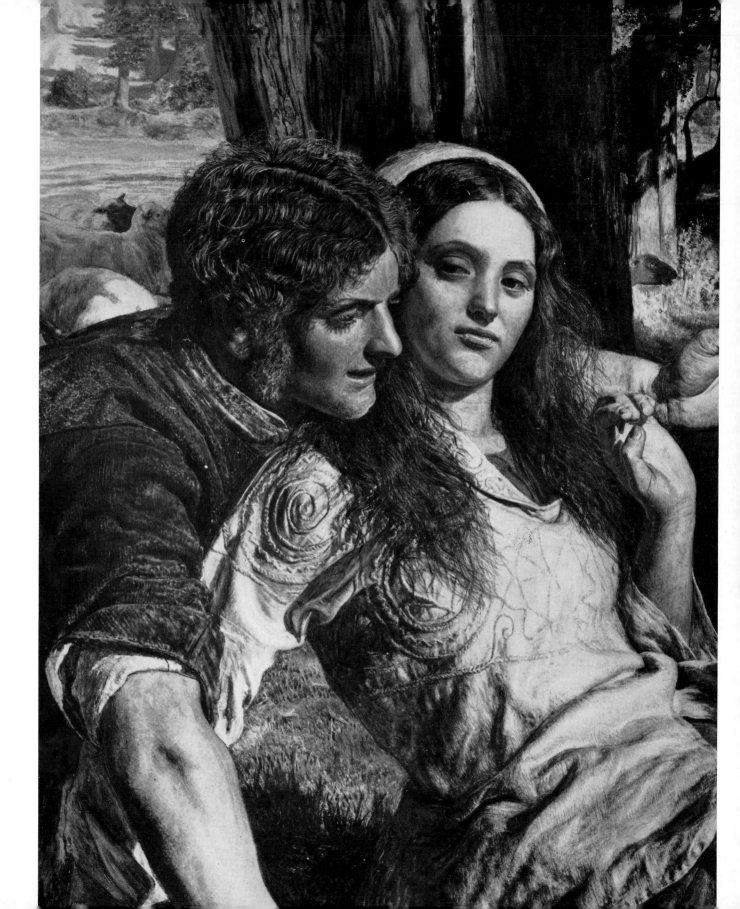

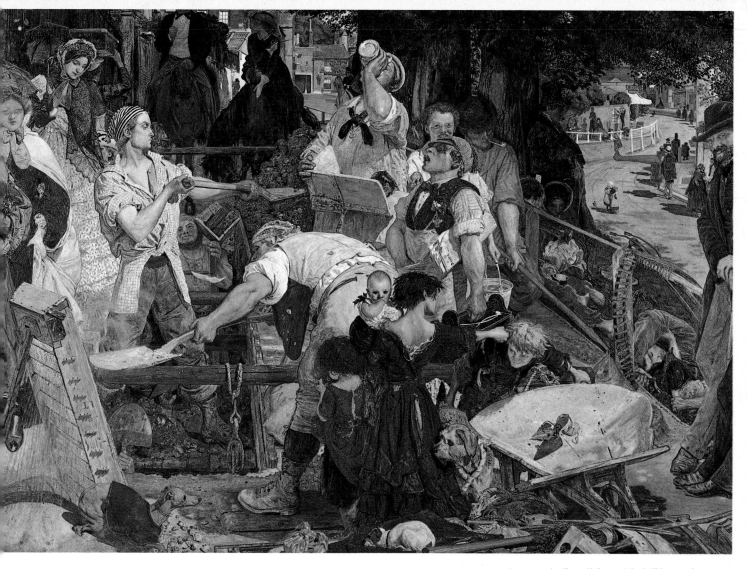

99 FORD MADOX BROWN (1821–93): Detail from *Work* (Plate 92)

98 *(opposite)* WILLIAM HOLMAN HUNT (1827–1910): Detail from *The hireling shepherd* (Plate 96)

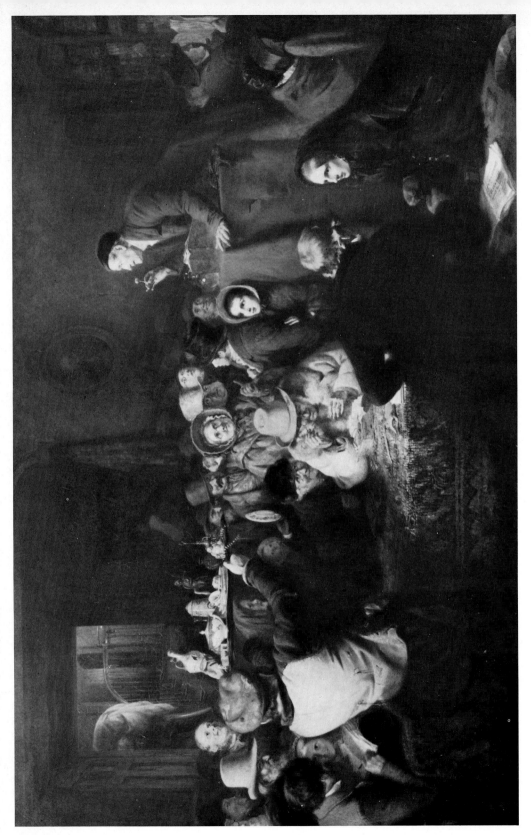

100 GEORGE BERNARD O'NEILL (1828–1917): *The last day of the sale*. Exhibited 1857. Canvas, 29⅛×44½ in. Burnley, Towneley Hall Art Gallery and Museum

The 1850s and 1860s were the flourishing years of the genre devoted to the modes and manners of the urban middle class. Paintings of this kind gained much of the favour earlier given to pictures of village life. Other levels of the social scale—higher and lower—came later into pictorial review. The 'realism' of the bourgeois school, unlike the 'truth to nature' of the Pre-Raphaelites, was little concerned with light and colour or in any critical way with the social system; but it added to a mild narrative element much that is now highly informative, as here, about Victorian modes and manners.

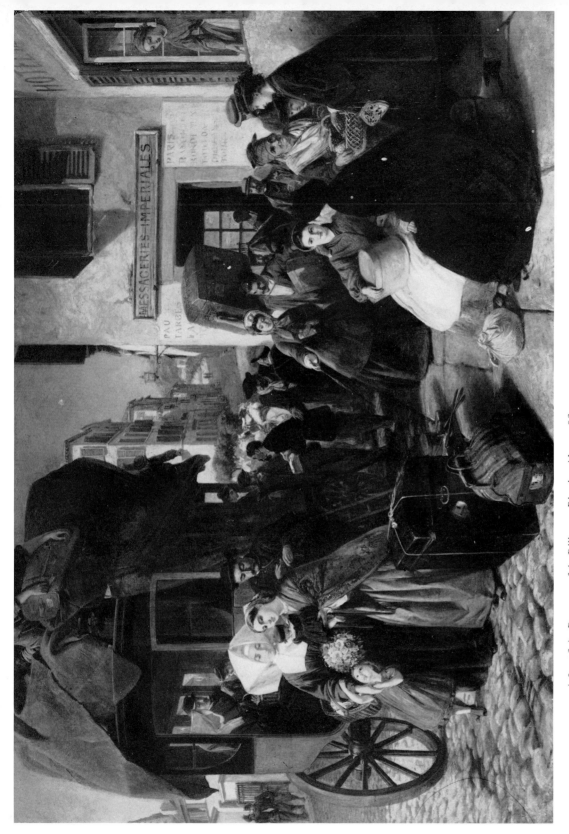

101 ABRAHAM SOLOMON (1824–62) : *Departure of the Diligence, Biarritz*. About 1862.
Canvas, 35 × 50 in. London, Royal Holloway College

Generally speaking, the Victorian picture of everyday life was a home-nurtured product. The eye of a Frith or his like, if turned on the foreign scene, was more apt to single out for portrayal that which allowed for an element of moral warning—a fashionable crowd at the gambling tables rather than the normal course of existence. Solomon, in contrast, concentrates on a more routine aspect of life, at a time when travel was more cumbersome and more difficult, and in consequence often more thrilling.

102
ARTHUR HUGHES
(1832–1915): *The knight of the sun*. 1860. Canvas, 40 × 52¼ in. Private Collection

Among the immediate followers of the Pre-Raphaelite Brotherhood, Arthur Hughes stands out as one devoted equally to the passion for detailed realism and the nostalgic sentiment that he admired in the work of Rossetti. Hughes has perhaps been underrated as a lesser disciple of the group. His *April love* has always been counted among the Pre-Raphaelite masterpieces but he has not been sufficiently appraised as one with an intensity of colour at his command. More than the Arthurian suggestion of *The knight of the sun* the depth of colour may strike the spectator; the vibrating chords are not only the rich tones of sunset but convey the artist's intensity of feeling.

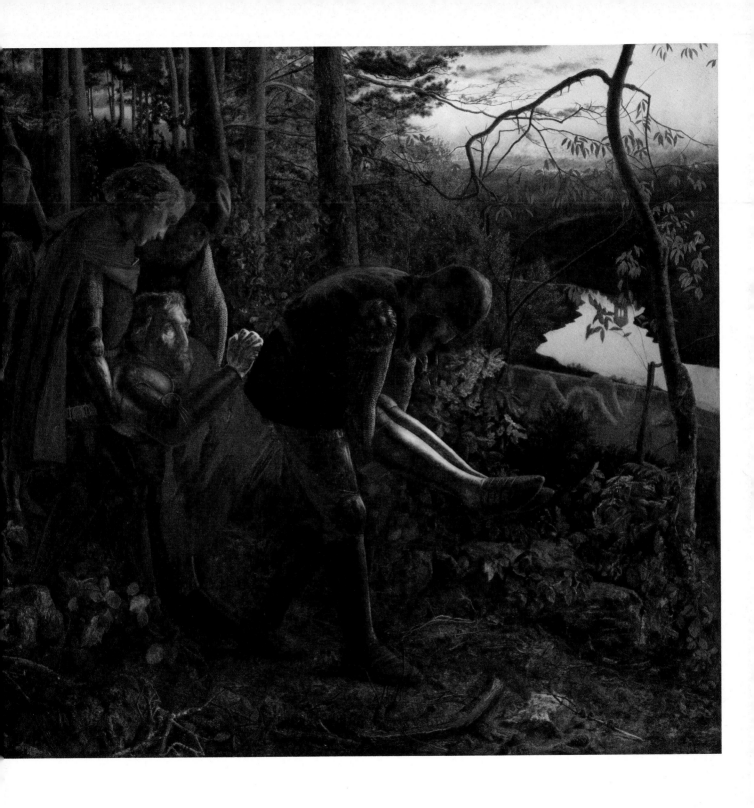

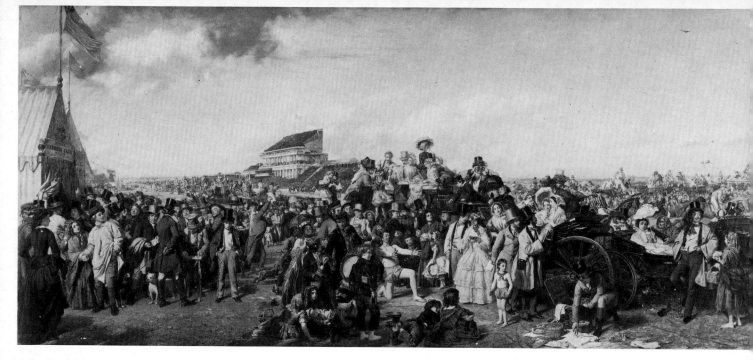

103 WILLIAM POWELL FRITH (1819–1909): *Derby Day*. 1856–8. Canvas, 40 × 88 in. London, Tate Gallery

104 JOHN RITCHIE (documented 1858–75): *Hampstead Heath*. 1859. Canvas, $32\frac{1}{2} \times 53\frac{1}{2}$ in. Private Collection

105
W. A. ATKINSON
(documented 1849–67):
The upset flower cart.
About 1858.
Canvas, $35\frac{1}{4} \times 27$ in.
Private Collection

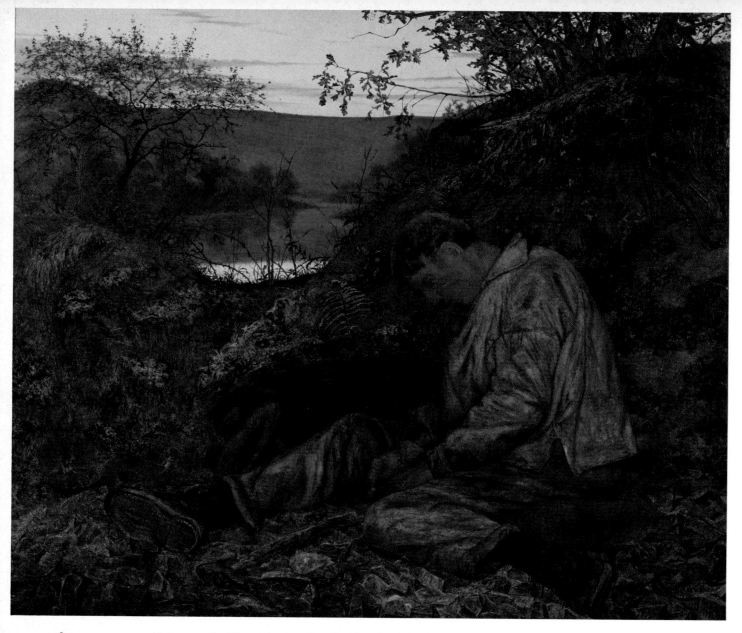

106 HENRY WALLIS (1830–1916): *The stonebreaker*. 1857. Panel, 25¾×31 in. Birmingham,
City Museum and Art Gallery

A beautiful example of the Pre-Raphaelites' capacity to take a theme from ordinary life—in
this case the death of a man whose poor livelihood was breaking stones—and to heighten both
its pathos and pictorial appeal in part through intense concentration on detail and also in
poetic feeling and colour.

107 *(opposite)* THOMAS FAED (1826–1900): Detail from *The last of the clan* (Plate 108)

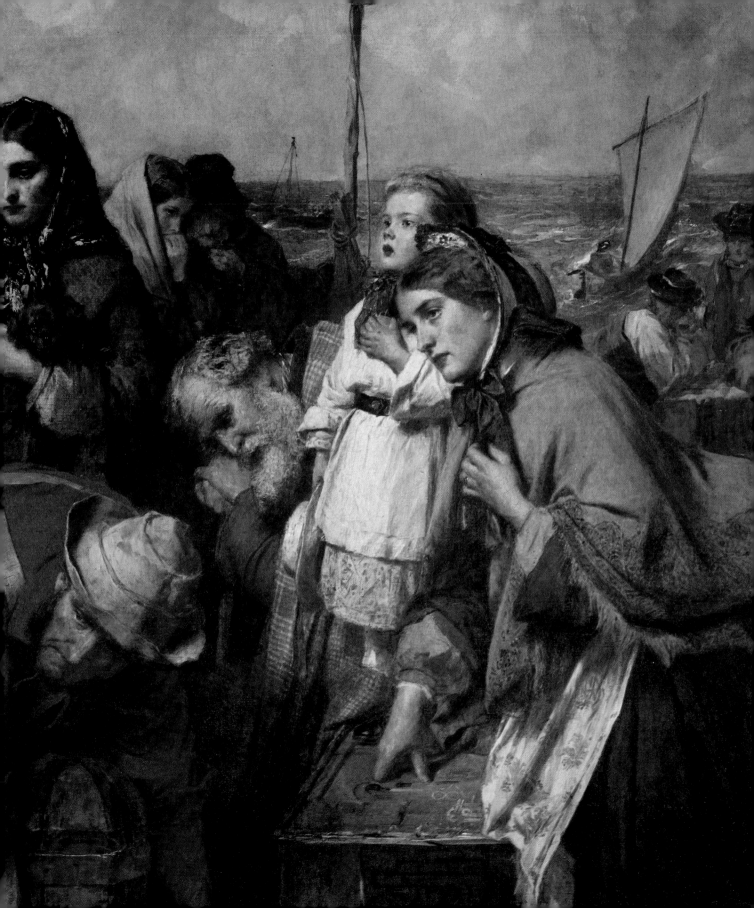

108 THOMAS FAED (1826–1900): *The last of the clan*. 1865. Canvas, 57 × 72 in. Private Collection

Exhibited at the Royal Academy in 1865, *The last of the clan* is a good example of the sentimental anecdotal painting so popular in the Victorian age. Though Faed might appeal to a non-aesthetic predilection in his public, his technique and sense of colour were admirable in themselves.

109 DANIEL MACLISE (1806–70): Detail from *The meeting of Wellington and Blücher.* 1859–61. London, Houses of Parliament

This vast fresco (132¾ × 544 inches) shows an incident that occurred at the end of the Battle of Waterloo, on 18 June 1815. Wellington and Blücher, surrounded by their retinues, greet each other in front of the ruined inn—La Belle Alliance—which had been Napoleon's headquarters. Maclise did a great deal of preparatory research to guarantee the authenticity of details. The uniforms of the leading generals were copied from those actually worn in the field on the day of battle. The War Office had special uniforms made, exact copies of the ones worn by the ordinary soldiers. Maclise studied weapons in the Tower of London. The work was at first well received. The *Art Journal* called it 'the greatest work of its class that has been produced in England'. Thirty-eight of his fellow artists presented Maclise with a gold *porte-crayon* to commemorate his achievement.

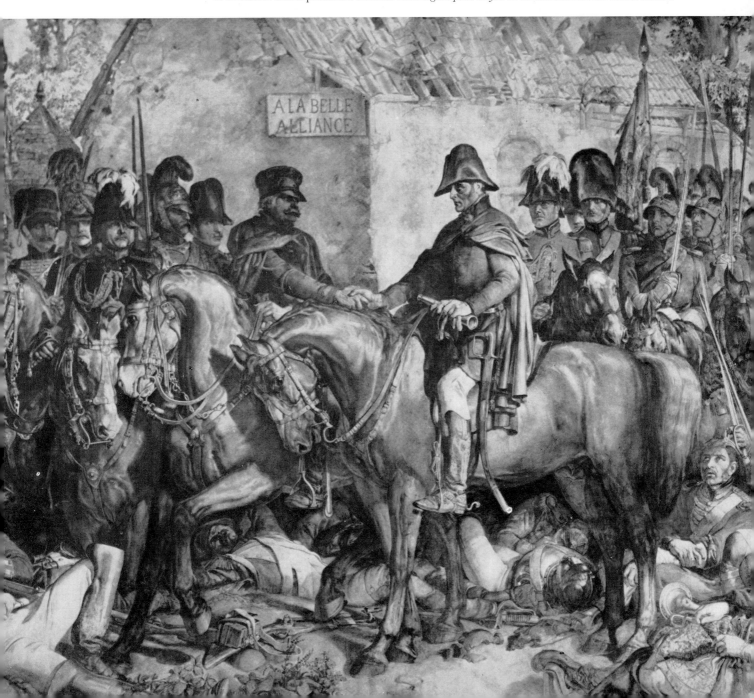

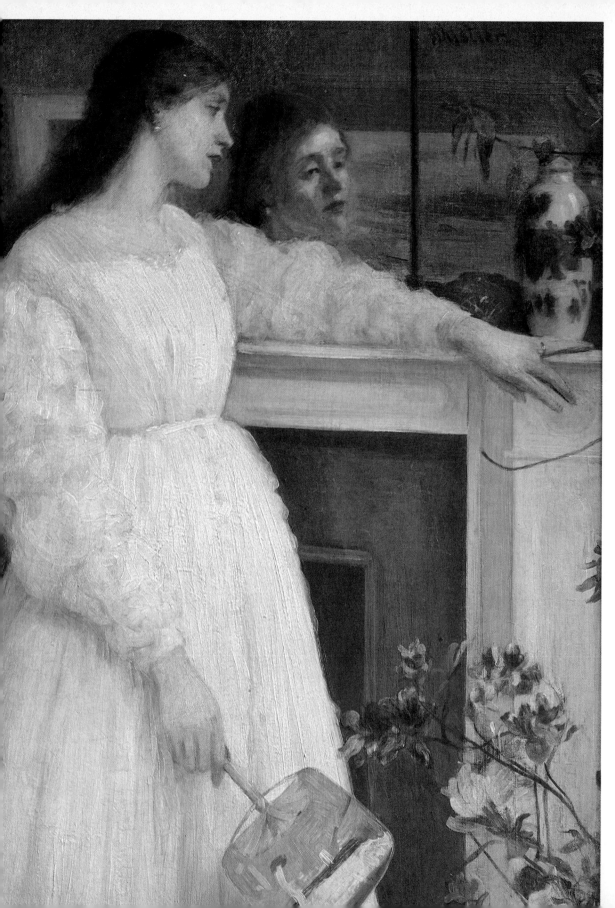

JAMES ABBOT
McNEILL
WHISTLER
(1834–1903):
*Symphony in white,
no. 2: the little
white girl.* 1864.
Canvas,
$30\frac{1}{8} \times 20\frac{1}{8}$ in.
London, Tate
Gallery

The 1860s were
years in which
Whistler was an
intimate of Dante
Gabriel Rossetti
and his circle in
Chelsea. Some
trace of Rossetti's
practice in this
decade of painting
single figures of
women in
contemplative
attitudes may be
found in
Whistler's *Little
white girl*, this
appearance of
languid
contemplation
inspiring
Swinburne's
poem 'Before the
Mirror'. A hint
of Whistler's
growing
interest in the art
of the Far East is
seen in the fan
and vase and the
decorative
treatment of the
spray of flowers.

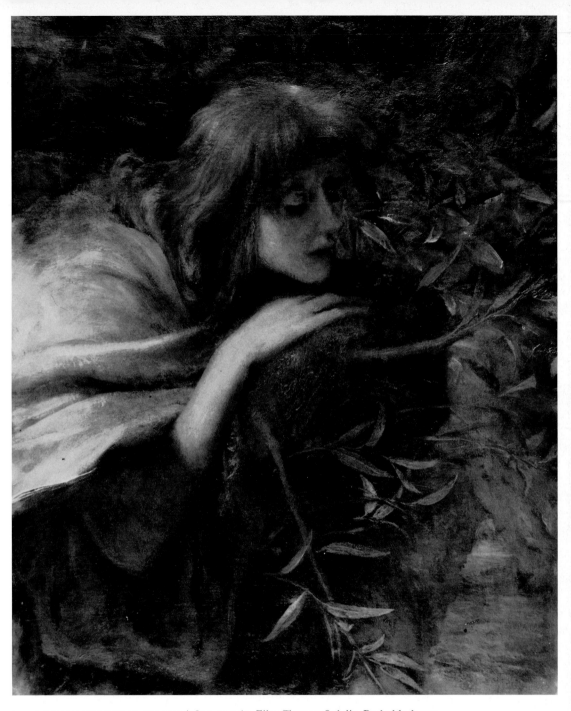

111 GEORGE FREDERIC WATTS (1817–1904): *Ellen Terry as Ophelia*. Probably begun 1864; reworked 1878–80. Canvas, 30 × 25 in. Compton, Watts Gallery

Ellen Terry (1847–1928), one of the great figures of the English stage, was married to Watts briefly in 1864. She returned to a stage career and in 1878 began her famous thirteen-year partnership with Henry Irving. Her first role at the Lyceum Theatre in that year was as Ophelia, and it is presumably then that Watts reworked this portrait of her, which he had begun the year of their marriage, when she was sixteen.

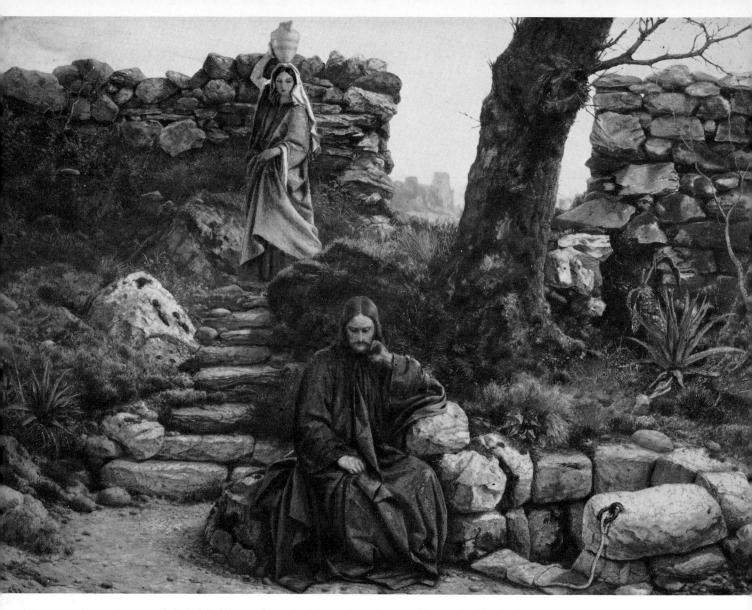

112 WILLIAM DYCE (1806–64): *Woman of Samaria*. About 1833. Canvas, 36⅛ × 28¼ in. Birmingham, City Museum and Art Gallery

113 (*opposite*) RICHARD DADD (1817–86): *Fairy Feller's masterstroke*. 1855–64. Canvas, 21¼ × 15½ in. London, Tate Gallery

Varied influences to which the Victorian artist was exposed can be discerned in the work of William Dyce: his *Woman of Samaria* seems to retain something of Nazarene austerity in general conception but also shows the stimulus to the elaboration of natural detail he had gained from his younger contemporaries in the Pre-Raphaelite movement. The picture also gives evidence of his strong religious convictions.

In Richard Dadd's astonishing *tour de force* there is a dimension filled with mischievous sprites that recalls Fuseli's elfland. The artist added detail of a complexity and minuteness that exceeded even the precision of the Pre-Raphaelites.

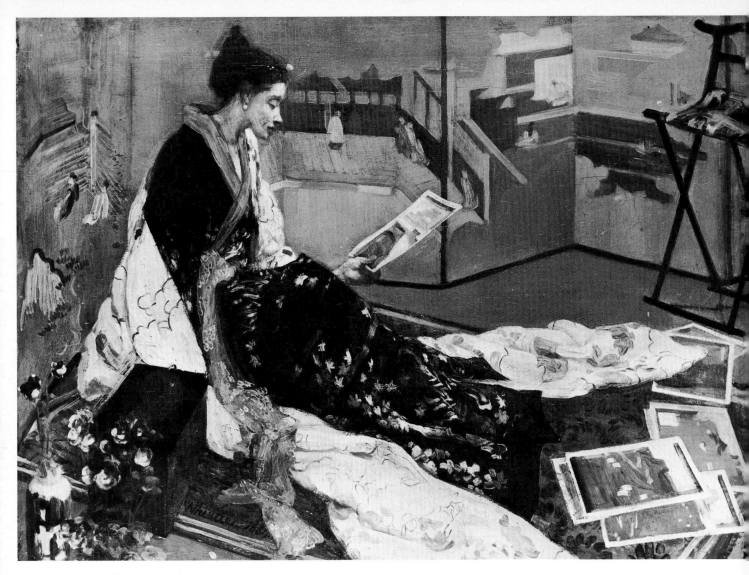

114 JAMES ABBOT McNEILL WHISTLER (1834–1903): *Caprice in purple and gold, no. 2: the golden screen.*
1864. Panel, 19¾×27 in. Washington, D.C., Freer Gallery of Art

Whistler might almost have intended to make a compendium of 'the Japanese taste' in the
model's flowered kimono, the prints by Hiroshige (one of which she is studying) and the
Japanese screen in this painting. The composition, however, is still Western in character.
Whistler had yet to arrive at the simplification of design in the Oriental manner that was to
distinguish his masterpieces of the 1870s.

115 JOHN EVAN HODGSON (1831–95): *European curiosities*. 1868. Canvas, $27\frac{1}{2} \times 35\frac{1}{2}$ in. Newcastle-upon-Tyne, Laing Art Gallery and Museum

Although it is usual to think of the second half of the nineteenth century as a period when the products of Far Eastern art flowed westward with an impact on European taste and effort, traffic between East and West plied both ways. European productions had their shock of surprise and a certain influence to bring to China and Japan. Hodgson—whose later works dealt almost exclusively with Eastern subjects—here illustrates the opposite of the traffic that brought a stream of exotic goods to Farmer and Rogers's Oriental Warehouse and Messrs Liberty's in London. He depicts the arrival on the other side of the world of 'European curiosities', undoubtedly seeming no less exotic to Oriental eyes.

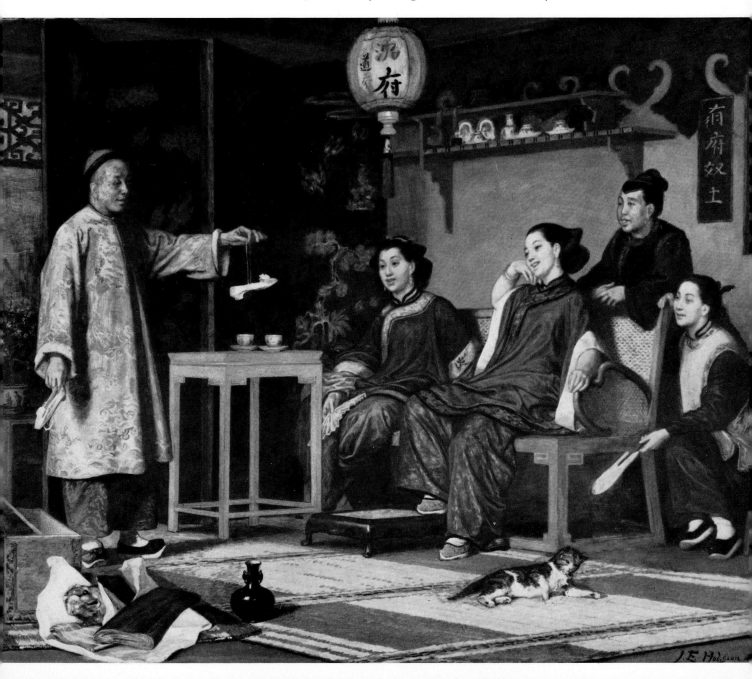

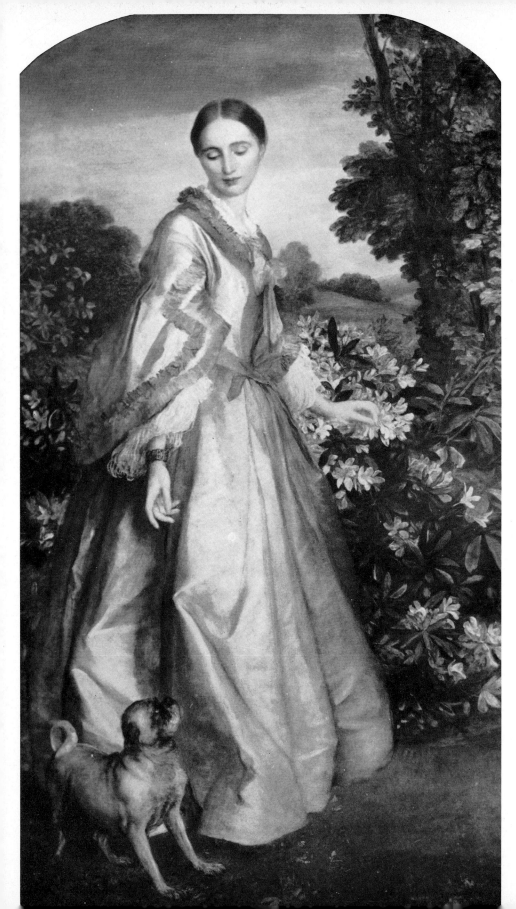

116

GEORGE FREDERIC WATTS
(1817–1904): *Mrs Louis Huth*.
About 1858. Canvas, 76 × 42 in.
Dublin, Municipal Gallery of
Modern Art

Though Watts is perhaps best known
as a portrait painter by his likenesses
of the great men of politics and the
Church, of learning, literature and
art, he painted many portraits of
women distinguished by elegance
and grace of feature enhanced by
the idealistic quality of his work.
This portrait of Mrs Louis Huth is
one of his most charming.

117

SIR FRANCIS GRANT
(1803–78): *Mrs John Hick*.
Exhibited 1861. Canvas,
96 × 58 in. Bolton, Museum
and Art Gallery

Beginning his career in art as a
painter of sporting pictures,
Francis Grant was versatile
enough after his initial success
in that genre to turn even more
successfully to portraiture. Sir
Walter Scott, not professing to
be a judge of art, noted in his
diary his awareness 'that
Francis Grant possesses, with
much cleverness, a sense of
beauty derived from the best
source—that is, the observation
of really good society'. Though
his aristocratic connections
gained him sitters, Grant
showed a decided ability.

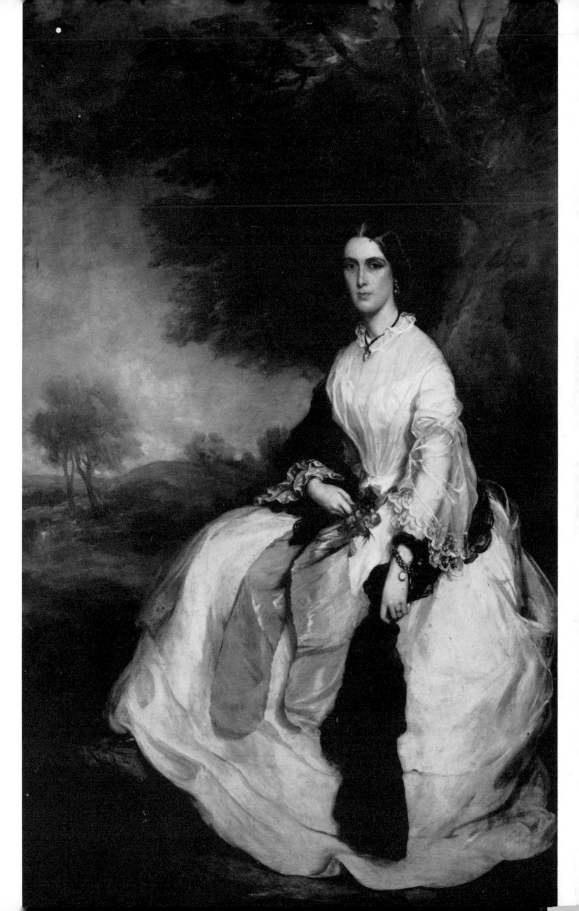

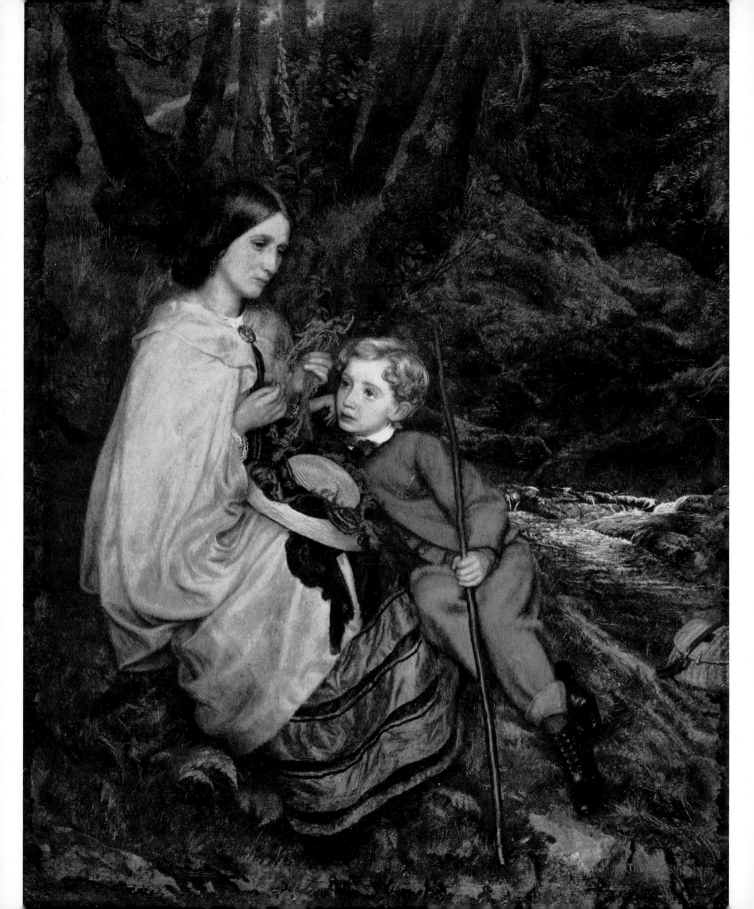

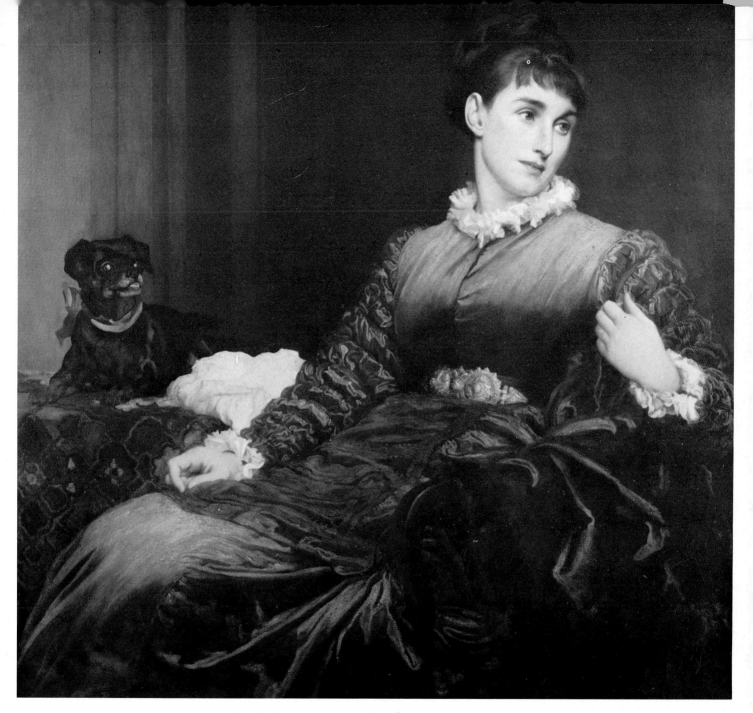

119 FREDERIC, LORD LEIGHTON (1830–96): *Mrs Evan Gordon.* 1875. Canvas, 36 × 37 in. London, Leighton House

Hughes had a simple and unpretentious style as a portrait painter that did not give him a remunerative place among the sought-after professionals but is delightfully seen in his portraits of women and children. An example is the portrait of Harriet Susanna Trist and her son. Mrs Trist was the wife of John Hamilton Trist, a Brighton wine merchant who gave Hughes a number of commissions.

Leighton was well equipped to convey the well-bred distinction of the upper ranks of Victorian society, as in the portrait of Mrs Evan Gordon, formerly Mary Sartoris.

118 (*opposite*) ARTHUR HUGHES (1832–1915): *Mrs Harriet Susanna Trist and son.* 1863. Canvas, 16½ × 13 in. Private Collection

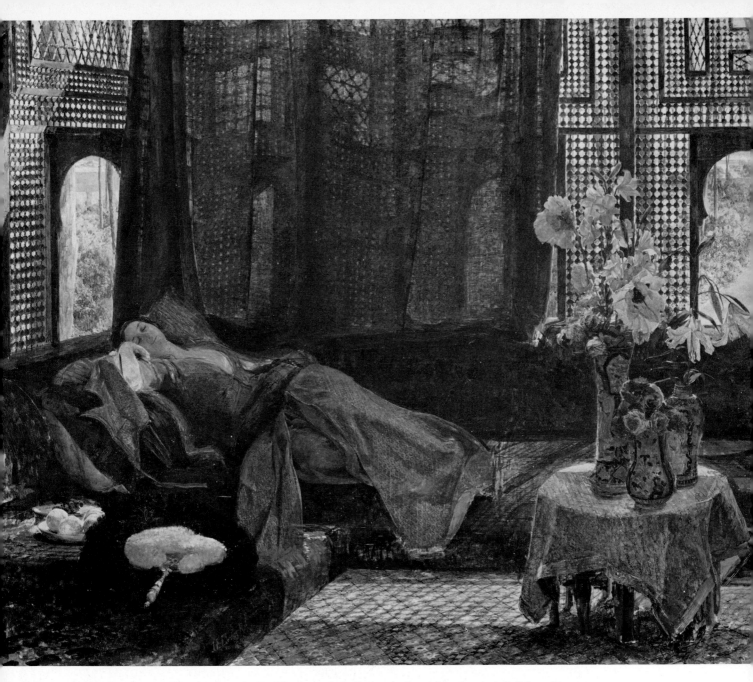

120 JOHN FREDERICK LEWIS (1805–76): *The siesta*. 1876. Canvas, $34\frac{7}{8} \times 43\frac{3}{4}$ in. London, Leighton House
(on loan from The Tate Gallery)

The effect of sunlight diffused in the curtained interior of a house in Cairo, falling—when
unobstructed—into patches of bright colour, especially interested Lewis during his long stay in
Egypt. This unfinished work gives an example of his favoured contrast between the intensity of light
outside and its reduction into appreciable terms of colour within. As in many of his works of this kind,
the reclining girl appears a Victorian type in spite of the Egyptian accessories. An elaborate watercolour,
probably made as a study for this oil painting, is in the Fitzwilliam Museum in Cambridge.

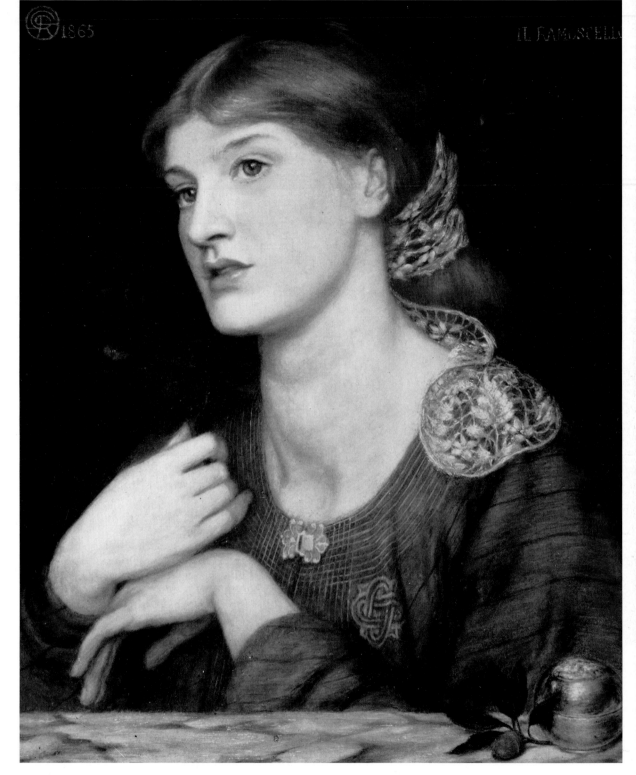

121
DANTE
GABRIEL
ROSSETTI
(1828–82):
Il Ramoscello.
1865. Panel,
$18\frac{3}{4} \times 15\frac{1}{2}$ in.
Cambridge,
Massachusetts,
Fogg Art
Museum

According to the artist's brother, W. M. Rossetti, this is a portrait of one of the daughters of William Graham. Originally known by its alternative title (*Bella e Buona*), it was renamed (*ramoscello* is Italian for 'little branch') in 1873 by Rossetti, who borrowed it, probably to assist him in the execution of a long-promised portrait of Graham's daughter, Amy. The new portrait was never carried out, but Rossetti took the opportunity of repainting much of the present picture, adding its new title to the background. Graham had the new work removed, but allowed the title to remain.

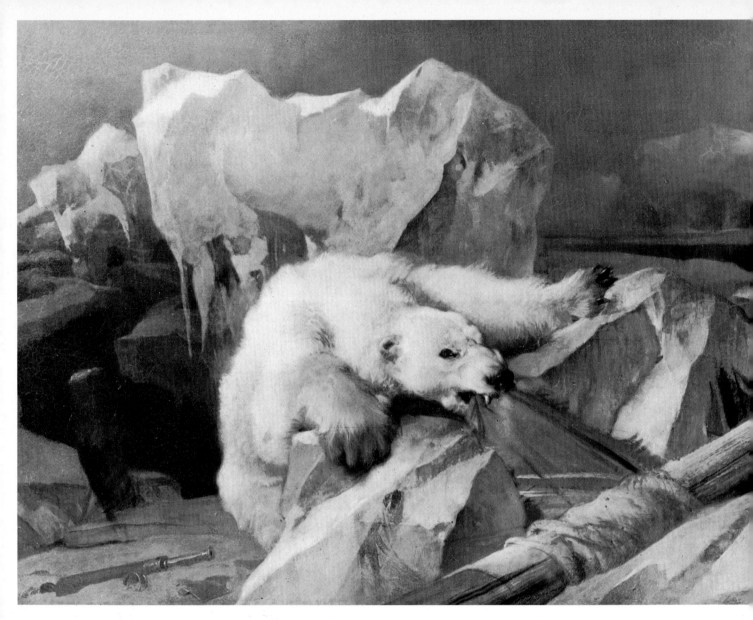

122 SIR EDWIN HENRY LANDSEER (1802–73): *Man proposes, God disposes.* 1864.
Canvas, 36 × 96 in. London, Royal Holloway College

The works of Landseer's later years do not represent a continued descent into mild inanities of canine humour but are strangely fitful and uneven, varying from the playful to the pathetic and the tragic. This painting, executed when he was sixty-two, is an example of his feeling for the chaotic drama of nature with a sense also of the losing battle of mankind against it that has something of Turner's pessimism. It might be compared in its comment on the fatalities of the wild with the *Swannery invaded by eagles*, one of his last important works.

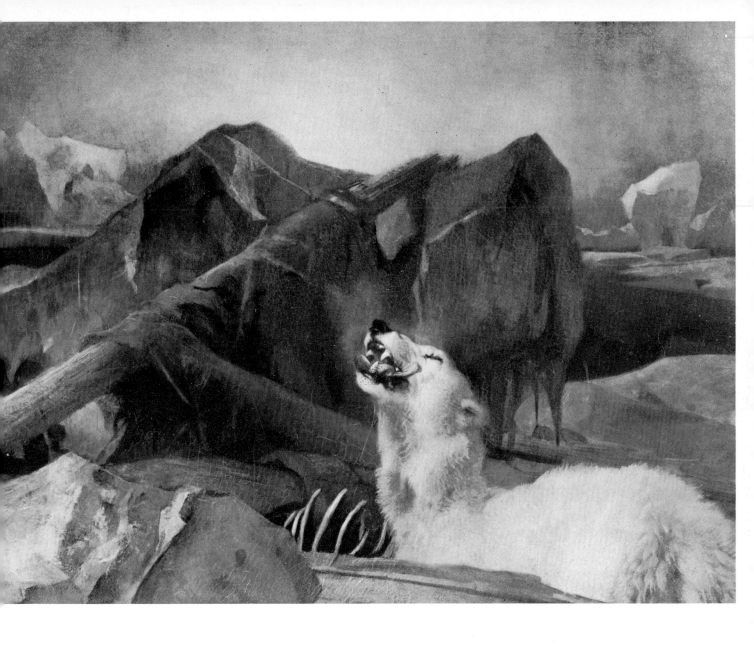

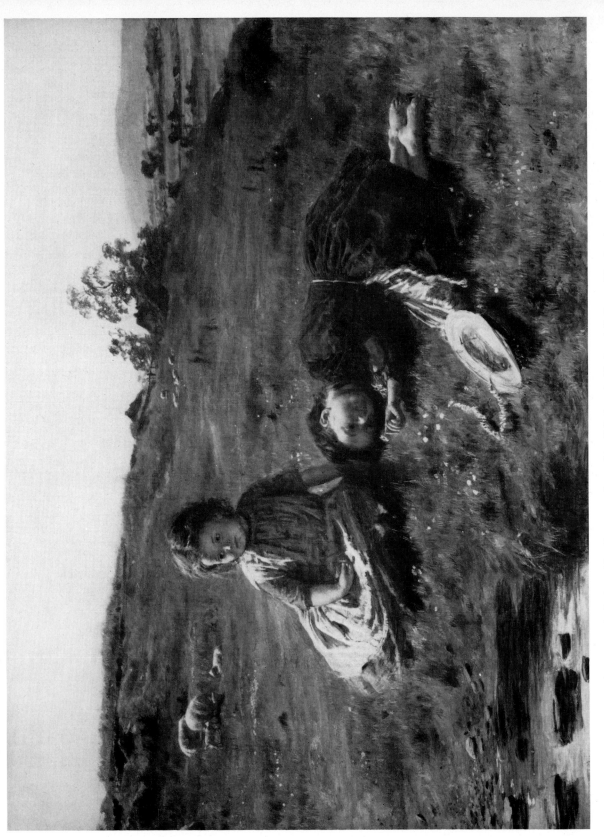

123 WILLIAM McTAGGART (1835–1910): *Spring*. 1864. Canvas, $17\frac{3}{4} \times 23\frac{3}{4}$ in. Edinburgh, National Gallery of Scotland

As a painter of open-air scenes of this kind, McTaggart has an individual eminence among the Scottish artists of the century. Excelling in effects of light, air and movement surrounding figures in outdoor pursuits, he evolved a form of expression that has been compared with French Impressionism, though his brief excursions to the Continent do not seem to have influenced his style and outlook on art. He remained a notably independent artist.

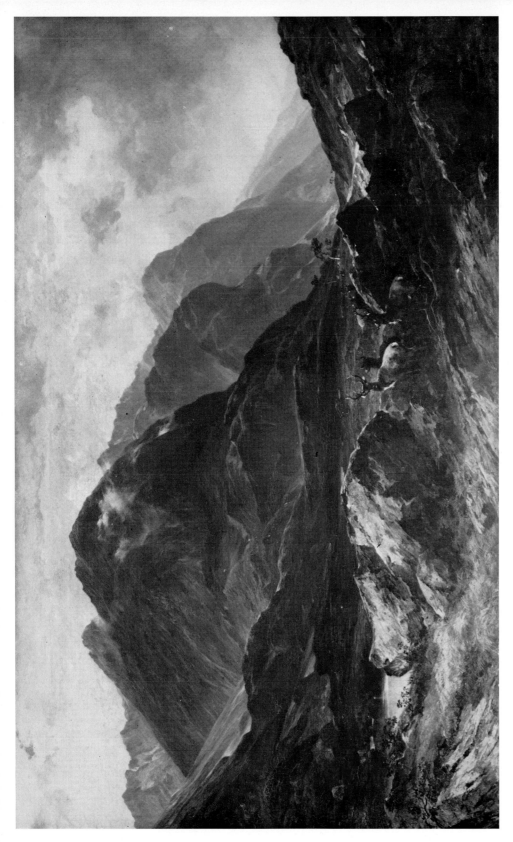

124 HORATIO McCULLOCH (1805–67) : *Glencoe*. 1864. Canvas, 43½ ×72 in. Glasgow,
Art Gallery and Museum

The mountains of Scotland were a discovery of the Romantic generation, no longer alarmed or
depressed by these heights as the cultured city-dwellers of the eighteenth century had been.
The highland landscape became the more popular from the favour shown to these regions by
Queen Victoria. McCulloch does justice to the wild and sombre valley of Glencoe in northern
Argyll with mountains rising steeply above the river Coe, which runs into Loch Leven. The
majesty of the scene is rendered with grim tones that evoke memory of the massacre here of
the Macdonald clan in 1692.

125 FRANK HOLL (1845–88): *No tidings from the sea*. 1870. Canvas, 26 × 36 in. Royal Collection. Reproduced by gracious permission of Her Majesty The Queen

The hardships of the poor in Victorian England, whose misery made a deep impression on foreign observers such as Dostoevsky and the French draughtsman Gavarni, became the special theme of English painters in the 1870s. Holl, before turning to the more lucrative pursuit of portrait painting, produced a number of forceful works of the kind here reproduced. The bleakness of the interior heightens the foreboding effect of the title.

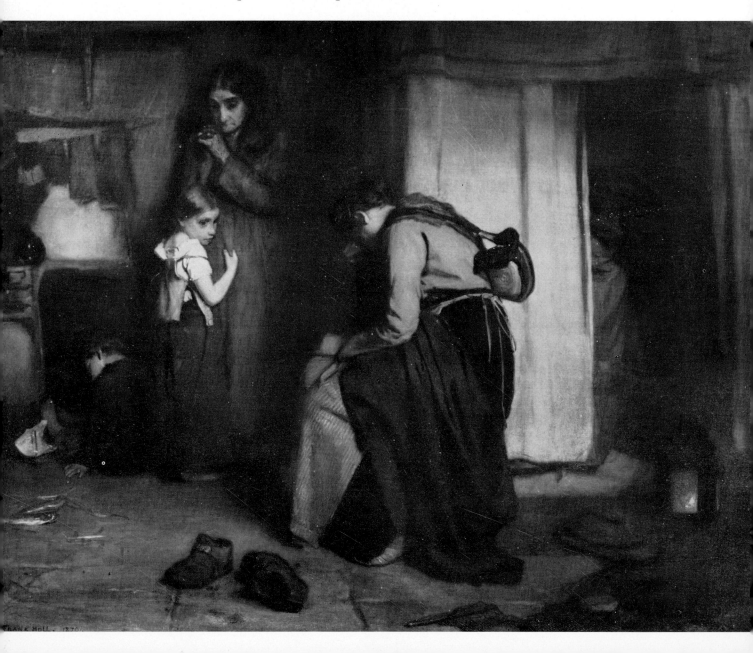

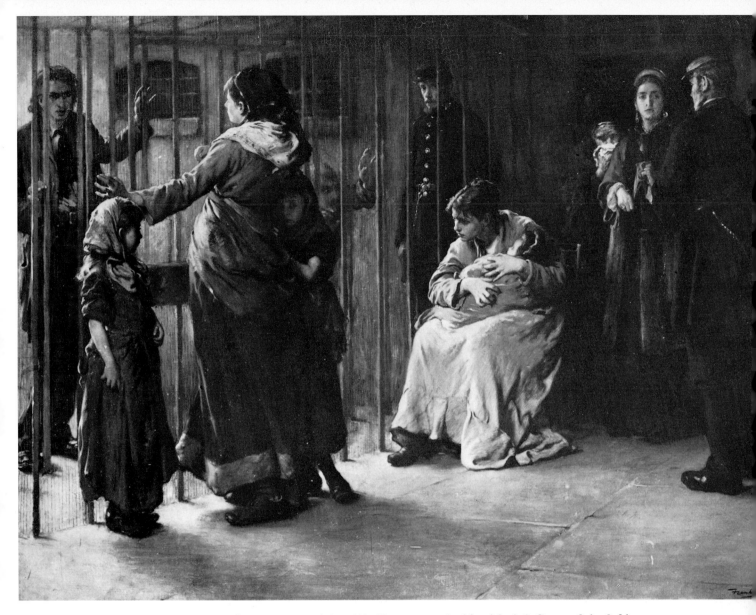

126 FRANK HOLL (1845–88): *Newgate: committed for trial*. 1878. Canvas, $61\frac{1}{4} \times 84\frac{3}{4}$ in.
London, Royal Holloway College

No tidings from the sea depends for its visual effect on its uncompromising harshness of light and
shade. Holl employed the same technique in other pictures designed to bring to public notice
pressing social problems of the day. *Newgate: committed for trial*, apparently based upon a real
incident that the artist had witnessed at Newgate, is a dramatic example.

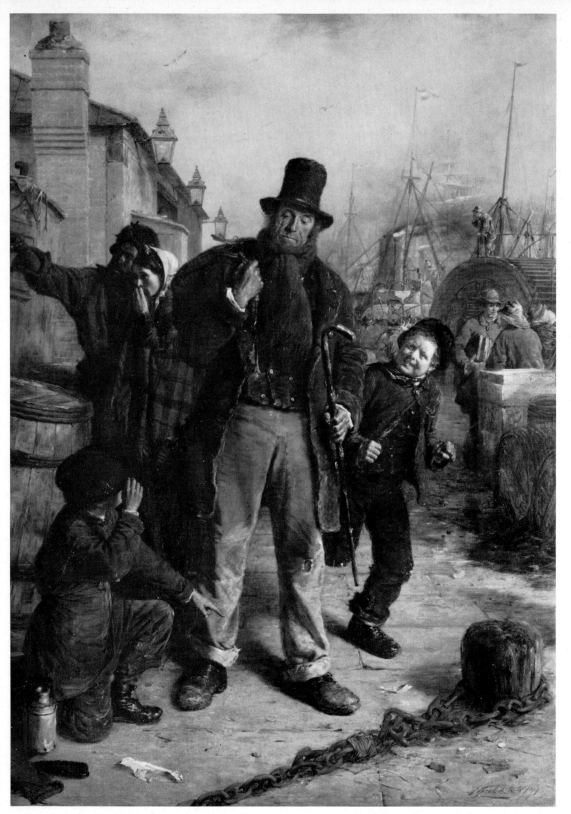

127

ERSKINE NICOL
(1825–1904): *An Irish
emigrant landing at Liverpool*.
1871. Canvas, $55\frac{3}{4} \times 39\frac{3}{4}$ in.
Edinburgh, National
Gallery of Scotland

Four years spent in Dublin
enabled Erskine Nicol to
paint Hibernian types with
the veracity that can be
appreciated in this picture.
The figure of the Irish
emigrant in frock coat,
cravat and tall hat is well
observed and the picture as
a whole is an informative
sidelight on social history.

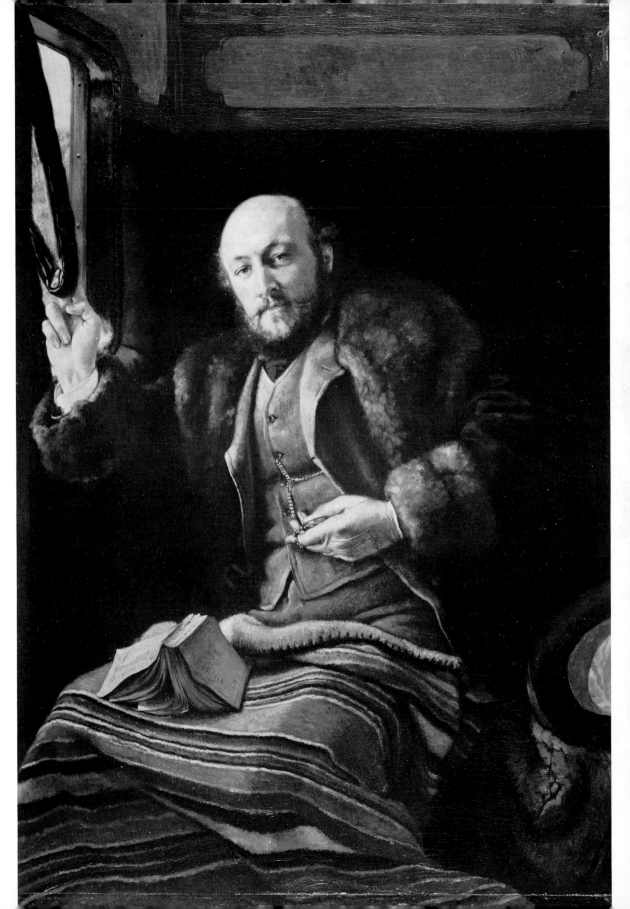

128
JAMES JACQUES
JOSEPH TISSOT
(1836–1902):
*Gentleman in a railway
carriage*. Mid-1870s.
Panel, 25 × 17 in.
Worcester,
Massachusetts,
Worcester Art
Museum

An upper level of
society in the 1870s
is represented by
Tissot's gentleman in
a railway carriage
(in the picture
probably originally
entitled *La première
classe*). The artist
gives pointed
emphasis to the
richness of the fur-
trimmed overcoat,
the concern for
comfort indicated by
the travelling rug
and the air of
aristocratically
restrained impatience
with which the
gentleman appears
about to measure
the performance of
the train by the watch
in his gloved hand.

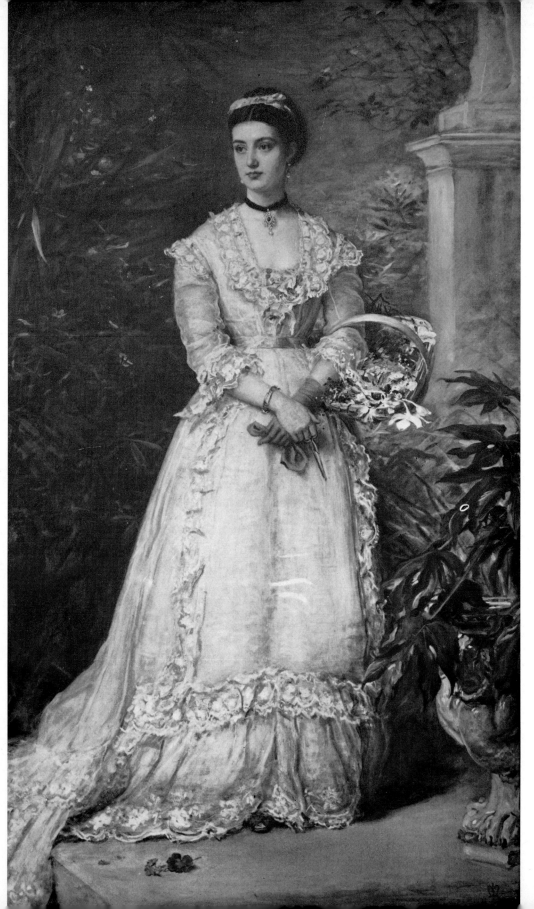

129

SIR JOHN EVERETT MILLAIS (1829–96): *Amy, Marchioness of Huntly*. 1869–70 (exhibited 1870). Canvas, 88 × 52 in. Collection of the Marquess of Huntly

In this portrait Millais arrived at a delightfully natural effect through the simplicity and lack of formality in composition. It is one of two portraits he painted in 1869, giving an incidental comment on his manner of life: they caused him to stay a month later in London than usual but by September he was able to resume his sporting routine and go deer stalking in the Highlands. Millais painted this portrait of Amy, daughter of Sir William Cunliffe-Brookes, Bt., at the time of her marriage to Charles, eleventh Marquess of Huntly.

JAMES JACQUES JOSEPH
TISSOT (1836–1902): *Still on
top*. About 1873–4.
Canvas, 34 × 21 in. Auckland,
Auckland City Art Gallery

Tissot several times made
decorative use of flags in the
period 1873–5, to which this
picture belongs. They suggest
some gala occasion, though
it is not known whether the
title was original or to
what event it might refer.
The setting was Tissot's
garden in London at 17
Grove End Road. The three
figures were repeated in
another of his pictures of
similar type.

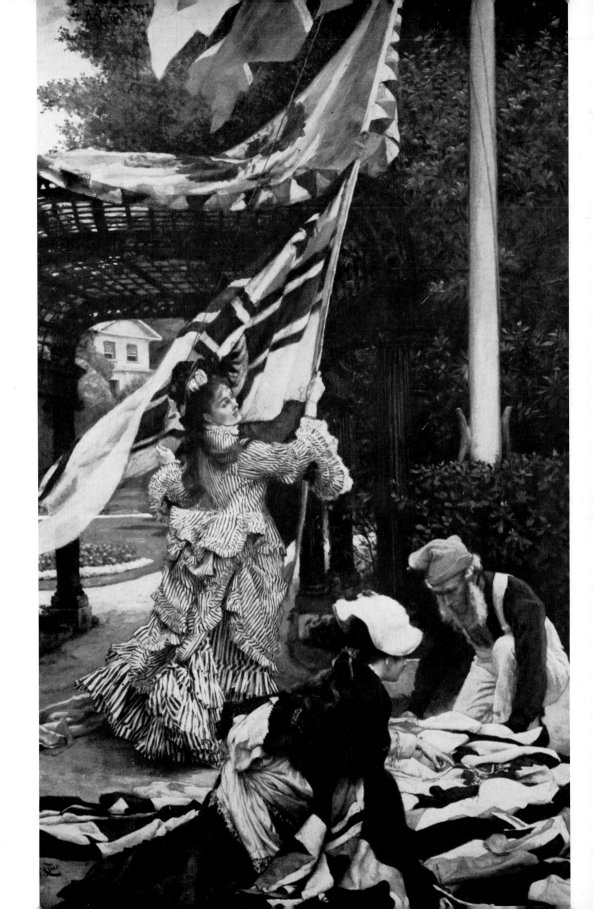

132 SIR JOHN EVERETT MILLAIS (1829–96):
Thomas Carlyle (*detail*). 1877. Canvas.
London, National Portrait Gallery

131 GEORGE FREDERIC WATTS
(1817–1904): *Thomas Carlyle*. 1868.
Canvas, $25\frac{1}{2} \times 20\frac{1}{2}$ in. London,
Victoria and Albert Musuem

133
JAMES ABBOT McNEILL
WHISTLER (1834–1903):
*Arrangement in grey and black,
no. 2: Thomas Carlyle.*
1872–3. Canvas,
$67\frac{3}{8} \times 56\frac{1}{2}$ in. Glasgow,
City Art Gallery and
Museum

An illuminating difference of approach and result is presented in these three
portraits of Thomas Carlyle (1795–1881). Watts, it seems, was nervously aware of
Carlyle's dislike for sitting and though he sought to give the impression of his
sitter's nobility and goodness, evoked the comment, 'You have made me look like
a mad labourer.' George Meredith, however, thought Carlyle had been accurately
portrayed with 'the look of Lear encountering the storm on the Cornish coast'.
Millais painted his realistic likeness with practised facility in three sittings. The
spectator may be less conscious of the sitter's personality in Whistler's version than
of the care for decorative placing derived from the Japanese print and the strength
and simplicity of silhouette inspired by Velazquez.

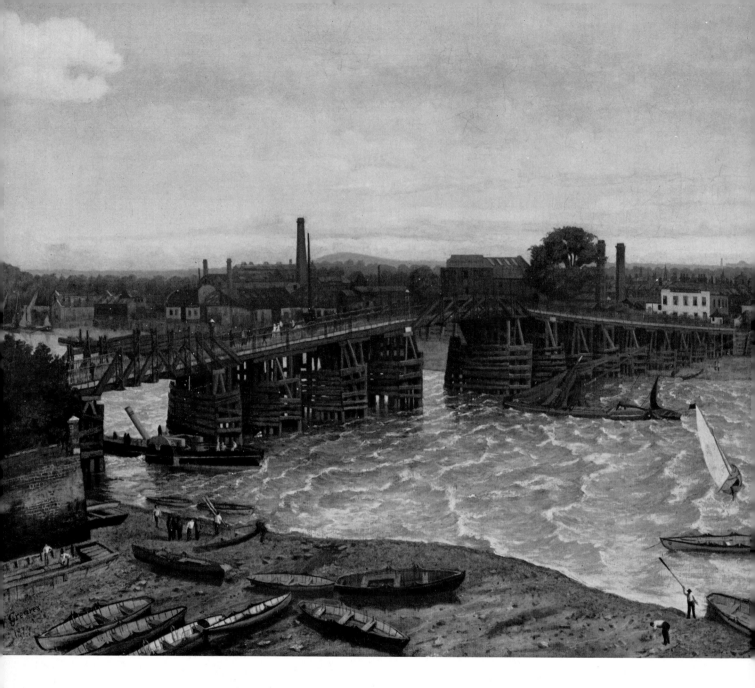

134 WALTER GREAVES (1846–1930): *Old Battersea Bridge*. 1874. Canvas, 23 × 30 in. London, Tate Gallery

135 JAMES ABBOT McNEIL WHISTLER (1834–1903): *Nocturne in blue and gold: Old Battersea Bridge (detail)*. About 1872–5. Canvas, 26¾ × 20 in. London, Tate Gallery

Opinions have varied considerably from one time to another as to the relative merits of Whistler and Walter Greaves. Greaves was long regarded as no more than the humble assistant who gained a modest degree of competence in painting by dint of imitating Whistler and as a result of Whistler's instruction. A different view was expressed by Walter Sickert at the time of the exhibition that at last brought Greaves into the limelight in 1911. 'A great master', was Sickert's enthusiastic description. That Greaves had an originality of his own is shown in the difference between the local attachment he evinces for Chelsea Reach and Whistler's more abstract approach.

A wide experience and sophisticated background of theory in the art of Whistler not only differentiate him from Greaves but contributed to give him a highly individual position in nineteenth-century art. His *Old Battersea Bridge* is a unique masterpiece.

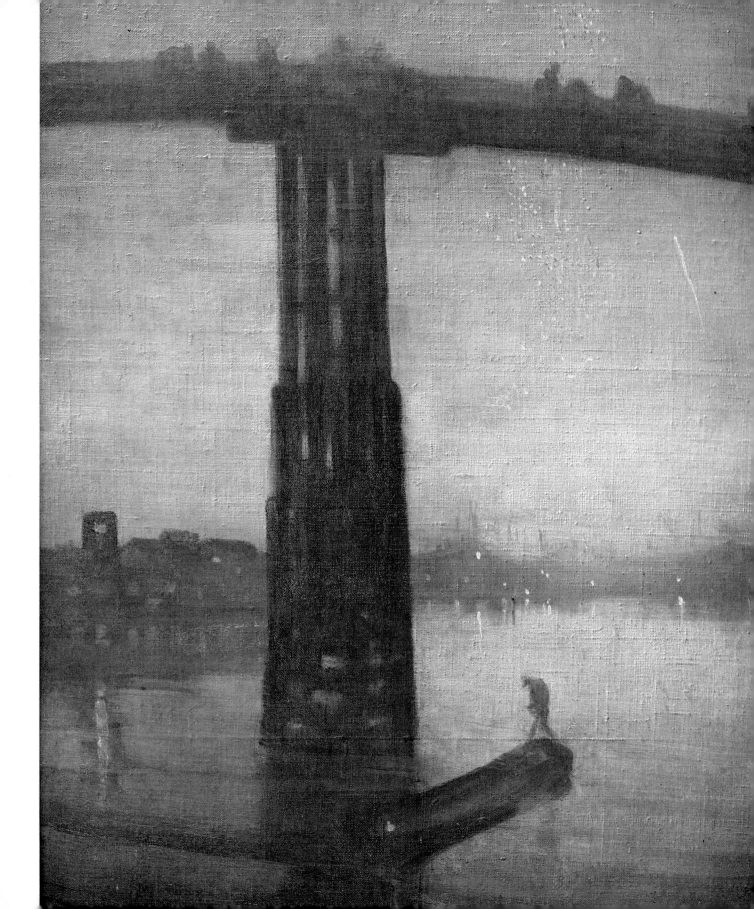

136 ALBERT JOSEPH MOORE (1841–93): *Reading aloud*. 1884. Tempera on paper on canvas, 42¼ × 81 in. Glasgow, Art Gallery and Museum

In contrast with most of his contemporary English painters, Albert Moore displayed no interest in story telling or the portrayal of everyday life. His standpoint was aesthetic in being concerned exclusively with classic beauty of feature and the graceful folds of classic garments, though not with the classical world in any more precise way. His picture titles accordingly introduce no name or subject of antique fable or history and are as simple and uncommunicative as *Reading aloud*.

137 SIR LAWRENCE ALMA-TADEMA (1836–1912): *The favourite poet*. 1888. Canvas, 15 × 20 in.
Port Sunlight, Lady Lever Art Gallery

Unlike Albert Moore's work, the title of Alma-Tadema's picture, *The favourite poet*, promptly
announces a story element. In spite of all the accessories of architecture and costume in which
he recalls the classical world and shows a considerable attainment in archaeology, he conveys,
in this ancient guise, ways of thought and behaviour by no means strange to the late Victorian
period and with a popular appeal not so different from that of paintings of contemporary genre.

138 JOHN SINGER SARGENT (1856–1925): *Paul Helleu sketching with his wife*. 1889.
Canvas, 26 × 32 in. New York, Brooklyn Museum

Sargent's inclination towards Impressionism was evident in the pleasure he took in painting
in the open air and in depicting others doing likewise, as in this picture of his close friend
Paul Helleu, the French painter and etcher, with his wife. He employed a lighter range of
colour than in his portraits. These outdoor works also included a painting of Claude Monet at
his easel and a watercolour of his sisters sketching.

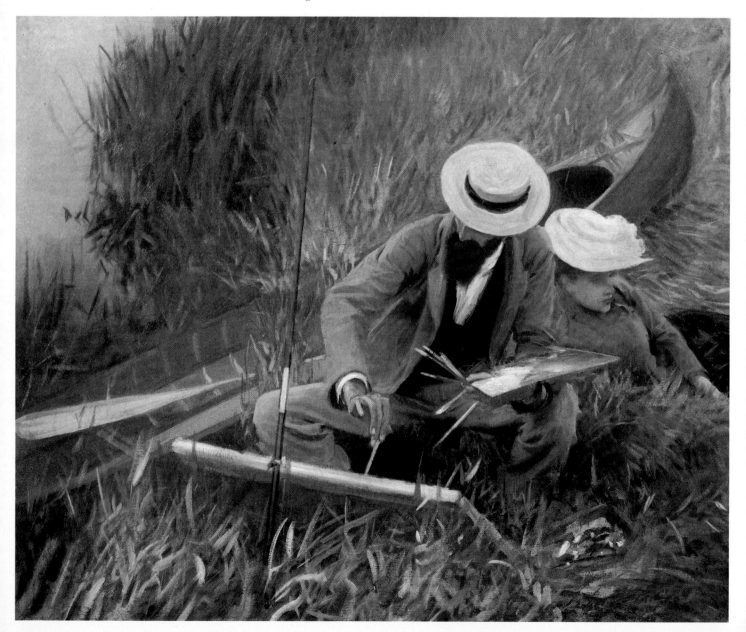

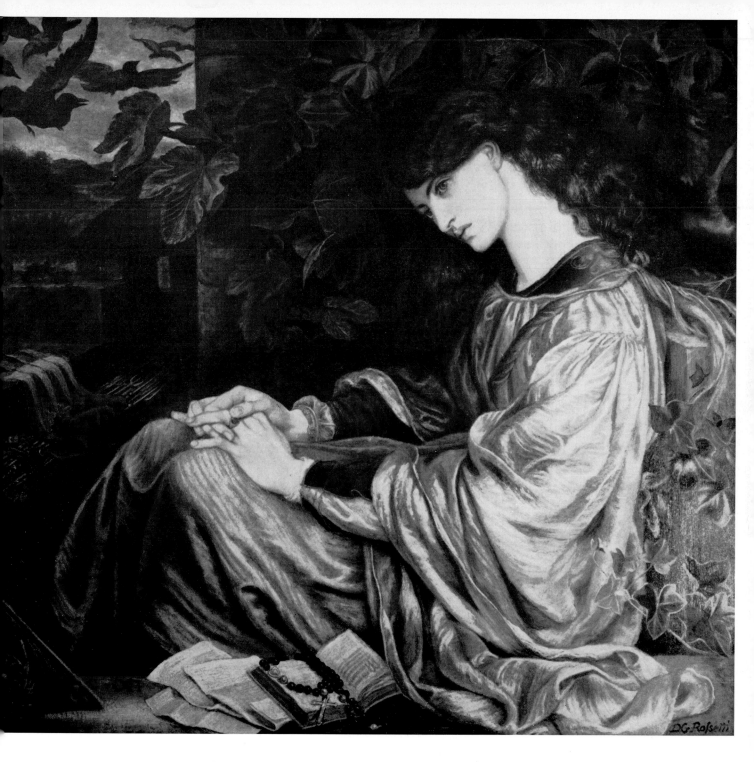

139 DANTE GABRIEL ROSSETTI (1828–82): *La Pia de' Tolomei*. 1881. Canvas, 41½ × 47½ in. Lawrence, Kansas, University of Kansas Museum of Art

One of the many contrasts afforded by Victorian painting appears between Sargent's direct view of externals and the brooding mysticism of Rossetti in this work. The subject of Rossetti's painting is taken from the passage in the fifth Canto of the *Purgatorio*, where Dante describes his meeting with Pia de' Tolomei, 'called Piety', daughter of a Sienese family, reputedly murdered by her husband and so placed by Dante among the unshriven victims of sudden and unforeseen death. The sitter was Jane Morris.

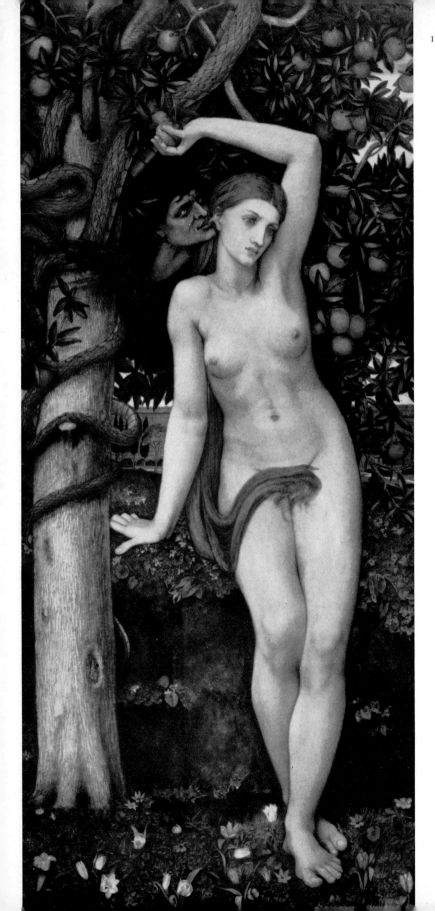

140 JOHN RODDAM SPENCER STANHOPE
(1829–1908): *Eve tempted*. Exhibited 1877.
Canvas, $63\frac{1}{2} \times 29\frac{3}{4}$ in.
Manchester, City Art Gallery

Spencer Stanhope represents a late stage of
Pre-Raphaelitism, in which the mystical passion
of Rossetti was changed into gentle and wistful
allegory. The human figure as Spencer
Stanhope depicts it might be described in Walter
Pater's phrase as 'frail and androgynous'. The
nude, never a conspicuous factor in
Pre-Raphaelite painting, has an almost
medieval timidity.

141 SIR EDWARD BURNE-JONES
(1833–98): *Tree of forgiveness.*
1882. Canvas, 75 × 42 in. Port
Sunlight, Lady Lever Art
Gallery

Burne-Jones here seems to
endeavour to correct the languid
asexuality of late Pre-Raphaelite
allegory by reference to great
Renaissance example. Phyllis,
daughter of the King of Thrace,
is made almost voluptuous in her
despairing love for Demophoön,
son of Theseus. The reluctant
Demophoön is cast in the heroic
mould of the figures by
Michelangelo that Burne-Jones
studied in the Sistine Chapel.

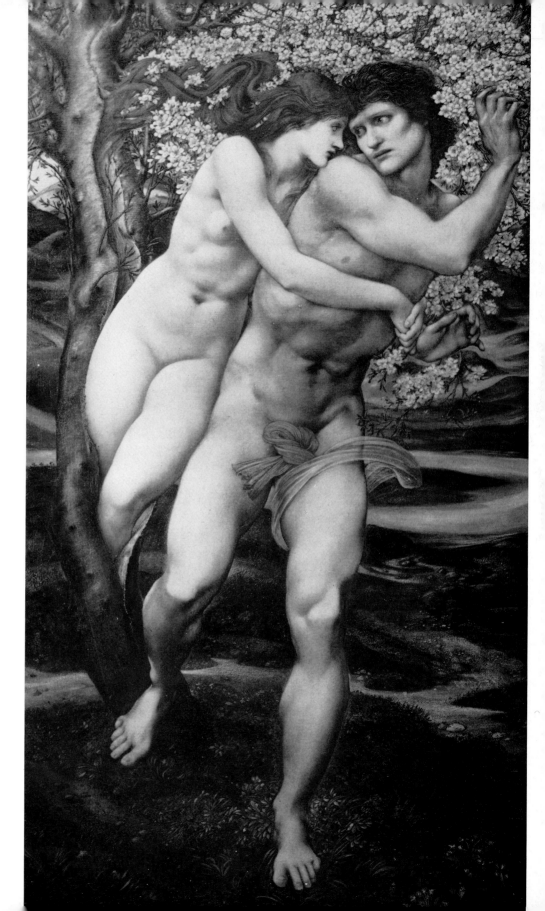

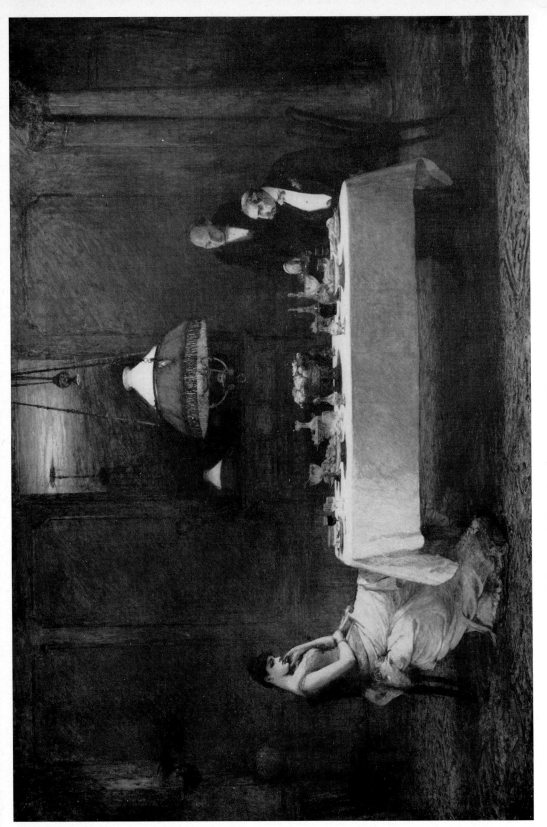

142 SIR WILLIAM QUILLER ORCHARDSON (1832–1910): *Le mariage de convenance*. 1883.
Canvas, $41\frac{1}{4} \times 60\frac{3}{4}$ in. Glasgow, Art Gallery and Museum

The troubles, marital and otherwise domestic, of the wealthy in the 1880s provided
Orchardson with an alternative genre to his historical costume pieces. The favoured setting
was a spacious interior, but here there is also a decided psychological implication in the
distance between the lady and the gentleman. The genre was little amenable to purely
aesthetic appraisal, the spectator being invited to form his own idea of the relation or dispute
between the figures portrayed. In thus posing a problem, the picture could be regarded as the
last refinement of pictorial anecdote.

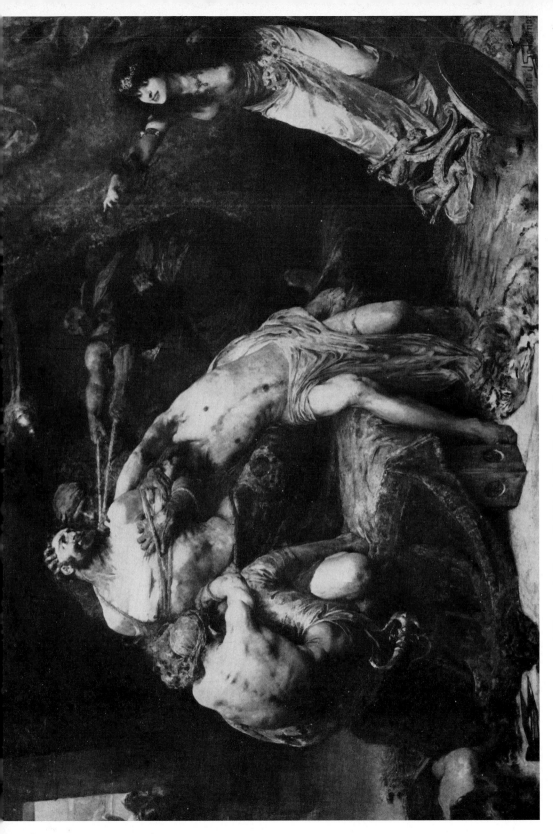

143 SOLOMON JOSEPH SOLOMON (1860–1927): *Samson*. Exhibited 1887. Canvas, 96 × 144 in.
Liverpool, Walker Art Gallery

The contrasts observable in painting in the nineteenth century were accentuated during the
later years. It is surprising to find in the same decade Orchardson's picture of high society and
its Victorian accessories portrayed with precise realism; and the fierce and almost baroque
energy that Solomon J. Solomon infused into his Biblical subject of Samson being delivered
into the hands of the Philistines through the treachery of Delilah. The differences of matter
and manner obscure the link that might be discovered in the pronouncedly illustrative
character of both works.

144 & 145 WILLIAM POWELL FRITH (1819–1909): *The private view at the Royal Academy.* 1881. Canvas, 40½ × 77 in. Collection of Mr C. J. R. Pope

Painted when Frith was in his sixties, this work shows no falling off in his ability to handle a large and detailed composition. His aim was to present the portraits of the persons eminent in various walks of life who, in the 1880s—more perhaps than at any other time before or since—were almost inevitably assembled at the Royal Academy Private View. Here are Gladstone, Browning, Huxley, Tenniel, Du Maurier, Leighton, Millais, Henry Irving, George Augustus Sala, Ellen Terry and Lily Langtry. Frith had the secondary aim of satirizing what he described as the 'aesthetic craze'. In contrast with Anthony Trollope, pictured as a no-nonsense man of letters, he introduced near by, 'a well-known apostle of the beautiful, with a herd of eager worshippers surrounding him'—i.e. Oscar Wilde, though Frith did not refer to him by name. The general decorum of the assembly lessens the intended difference between Aesthetes and Philistines.

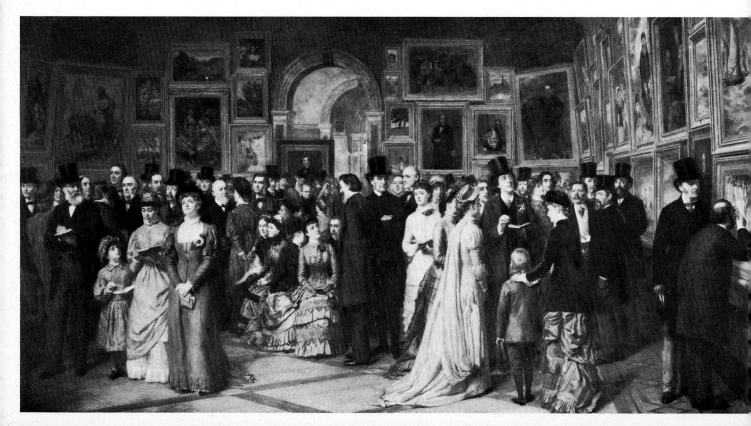

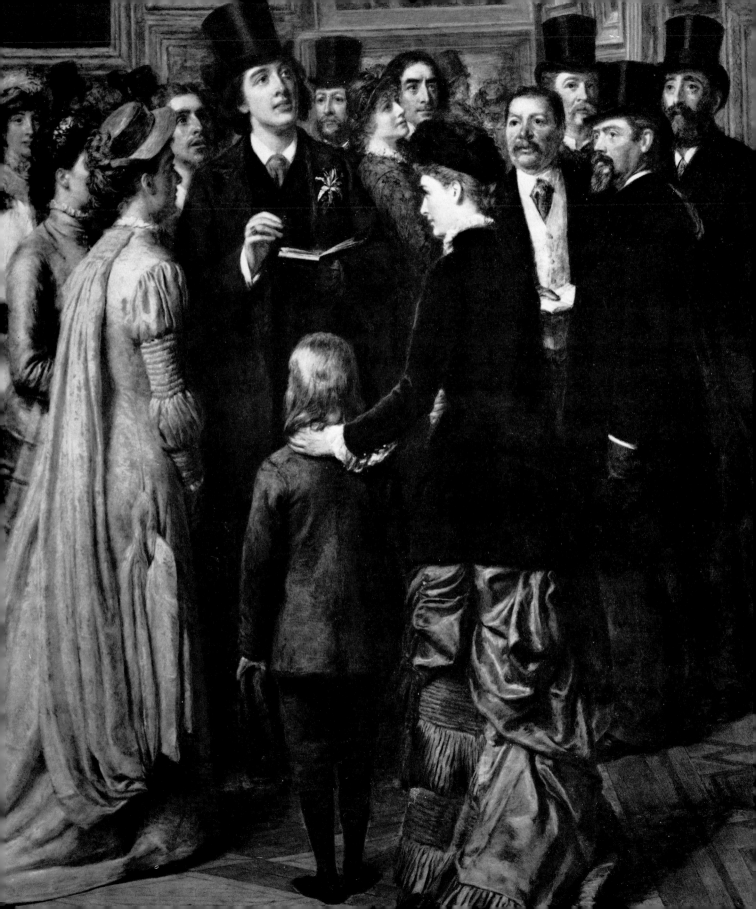

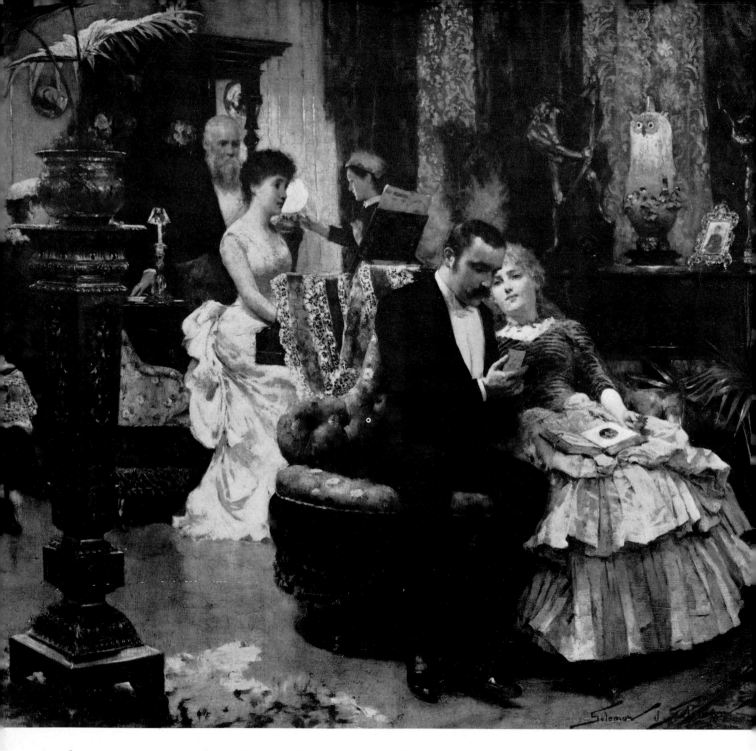

146 SOLOMON JOSEPH SOLOMON (1860–1927): *Conversation piece* (*detail*). 1884. Canvas, 40 × 50 in. London, Leighton House

147 (*opposite*) BRITON RIVIERE (1840–1920): *Sympathy*. 1877. Canvas, 48 × 40 in. London, Royal Holloway College

The paintings of the later Victorian years give an idea of social life that could not otherwise be acquired. The 'conversation piece' of Solomon is an instance, a document rather than a work of art but veracious in character and in such detail as the 'sociable' that permitted the informal conversation between the sexes.

Riviere's *Sympathy*, if liable to cause an aesthetic qualm, is a truthful enough indication of the sentimental taste of the period.

148 JOHN O'CONNOR (1830–89): *St Pancras Hotel and Station*. 1884. Canvas, 36⅛ × 60⅛ in. London, The London Museum

149 (*opposite*) ATKINSON GRIMSHAW (1836–93): *Piccadilly by night*. 1885–8. Canvas, 29½ × 24½ in. Private Collection

Painters responded to the homeliness of London in the late Victorian period, the heaviness of atmosphere that, whatever its other drawbacks, made for a warm depth of colour, the softened outlines of buildings, the comfortable glow of gas lamps and the moderate pace of traffic. O'Connor brings out romantically the slatternly bustle beneath the fantastic spires of St Pancras.

Grimshaw, during the years he lived in London, painted the metropolis by night with all the feeling he had earlier devoted to the docklands of Liverpool and Hull. It was then that he became acquainted with Whistler, who is quoted as remarking, 'I considered myself the inventor of nocturnes until I saw Grimmy's moonlit pictures.'

150

GEORGE FREDERIC
WATTS (1817–1904):
Oil sketch for *Mammon*.
1884–5. Canvas,
21 × 12½ in. Compton,
Watts Gallery

151

(*opposite*) GEORGE
FREDERIC WATTS:
Cardinal Manning. 1882.
Canvas, 35½ × 27½ in.
London, National
Portrait Gallery

Watts found an alternative
to the grand manner of
the past in a personal
effort to place painting on
a lofty level. His allegories
were sometimes marred
by an obtrusively pointed
moral but *Mammon*,
symbol of all those
materialistic considera-
tions outside Watts's
idealistic view of life, has
an impressive brutality.
The final version of this
oil sketch is in the Tate
Gallery.

The tensions of a high
plane of intellectual and
moral existence variously
appear in his portraits of
great contemporaries and
may be discerned in his
Cardinal Manning.

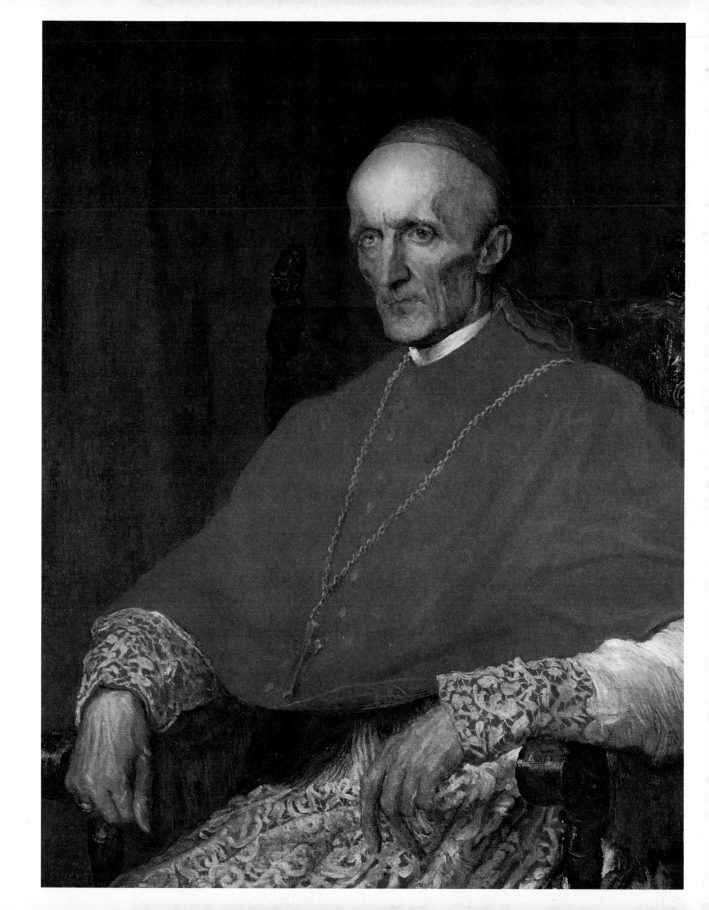

152 & 153
SIR JOHN EVERETT MILLAIS
(1829–96): *William Gladstone.*
1858. Panel, 25 × 21½ in.
London, National Portrait Gallery

The portrait of Gladstone was one
of the most impressive renderings
of character in Millais's later
work. There seems to have been
a sympathetic understanding
between the two. Gladstone
admired the painter's power of
concentration and the intense
devotion to work that was a
cardinal Victorian virtue.
According to Millais's son, his
father was well able to engage
the interest of his sitter while
apparently absorbed in the
process of painting. Gladstone
was described as not only an
ideal sitter but an entertaining
companion on subjects as various
as Florentine painting and early
Scottish history.

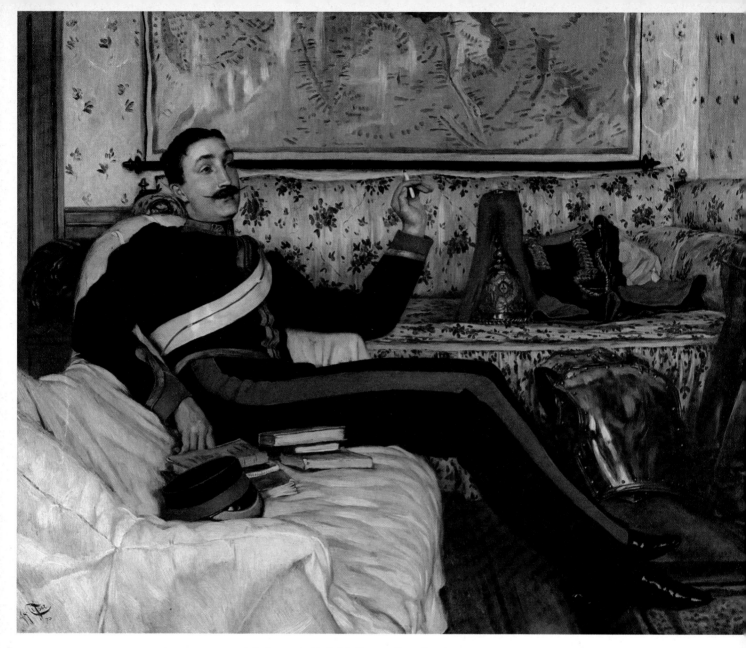

154 JAMES JACQUES JOSEPH TISSOT (1836–1902): *Frederick Gustavus Burnaby*. 1870.
Panel, 19½ × 23½ in. London, National Portrait Gallery

Tissot's portrait of the cavalry officer, Frederick Burnaby (1842–85), suggests a nineteenth-century Frenchman's idea of a typical Englishman in the exaggeration given to the languid pose and the air of apparent vacuity. But this appearance disguised a fascinating and colourful character. Commissioned into the Royal Horse Guards in 1859, his capacity for feats of endurance and adventure took Burnaby in 1870, the year the portrait was painted, across Russia to explore its little-known southeastern regions. He was a *Times* correspondent with the Carlists in Spain in 1874, crossed the English Channel in a balloon in 1882, and participated, without official leave, in the Suakin campaign of 1884 and in the Gordon relief expedition of 1885. He died from a spear wound at Abu Klea in January 1885.

155 JOHN SINGER SARGENT (1856–1925): *Robert Louis Stevenson and his wife.* 1885.
Canvas, 20½ × 24½ in. United States, Collection of Mr and Mrs John Hay Whitney

Exaggeration of pose of another kind gives a particular distinction to Sargent's portrait of
Robert Louis Stevenson and his wife. It was painted in the Stevensons' dining room at
Skerryvore, Bournemouth. In a letter to Will Low dated 22 October 1885, Stevenson wrote:
'Sargent was down again and painted a portrait of me walking about in my own dining-room,
in my own velveteen jacket, and twisting as I go my own moustache. . . . It is, I think, excellent,
but it is too eccentric to be exhibited. I am at one extreme corner; my wife, in this wild dress,
and looking like a ghost, is at the extreme other end; between us an open door exhibits my
palatial entrance hall and a part of my respected staircase. All this is touched in lovely, with
that witty touch of Sargent's; but, of course, it looks dam queer as a whole.'

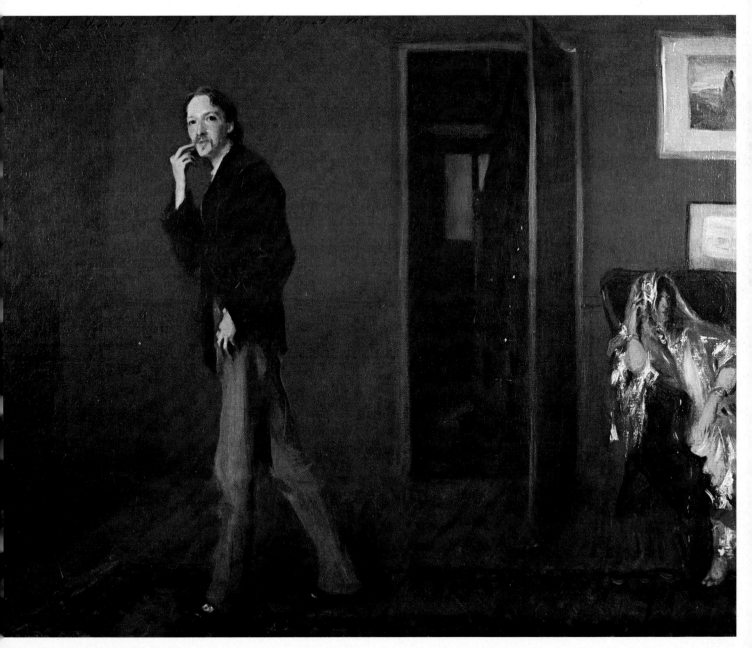

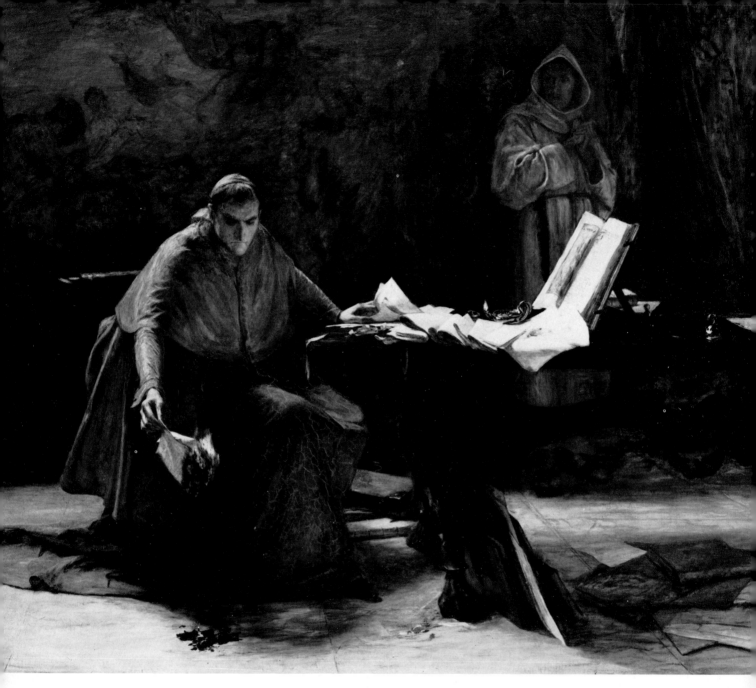

156 JOHN PETTIE (1839–93): *A state secret*. 1874. Canvas, 48×64 in. London, Royal Holloway College

157 (*opposite*) GEORGE SMITH (1829–1901): *Sleeping boots boy*. About 1880. Canvas, 14×12 in.
London, South London Art Gallery

The story element in a work such as Pettie's *State secret* is liable to different forms of appraisal. It
may be regarded as an entertainment, in the same way as a chapter from an historical novel. It
may on the other hand be criticized as an invasion of a field properly belonging to literature and as
losing sight of the essential independence of form and colour properly belonging to painting.

The swing of the century's pendulum is seen again in the difference between the historical
anecdote and the glimpse of everyday life afforded by Smith's *Sleeping boots boy*, though an
illustrative element in both appears in the references to happenings 'off stage'.

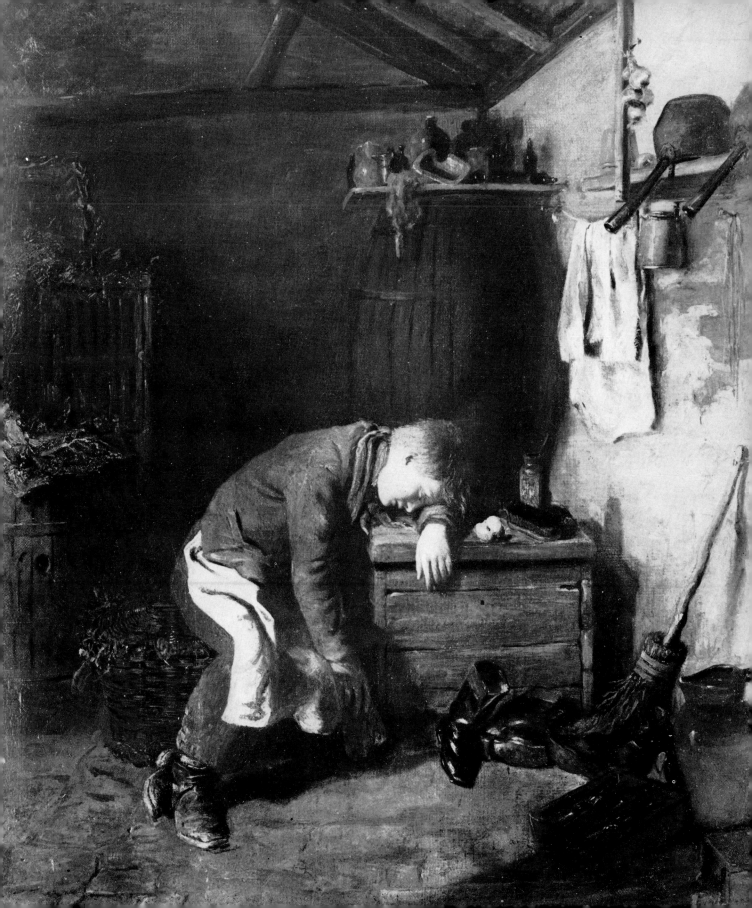

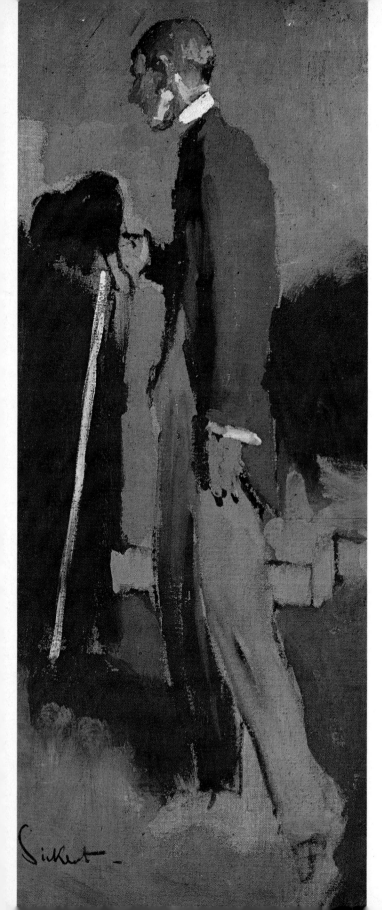

158 WALTER RICHARD SICKERT (1860–1942):
Aubrey Beardsley. 1894. Canvas, 30 × 12¼ in.
London, Tate Gallery

Slimness of figure in the portraits of the 1890s
seems to have been given special attention as a
mark of the distinction or elegance belonging to
the *fin de siècle*. The thin figure of Aubrey
Beardsley as portrayed by Sickert sympathetically
evokes Beardsley's elegance of draughtsmanship.

Whistler gained from his study of Velazquez a
special feeling for the dignity of the full-length,
well exemplified in his portrait of F. R. Leyland,
who was owner of the Leyland Shipping Line as
well as a collector, accomplished musician and a
patron of art.

Slender grace is stylized in Burne-Jones's
portrayal of the Countess of Plymouth.

159 JAMES ABBOT MCNEILL WHISTLER (1834–1903):
Arrangement in black: F. R. Leyland. 1873.
Canvas, 75⅞ × 36¼ in. Washington, D.C., Freer
Gallery of Art

160 SIR EDWARD BURNE-JONES (1833–98): *The
Countess of Plymouth.* 1893. Canvas, 78½ × 37 in.
The Earl of Plymouth (on loan to The National
Museum of Wales, Cardiff)

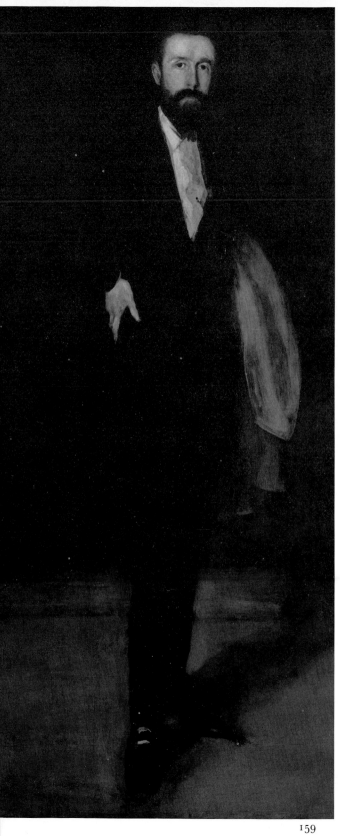

159 160

161 SIR FRANK DICKSEE (1853–1928): *Funeral of a viking*. 1893. Canvas, 72½ × 119¼ in.
Manchester, City Art Gallery

The difference between imaginary history and what is represented as having a basis of fact is not
always clearly drawn in nineteenth-century paintings. There may never have been such a scene
as Dicksee paints; although detail is circumstantial, the gusto of action comes entirely from the
artist's imagination.

162 SIR EDWARD BURNE-JONES (1833–98): *Beguiling of Merlin (detail)*. 1874. Canvas, 73 × 43 in.
Port Sunlight, Lady Lever Art Gallery

The sources of Burne-Jones's works were various, including medieval ballads, classical myths,
the poems of Chaucer and Spenser and, in particular, the Arthurian legend. His consciously
aesthetic style reflects the medievalizing influence of Rossetti and the idealistic design of
William Morris. His *Beguiling of Merlin* is one of his most complete and forceful compositions.

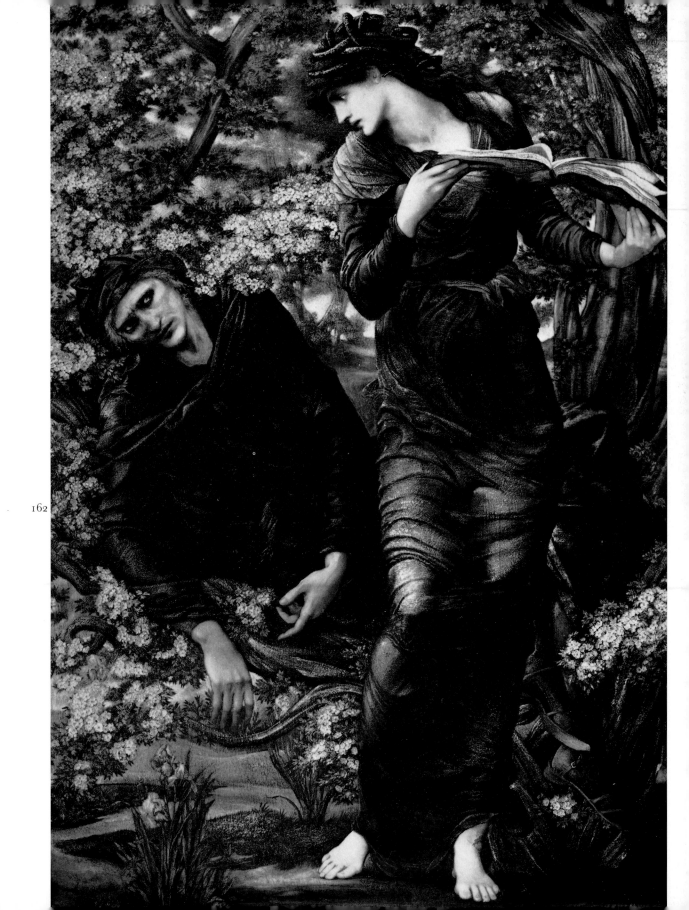

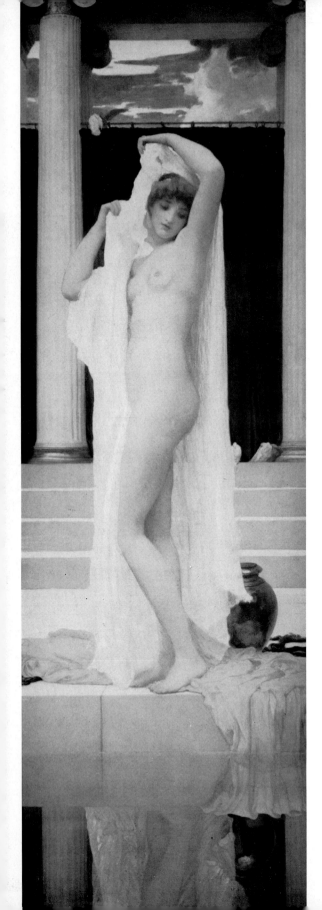

163 FREDERIC, LORD LEIGHTON (1830–96): *The bath of Psyche*. 1890. Canvas, $74\frac{1}{2} \times 24\frac{1}{2}$ in. London, Leighton House (on loan from The Tate Gallery)

In an age otherwise prudishly inclined, paintings of the nude found sanction as a vehicle of classical ideas and ideals, preferably in association with a setting of classical columns and Pentelic marble. There are many examples in the work of Leighton, whose polished academic style is typically represented in *The bath of Psyche* (in 1890 a purchase for The Tate Gallery under the terms of the Chantrey Bequest). The life-size figure of Psyche was described by an admiring biographer as a 'suave conception . . . informed with a spirit of perfect chastity'.

164 PHILIP WILSON STEER (1860–1942): *Nude sitting on a bed*. 1896. Canvas, 37 × 43 in.
Private Collection

Steer, in a manner entirely dissimilar to that of Leighton, though in the same decade, applied
himself to a similar subject. But French realism had left an impression on him, and this lively
study for the *Toilet of Venus* (London, Tate Gallery) was described in the words of his
biographer, D. S. MacColl, as a 'rather pert nude with a far-away, family likeness to
Manet's *Olympia*'.

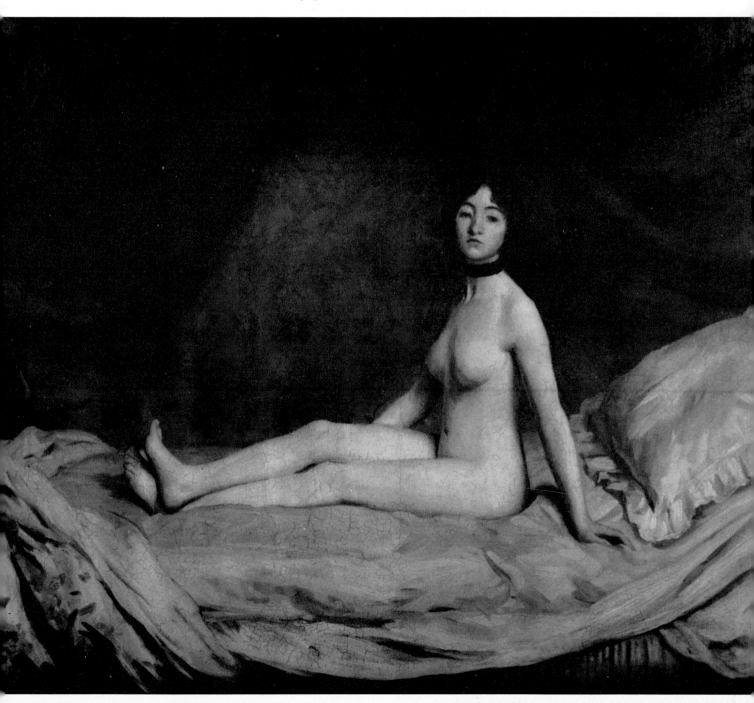

166 AUBREY VINCENT BEARDSLEY (1872–98): *Caprice*. About 1894. Canvas, 30 × 25 in.
London, Tate Gallery

There is once more a sharp contrast in turning from *A wedding morning* to that sophisticated
world that was Aubrey Beardsley's special creation. Said to be his only oil painting, *Caprice*
displays the bold, simplified sense of linear pattern and decadent refinement of sensation
that characterize his graphic brilliance in black and white.

165 JOHN HENRY F. BACON (1868–1914): *A wedding morning*. 1892. Canvas, 46 × 64 in.
Port Sunlight, Lady Lever Art Gallery

The genre picture that had passed through several phases since the beginning of the century—
peasant humours, bourgeois solemnities, working-class tribulations—had another variant in
the 1890s in the realistic treatment of a respectable level of lower-middle-class life, as in this
painting by John Bacon.

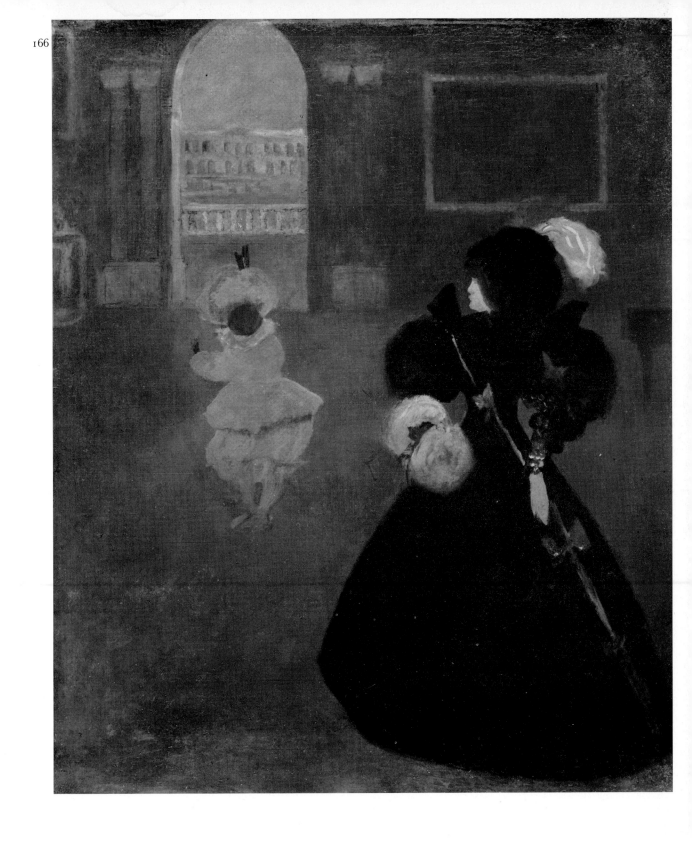

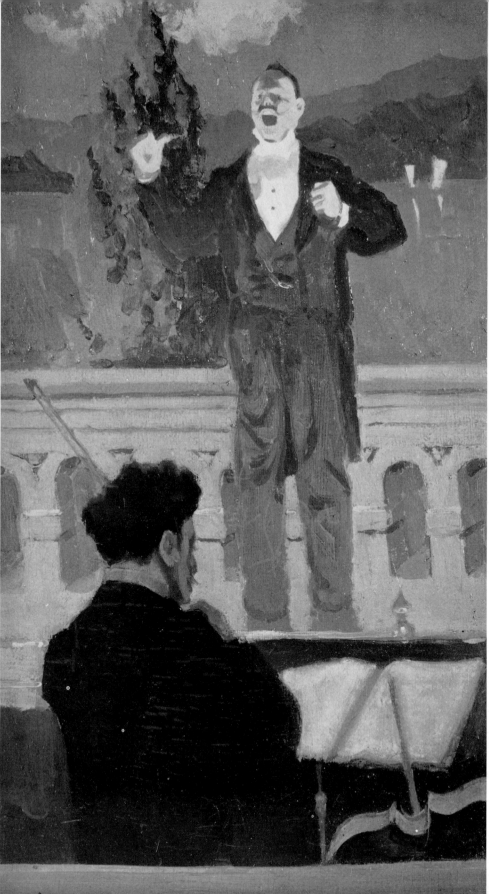

167

WALTER RICHARD SICKERT
(1860–1942): *The mammoth comique*.
About 1887. Canvas, 19½ × 11½ in.
Collection of Lord Cottesloe

Although Sickert was assistant to
Whistler in the 1880s and instructed
by him in etching, he was more
influenced in painting by Degas and
that French master's liking for the
theatre as a subject. In reaction to
Whistler's abstract refinements and
with implicit encouragement from
Degas to look on art as 'dealing
joyously with gross material facts',
Sickert found a particular relish in
the London music-hall and its
characters such as the 'comic lion'
of this work. The relation of the
silhouetted violinist and stage and
the tilt of lighting recall Degas's
Ballet scene from 'Robert le Diable'
(London, Victoria and Albert
Museum).

168

WALTER RICHARD
SICKERT (1860–1942):
The Old Bedford. 1897–8.
Canvas, 50 × 30½ in. Ottawa,
National Gallery of
Canada

Sickert had a great affection
for the rococo gilt and the
cockney audience of the Old
Bedford Music-hall in
Camden Town, the favourite
hall of Marie Lloyd, also
known as the Family
Theatre. It has gained a
permanent celebrity in
Sickert's paintings and
etchings, the result of
countless sketches made on
nightly visits. The Old
Bedford burned down in
1899, not long after Sickert
painted this version.

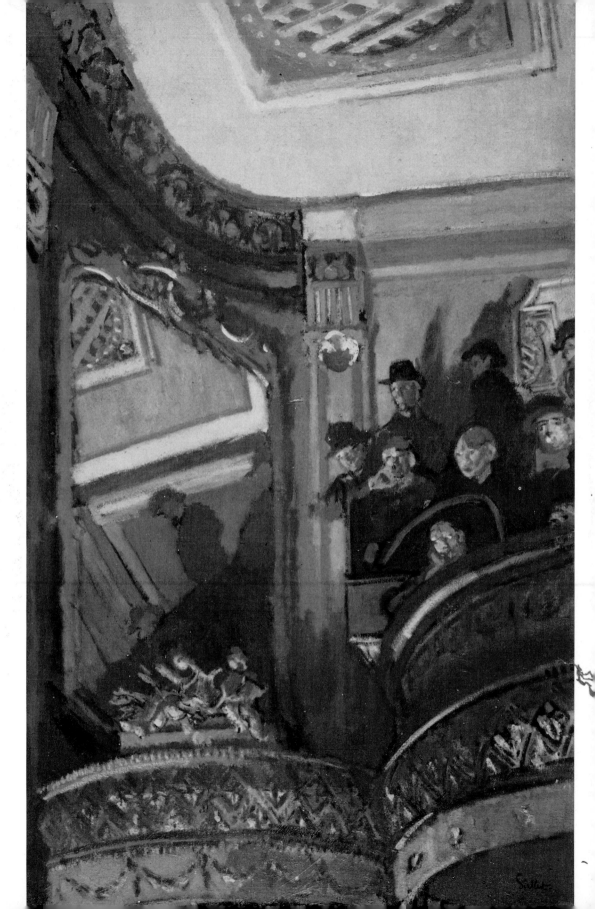

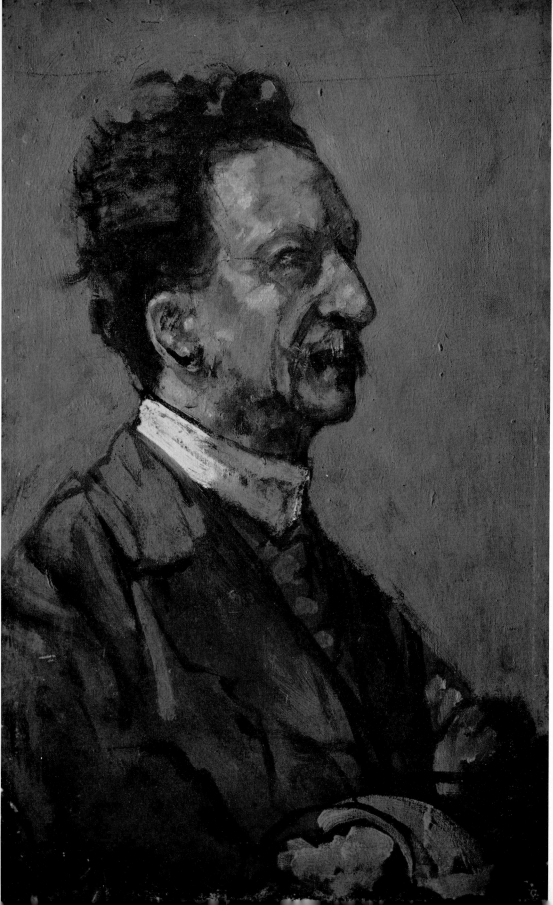

WALTER RICHARD
SICKERT (1860–1942):
Fred Winter. 1898.
Canvas, 25½ × 14½ in.
Washington, D.C., The
Phillips Collection

Sickert shared the
unconventional attitude
of the Impressionists to
portraiture, seeking for
the unstudied rather than
the deliberately posed
effect and using accents of
light and colour to give
animation instead of a
fixity of contour.

169

170

JOHN SINGER SARGENT
(1856–1925): *Beatrice
Townsend.* About 1882.
Canvas, 32½ × 23 in.
United States, from the
Collection of Mr and
Mrs Paul Mellon

The grand manner of
portraiture, by no means
pompous or conventional
and attained with an
apparent ease, is here
exemplified in one of
Sargent's best portraits
of the last two decades of
the nineteenth century.
The sitter, who died in
1884 at the age of
fourteen, was the
daughter of John Joseph
Townsend and his wife
Catherine, Americans
living in London.

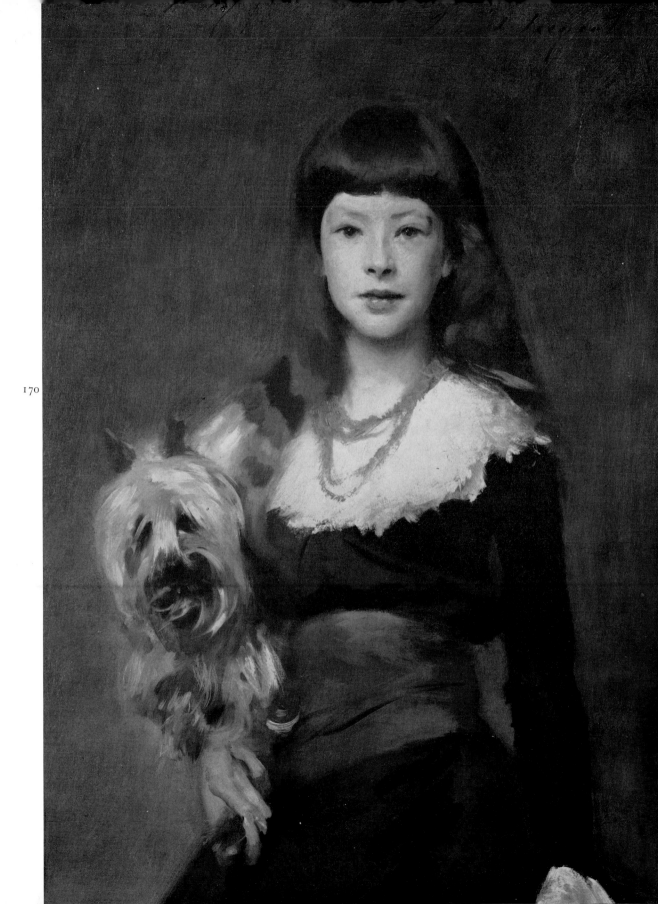

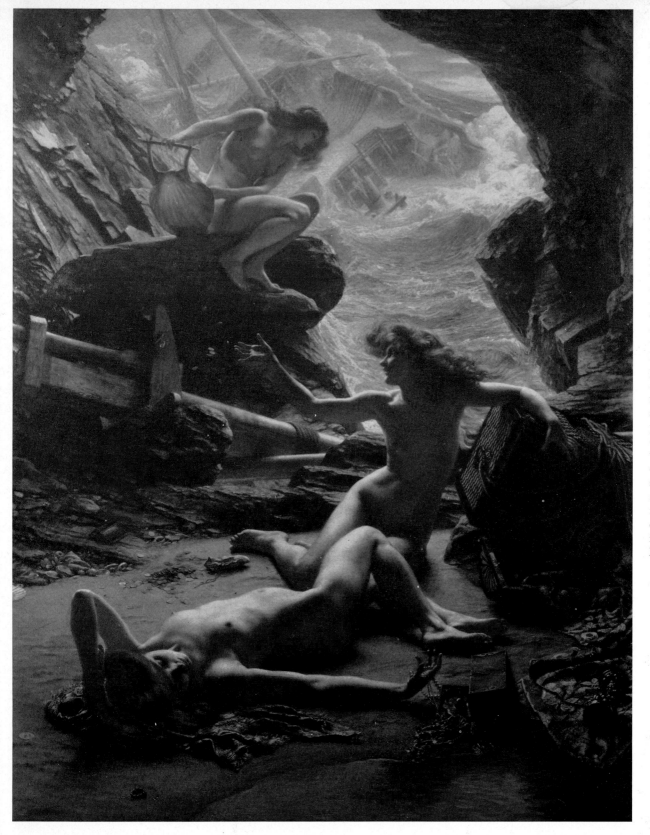

171
SIR EDWARD
POYNTER
(1836–1919):
*The cave of the
storm nymphs.*
1903. Canvas,
$57\frac{1}{2} \times 43\frac{1}{2}$ in.
Private
Collection

Poynter's
mastery of
figure
drawing,
which gave
him a
particular
eminence
among the
academic
draughtsmen
of his time,
was shown to
advantage in
paintings such
as this—the
final,
somewhat
playful
expression of
what had
earlier been a
serious
attempt to
revive the
classical
idiom of the
Renaissance.

ALMA-TADEMA, *Sir Lawrence*

Born in the village of Dronryp in Friesland on 8 January 1836, Lawrence Alma-Tadema studied art in Antwerp under Wappers and De Keyser and afterwards with Baron Leys. The influence of the Belgian historical school led him to paint scenes from various periods of history: first Merovingian; about 1863 Egyptian subjects; and about 1865 the classical subjects that remained his speciality. He came to live in England in 1869, when he exhibited *The Pyrrhic dance* (sharply criticized by Ruskin) at the Royal Academy. He was naturalized in 1873, elected A.R.A. in 1876, R.A. in 1879, and knighted in 1899. He received the Order of Merit in 1903. He died in Wiesbaden on 24 June 1912. Characteristic paintings are in the Tate Gallery, and the Victoria and Albert Museum has a large number of drawings by him and books from his library, 1,935 items in all, presented by a group of friends and admirers.

ATKINSON, *W. A.*

Very little is known about W. A. Atkinson other than that he lived in London and painted genre and historical pictures. He is documented from 1849 to 1867.

BACON, *John Henry F.*

Born in London in 1868, John Henry Bacon painted primarily domestic and genre scenes. He exhibited at the Royal Academy from 1889. His most famous work is *The City of London Imperial Volunteers return to London from South Africa on Monday, 29th October, 1900* (London, Guildhall). He died in 1914.

BEARDSLEY, *Aubrey Vincent*

Born in Brighton on 21 August 1872, Aubrey Vincent Beardsley, working mainly as a draughtsman, summed up the character of the 1890s in art with a comprehensive brilliance. A remaining Pre-Raphaelite influence, the decorative aspect of Whistler's art as represented by the Peacock Room, the Japanese print and its dynamic translation in the posters of Toulouse-Lautrec, the dandyism of the eighteenth century and its elegant souvenir in the work of Charles Conder—all contributed in turn to his eclecticism but became newly individual in result. Originally working in an architect's office and later for an insurance company in the City of London, Beardsley found his first opportunity in 1893 in illustrations for Messrs J. M. Dent's edition of *Morte d'Arthur*. In the same year an article on his work by Joseph Pennell in the first number of *The Studio* brought him the commission to illustrate the English edition of Oscar Wilde's *Salome*. In 1894 as art editor of *The Yellow Book* he made that new venture famous in its bold visual appeal, though the Wilde trial in 1895 caused the publisher, John Lane, to dispense with Beardsley's designs as too much of a challenge to convention. *The Savoy* was started as an alternative in 1896 and Beardsley entered now on his most fruitful period with his drawings for *The Rape of the Lock*, the *Rhinegold*, *Lysistrata*, Dowson's *Pierrot of the Minute*, Johnson's *Volpone* and Gautier's *Mademoiselle de Maupin*. The last two were published posthumously. Beardsley died of tuberculosis at Mentone on 16 March 1898.

BEECHEY, *Sir William*

Born in Burford, Oxfordshire, on 12 December 1753, William Beechey was one of the portrait painters who carried the eighteenth-century tradition forward into the new century. He entered the Royal Academy Schools in 1772 and worked in Norwich from about 1783 to 1786, afterwards settling in London. He was elected A.R.A. in 1793 and R.A. in 1798. In that year he was also knighted and appointed portrait painter to Queen Charlotte. He died in Hampstead on 28 January 1839.

BLAKE, *William*

Painter, engraver, poet and mystic, William Blake was born on 28 November 1757 at 28 Broad Street (later Broadwick Street), Golden Square, London. He went to Henry Pars's drawing school from the age of ten to fourteen and in 1771 was apprenticed to James Basire, engraver to the Society of Antiquaries, for whom he copied monuments in Westminster Abbey. His own work was influenced by this study of Gothic sculpture. In 1778 he entered the Royal Academy Schools and in 1780 contributed a small historical painting in watercolour, *The death of*

Earl Godwin, to the Academy exhibition, the first of twelve works exhibited there up to 1808. Acquaintance with John Flaxman, Henry Fuseli and Thomas Stothard led to their employing him as engraver and some exchange of influence in style.

In 1782 he married Catherine Boutcher, a market gardener's daughter, and in 1784 opened a shop as print-seller and engraver next door to the family house, with his brother Robert as assistant. He gave up the shop when Robert died in 1787 and from that time his work became more visionary in character. He lived with his wife, whom he taught to draw and colour, from 1793 to 1800 at Hercules Buildings, Lambeth, writing and engraving his lyrical poems and the 'prophetic' books in which he evolved a mythology of his own. To the conventional method of engraving with incised lines he added the system of relief etching revealed in a dream by Robert. The works produced by this method included the *Songs of Innocence* (1789) and the complementary *Songs of Experience* (1794). The long series of 'Prophetical Books' followed. Commissions included engraving Flaxman's designs for the *Odyssey*, designs for Young's *Night Thoughts* (1797) and Flaxman's commission for a set of designs to Gray's *Poems* (1797; rediscovered in 1919 and first publicly shown at the Tate Gallery, London, in 1971, after their purchase by Mr Paul Mellon). A helpful patron was Thomas Butts, who gave him an order for fifty small paintings at a guinea each. Blake had hopes of further patronage from the poet William Hayley, to whom Flaxman introduced him, but the interlude spent at Felpham near Bognor from 1800 to 1803 under Hayley's auspices proved sadly disappointing. Blake returned to London to fight a harder battle against adverse circumstances than before. Complex and obscure, the *Milton* and *Jerusalem* of 1804 were not works that invited a public though the illustrations of *Jerusalem* had unique magnificence. Blake's exhibition of 1809 was accompanied by a manifesto substantially directed against the oil medium and academic realism, and in favour of 'fresco'—his own form of tempera. The exhibition gained scant notice, and in poverty and obscurity Blake lived between 1809 and 1818, as he said, 'by miracle'. In 1818 he met John Linnell, who not only came to the rescue but was the means of enabling Blake to produce the marvellous engravings in illustration of the Book of Job and the 102 illustrations for *Dante* that occupied Blake until his death.

He died at 3 Fountain Court, London, on 12 August 1827. A small circle of devotees in his last years included Linnell, Samuel Palmer, Edward Calvert and George Richmond. His influence extended to Pre-Raphaelitism as represented by Dante Gabriel Rossetti.

BONINGTON, *Richard Parkes*

Born in Arnold, near Nottingham, on 25 October 1802, Richard Parkes Bonington was the son of a landscape and portrait painter (and former governor of Nottingham jail), who took him to France in 1817 when the family settled in Calais. Bonington first studied under the accomplished watercolourist, Louis Francia, in Calais and afterwards in Paris in the studio of Baron Gros. He copied in the Louvre and exhibited at the Salon from 1822, his contribution to the Salon of 1824 reinforcing the impression then made by John Constable. In 1826 he painted in Venice during a two months' stay in Italy and revisited England in 1825 and 1827, but most of his work was done in France. Landscapes in Normandy and on the French coast were among his principal paintings and were much admired by Delacroix and Corot. Delacroix was fascinated also by the watercolours of historical subjects that Bonington executed in the Romantic spirit of the time. He exhibited at the Royal Academy in 1827 and 1828. He died on 23 September 1828 in London.

BROWN, *Ford Madox*

Born on 16 April 1821 in Calais, where his father, a retired naval man, had gone to live, Ford Madox Brown went to Bruges to study art at the age of fourteen and later studied under Baron Wappers in Antwerp. He first exhibited at the Royal Academy in 1840 with a picture called *The giaour's confession* and in 1843 took part unsuccessfully in the competition for the decoration of the new Houses of Parliament. In 1845 a visit to Rome brought him into contact with the German Nazarene group. He was sought out after his return to England by the young Dante Gabriel Rossetti, who was informally his pupil for a short while. Through him Madox Brown became associated with the Pre-Raphaelite Brotherhood, founded in 1848, and though never counted as a member in the movement he was influenced by the outlook it generated and the idea of 'truth to nature'. Two of his principal paintings,

Work (1852–65; Plate 92) and *The last of England* (1855; Birmingham, City Museum and Art Gallery), show his Pre-Raphaelite sympathies. *Pretty baa-lambs* (1882; Oxford, Ashmolean Museum) was said to be his first picture painted in the open air. Other paintings showed more of the Romantic taste for the imagined historical or literary scene: an example is his *Chaucer at the Court of Edward III*, the large picture in Sydney, 1851, intended as a triptych with side panels depicting Shakespeare and Byron. From 1878 onwards he gave much time and effort to his twelve mural paintings for the Town Hall, Manchester, with themes of local and social history. He died in London on 6 October 1893.

BURNE-JONES, *Sir Edward Coley*

Born in Birmingham on 28 August 1823, of Welsh ancestry, Edward Coley Burne-Jones went from King Edward VI's Grammar School to Exeter College, Oxford, with a view to entering the Church. Together with his friend and fellow undergraduate William Morris, he became enthusiastic over the writings of Ruskin and the Pre-Raphaelite paintings they were able to see at Oxford. In 1856 Burne-Jones gained an introduction to D. G. Rossetti and was encouraged by him to take up art in earnest. Morris joined them and the three worked for a time in companionable fashion at 17 Red Lion Square. They cooperated at Oxford in 1857 in the attempt to decorate the debating hall (later the library) of the Oxford Union with frescoes. Chivalrous legend as in Malory's *Morte d'Arthur* became a theme in which Burne-Jones never lost interest, though as time went on he added religious and classical allegories to the imagined age of dedicated knights and strange enchantment. Visits to Italy and admiration for Renaissance masters had some effect on his style. In 1860 he was married to Georgiana Macdonald, a year after Morris married Jane Burden. From the 1860s onwards Burne-Jones's efforts were divided between painting and designs for Morris's firm and enterprises in craftmanship that included tapestry, stained glass, tiles and book decorations for the Kelmscott Press.

The visions of a dream world he contributed to the Grosvenor Gallery that opened in 1877 linked him with the aesthetic movement of the time. He was induced by Ruskin to give evidence against Whistler, another star of the Grosvenor Gallery, in the famous libel action of 1878. He was elected A.R.A. in 1886 (he resigned in 1893) and was made a baronet in 1894. He died in Fulham on 17 June 1898.

CALLCOTT, *Sir Augustus Wall*

Born in Kensington on 20 February 1779, Augustus Wall Callcott first took to musical studies like his brother, the musical composer Dr Callcott, but it is said that admiration for drawings by Thomas Stothard caused him to turn to visual art. He entered the Royal Academy Schools in 1797 and became a pupil of the fashionable portrait painter John Hoppner. Callcott painted portraits at first but later devoted himself to landscape and coast scenes. He was elected A.R.A. in 1806 and R.A. in 1810. He was knighted by Queen Victoria in 1837. He attempted some historical subjects in later years but was less successful with *Raphael and the Fornarina* and *Milton dictating to his daughters* than with landscapes. He died in Kensington on 25 November 1844.

CHAMBERS, *George*

Born in Whitby in 1803, George Chambers was a sailor's son and went to sea at the age of ten. His precocious talent was recognized, however, and he was allowed to devote himself to drawing and painting shipping scenes at Whitby while working as a house painter. He worked his way to London on a trading vessel and was employed for seven years in painting the panorama of London at the Colosseum, Regent's Park. He was also a scene painter at the Pavilion Theatre. He exhibited at the Royal Academy, the Old Water Colour Society and elsewhere, 1827–40, his subjects being mainly coastal and river scenes and naval engagements. He died in London on 29 October 1840.

COLLINS, *William*

Born in London on 18 September 1788, William Collins was the son of an Irish picture dealer. He entered the Royal Academy Schools in 1807 and exhibited 121 pictures at the Academy from 1807 to 1846, mainly landscapes

with rustic figures. He was elected A.R.A. in 1814 and R.A. in 1820. He made some journeys abroad and is said to have endangered his health by sketching in hot sunshine in Italy. He died in London on 17 February 1847. Collins was the father of the Pre-Raphaelite adherent Charles Allston Collins and the novelist Wilkie Collins.

CONSTABLE, *John*

Born in East Bergholt, Suffolk, on 11 June 1776, John Constable was the son of a well-to-do miller, Golding Constable. After a good general education he worked for a trial period in the paternal mill, but his wish to be a painter was strong enough to overcome opposition and he became a student in the Royal Academy Schools in 1798. His first exhibited picture, entitled simply *A landscape* (1802), was commended by Benjamin West, then P.R.A., whose dictum that 'light and shadow never stand still' was to be superbly borne out in Constable's work. Though Suffolk remained foremost in his affections, Constable visited various parts of England in the next few years: Kent in 1805, the Lake District in 1806, Warwickshire in 1809, Salisbury in 1811. He became engaged in 1811 to Maria Bicknell, granddaughter of the rector of East Bergholt, Dr Rhudde, though they were not married until 1816. His father died in that year and his inheritance, together with the bequest to Maria from Dr Rhudde, who died in 1819, freed them from financial worry. No longer hampered by portrait commissions Constable could devote himself to landscape. They moved to Keppel Street, Russell Square, London, in 1817, though Constable continued to make regular visits to his native Suffolk; these visits were varied by excursions to Salisbury to see his friend and patron, the Reverend John Fisher, and to Brighton for the sake of his wife's health. He found a patron in Sir George Beaumont, connoisseur and amateur painter, but recognition was slow to come from the public and the Academy. He was an unsuccessful candidate for A.R.A. in 1813, not being granted Associateship until 1819, and was again unsuccessful in his candidature in 1821 for full membership as R.A. For this he had to wait another eight years. In contrast was his instant success in France, where *The haywain* deeply impressed artists and others at the Salon of 1824 and gained him the award of a gold medal. In 1827 the family, by this time including three sons and three daugh-

ters, moved to Well Walk, Hampstead. A fourth son was born in 1828, the year Constable's wife died. His *Hadleigh Castle* (London, Tate Gallery), exhibited at the R.A. in 1829, seemed to reflect the personal agitation of the time in its restless technique. In 1829, at last elected R.A., he began work on *English Landscape*, with mezzotints by David Lucas from Constable's paintings and the artist's own letterpress. The final part of the work was issued in 1832 and the publication of his notes encouraged him to expand them in a series of lectures delivered at various places between 1833 and 1836. The course given in 1836 at the Royal Institution surveyed the origin and historical development of landscape painting and gave an incisive account of its decline in the eighteenth century and revival in England.

Constable died on 1 April 1837. Though he left much pictorial testimony to his affection for his native region, thus permanently affixing the name 'Constable country' to the Stour valley near his birthplace on the borders of Essex and Suffolk, he painted masterpieces of landscape also at Hampstead, Salisbury, Brighton and elsewhere. He is well represented in the National Gallery, London, and the Tate Gallery, but an unrivalled London collection of his works is in the Victoria and Albert Museum, mainly the gift made in 1888 by Constable's daughter, Isabel, in her own name and on behalf of her sister Marie Louisa and her brother Lionel Bicknell. The gift comprised 98 oil paintings, 300 drawings and watercolours and three sketchbooks. This splendid addition to the Sheepshanks gift of six paintings in 1857 was complemented by the bequest in 1900 of the full-scale oil sketches for the *Leaping horse* and *The haywain*.

COX, *David*

Born in Deritend, near Birmingham, on 29 April 1783, David Cox found early employment in scene painting at the Birmingham Theatre Royal. In 1804 he came to London, where he had lessons in watercolour from John Varley and also worked at Astley's Theatre. He first exhibited at the Royal Academy in 1805 and was a constant exhibitor at the Old Water Colour Society, 1812–59. He became a drawing master at Dulwich and later at Hereford, painting frequently in North Wales. He had lessons in oil painting from William Müller in 1839 and

was Keeper of the National Gallery and under a new dispensation was made Director in 1855. His knowledge and appreciation of art in Italy, combined with that of his wife, *née* Elizabeth Rigby, whom he married in 1849, enabled him to secure wonderful works to add to the National Gallery in London. He died in Pisa on 24 December 1865.

ETTY, *William*

Born in York on 10 March 1787, William Etty was the seventh child of a miller, baker and confectioner. He was apprenticed at twelve to a letterpress printer in Hull, with whom he served seven years, but when nineteen he went to London with the help of relatives to study art. In 1807 he entered the Royal Academy Schools, where he continued to work from the living model for most of his life. He also worked for a year in Thomas Lawrence's studio, greatly admiring that master's style of portraiture. He exhibited at the Royal Academy from 1811 and first gained success in the period 1816–21, especially with *The coral finder— Venus and her youthful satellites arriving at the Isle of Paphos* (1820) and *Cleopatra's arrival in Cilicia* (1821; Port Sunlight, Lady Lever Art Gallery). A trip to Italy in 1822–3, where he was mostly attracted by Venice, made him an enthusiastic student of Titian, Tintoretto and Veronese. His own warm colour and handling of flesh tones in painting the nude derived a stimulus from them, though his admiration for Rubens was another factor of influence. That Rubens was inspiring to Delacroix also helps to explain a certain superficial likeness between Etty and his great French contemporary; as well as the general nature of a period much affected by the idea of a Romantic 'grand manner'. In 1824 Etty's *Pandora crowned by the seasons* (now at Leeds Art Gallery) was bought by Sir Thomas Lawrence, then P.R.A. Etty was elected A.R.A. in 1824 and R.A. in 1828. His works included Biblical subjects, mythological, allegorical and historical compositions, paintings of single nude figures, portraits and a certain number of landscapes and still lifes. The collection of over 130 works of his choice at the Society of Arts in the Adelphi must have presented a sumptuous spectacle but was not a financial success and received little praise. Etty died later in the same year, on 13 November 1849.

FAED, *Thomas*

Born in Burley Mill, Kirkcudbrightshire, on 8 June 1826, Thomas Faed was the son of a Scottish engineer and millwright. On his father's death the boy, aged fifteen, joined his elder brother John, already established as a painter in Edinburgh. Thomas Faed studied at the Trustees' Academy and in 1849 was elected Associate of the Royal Scottish Academy, exhibiting in that year his painting of *Scott and his friends at Abbotsford*. He first exhibited at the Royal Academy in 1851 and in the following year settled in London. He was a regular contributor of paintings essentially popular favourites in comprising pathos, humour and domestic sentiment in portrayal of Scottish peasant life, a sound technique offsetting the tendency to sentimentalize. He was elected A.R.A. in 1861, R.A. in 1864 and continued to exhibit until 1892, when his failing sight compelled him to give up painting. He died in St John's Wood on 17 August 1900.

FRITH, *William Powell*

Born in Aldfield, Yorkshire, on 9 January 1819, William Powell Frith went through the usual curriculum of early nineteenth-century art training, going to Sass's drawing school in 1835 and becoming a student in the Royal Academy Schools in 1837. His first exhibited works were literary illustrations and imagined historical scenes such as were popular at the time. In 1840 he sent *Othello and Desdemona* and *Jenny Deans and Madge Wildfire* to the British Institution and *Malvolio before the Countess Olivia* to the Royal Academy. In 1842 his *Dolly Varden* had the approval of Dickens. In 1845 *The village pastor* suggested by Goldsmith's poem led to his election as A.R.A. A series of pictures followed giving a nineteenth-century view of an earlier age, for example, *English merry-making a hundred years ago* (1847). He was elected R.A. in 1853.

A break with literature and historical anecdote is clearly indicated in the first of his major works, scenes of contemporary life: the picture of holiday Margate, *Life at the seaside* (Royal Collection), an Academy sensation of 1854 bought by Queen Victoria. It is tempting to think that Frith was influenced by the Pre-Raphaelite conception of 'truth to nature' though he always professed to regard Pre-Raphaelitism as an eccentric craze. He

scarcely seems to have realized what a departure he had made, for in the following year he was still Shakespearian with *Maria tricks Malvolio*. But in 1858 followed his masterpiece *Derby Day* (Plate 103) with its panoramic pattern of incident and inimitable stamp of truth to an observed scene. In spite of its success, Frith does not seem to have clearly distinguished its contemporaneous character from his other work and in 1860 he was still capable of the novelette style of *Claude Duval, the highwayman, compelling a lady to dance for him*. But in 1862 *The railway station* returned to realism, completing a social trilogy of permanent value. His later *Road to ruin* and *Race for wealth* series combined realism with ethical purpose. An outstanding work of group portraiture was *The private view* of 1883. Frith died on 2 November 1909 in his ninety-first year.

FUSELI, *Henry*

Born in Zürich on 7 February 1741, Johann Heinrich Füssli, later known as Henry Fuseli, had two periods of work in England: first from 1764 to 1770 and then from 1779 to 1825, the year of his death at Putney Hill in the house of his patron, the Countess of Guildford. The second English period, which extended into the nineteenth century, reflects the storm and stress of Romanticism in the atmosphere of terror, suspense and dream and the emphasis on the demoniac and fantastic. He gained fame in 1782 with *The nightmare* (Zürich, Kunsthaus). The opening of Boydell's Shakespeare Gallery in 1789 heightened his always strong interest in Shakespearian subjects, divided towards the end of the eighteenth century between the climactic moments of terror in *Macbeth* and the spirit world of *A Midsummer Night's Dream*. His own Milton Gallery was a sequel, 1799–1800, to which *Sin pursued by death* (Zürich, Kunsthaus) and *Satan building the bridge over chaos* were among his contributions. Legendary episodes occupied his last years, for example *Theseus and the Minotaur*, exhibited at the Academy in 1820. Fuseli was elected R.A. in 1790 and was Professor of Painting at the Royal Academy from 1799 to 1805. He became Keeper of the Academy with residence at Somerset House in 1804 and in 1810 was re-elected Professor. In 1805 he edited *Pilkington's Dictionary of Painters* and wrote the introduction to the edition of Blair's *The Grave* with Blake's designs. He died in London on 16 April 1825 and was buried in St Paul's Cathedral.

Minor followers in an imaginative vein in the early nineteenth century were William Young Ottley (1771–1836) and Theodor von Holst (1810–44).

GALE, *William*

Born in London, 1823, William Gale attended the Royal Academy Schools. He painted mainly historical, Biblical and mythological subjects, although his early works also include some genre scenes in Pre-Raphaelite style, of which *The confidante* (1857; London, Tate Gallery) is an example. He exhibited at the Royal Academy from 1844 to 1893. He travelled to Italy (1851), Syria (1862), Palestine (1867) and Algeria (1876–7) and died in 1909.

GOODALL, *Frederick*

Born in 1822, a member of an artistic family, Frederick Goodall was taught by his father, the engraver Edward Goodall. From 1838 he exhibited at the Royal Academy and was elected A.R.A. in 1852 and R.A. in 1863. Early in his career he found material for many pictures in visits to Normandy, Brittany and Ireland, and varied village subjects with excursions into the anecdotal 'olden time' so often favoured by Victorian painters. In 1858 he visited Egypt and most of his later subjects were scriptural with an Egyptian setting or views of the Nile and the Pyramids. He died in London on 28 August 1904.

GRANT, *Sir Francis*

Born in 1803, the younger son of Francis Grant, laird of Kilgraston in Perthshire, Francis Grant was educated for the bar but abandoned the law for painting at the age of twenty-four. Devoted to fox-hunting and other sports, he made them the subject of his early pictures; his first exhibit at the Royal Academy was *The Melton breakfast* (1834). *The Melton Hunt* (1839) contained some thirty-six portraits. In 1841 he painted the equestrian portrait of Queen Victoria accompanied by Lord Melbourne and the Lords-in-Waiting (Royal Collection), made popular in engraving. He subsequently devoted himself mainly to portraiture and had many aristocratic sitters. He became President of the Royal Academy and was knighted in 1866.

As P.R.A. he skilfully concluded the negotiations with the Government that enabled the Academy to occupy Burlington House. He died in Melton Mowbray, Leicester, in 1878.

GREAVES, *Walter*

Born in Chelsea on 4 July 1846, Walter Greaves was one of six children of a Thames waterman and boatbuilder. He and his brother Henry as boys decorated the prows of the city barges kept at Chelsea and began to paint the river scene. *Hammersmith Bridge on boat race day* (London, Tate Gallery) was a remarkable work by Walter Greaves, dated 1862. It was in the following year that he first saw Whistler sketching Old Battersea Bridge, and acquaintance with him subsequently became devotion. For twenty years Greaves was Whistler's handyman and assistant, imitating the master's mannerisms of dress and copying his style, although his paintings nevertheless retained a distinct style of their own. Whistler severed all connection with the Greaves brothers in the 1880s. The boatbuilding business also came to an end and the brothers lived by selling drawings and etching for small sums. Critical approval for an exhibition in 1911 did not rescue Walter Greaves from poverty. His last eight years were spent as a Poor Brother in the Charterhouse, where he died on 23 November 1930.

GRIMSHAW, *Atkinson*

Born in Leeds on 6 September 1836, a policeman's son, Atkinson Grimshaw formed an early ambition to be a painter. He worked as a clerk on the Great Northern Railway from 1852 to 1861 but his wife, whom he married when he was twenty-two, encouraged him to paint in his spare time. During the 1860s he had considerable success working independently, especially with his moonlight landscapes. In 1870 he was able to rent a large Jacobean house, Knostrop. In reaction against the strictness of a Nonconformist upbringing he and his wife became Catholic. Financial and other difficulties followed but in 1880 Grimshaw began to paint the town scenes—streets and docks in London, Leeds, Liverpool and Hull—that uniquely evoked the late Victorian urban background. He died at Knostrop on 13 October 1893.

HAVELL, *Edmund*

Born in 1819, the son of a landscape painter of the same name, Edmund Havell lived in Reading and London. He exhibited at the Royal Academy from 1835 to 1895. His work includes mainly genre subjects and portraits but he also produced a number of lithographs. He died in 1894.

HAYDON, *Benjamin Robert*

Born in Plymouth on 26 January 1786, the son of a bookseller in the town, Benjamin Robert Haydon went to London to study at the Royal Academy Schools in 1804. His first efforts in 'high art', *The death of L. Sicinius Dentatus* and *Macbeth*, were coldly received. Disappointment caused him to launch an attack on the Royal Academy that he later violently repeated. His next works, *The judgment of Solomon* and *Christ's entry into Jerusalem*, brought him considerable sums, though not enough to clear the debts that harassed him throughout his life. His huge *Raising of Lazarus* (1821–3) was seized and sold by one of his creditors. A few days later he was imprisoned for debt. Released with the help of friends, he painted some portraits and examples of popular genre: *The mock election* bought by George IV, *Chairing the member* (London, Tate Gallery) and *Punch or May Day* (Plate 19)—all ably executed though a descent from his lofty ambitions. To be passed over in 1843 in the competition for decorating the Houses of Parliament was a sad blow but worse was to come. His *Banishment of Aristides* and *The burning of Rome by Nero*, exhibited in 1846 at the Egyptian Hall, attracted no attention and incurred a heavy loss, while General Tom Thumb, a freak on show in the same building, drew large crowds. In despair he took his life on 21 June 1846. Despite his violence of temper Haydon was a man of discernment as shown by his efforts to obtain the acquisition of the Elgin Marbles for the nation; and a conspicuous literary gift appeared in his *Autobiography and Journals*, published in 1853.

HERBERT, *John Rogers*

Born in Maldon, Essex, on 23 January 1810, John Rogers Herbert went to London in 1826 to study at the Royal Academy Schools. His early paintings were of Romantic

subjects but about 1840 he became Roman Catholic through the influence of Welby Pugin, with whom he shared a reverence for medieval art. A similar trend of thought and belief to that of the German Nazarenes gave simplicity and earnestness to his style. He was elected A.R.A. in 1841 and R.A. in 1846. He contributed frescoes to the decoration of the Houses of Parliament although these are of less note than his easel pictures and have not lasted so well. Herbert died in Kilburn in 1890.

HODGSON, *John Evan*

Born in London in 1831, John Evan Hodgson spent his early youth in Russia. Returning to London, he was educated at Rugby and, after a short commercial career, entered the Royal Academy Schools in 1853. He exhibited at the Royal Academy from 1856 to 1893, was elected A.R.A. in 1872 and R.A. in 1879. He was Librarian and Professor of Painting at the Academy from 1882 to 1895. He painted genre, landscape and historical pictures, but after visiting North Africa in 1868 his works were almost exclusively Eastern in subject. He died in 1895.

HOLL, *Frank*

Born in London in 1845, son of Francis Holl, A.R.A., an engraver, Frank Holl went to the Royal Academy Schools in 1860 and first exhibited at the Academy in 1864. Aiming as he put it 'to bring home to the hearts and minds of Mayfair the temptations to which the poor are ever subject' he was for some time a vigorous exponent of social realism. He was elected A.R.A. in 1878 and R.A. in 1884. He was also a fashionable portrait painter, whose sitters included the Prince of Wales, William Gladstone, Lord Roberts and John Bright. He died in London in 1888.

HOLLAND, *James*

Born in Burslem, Staffordshire, on 17 October 1800, James Holland worked as a boy in the factory of James Davenport painting flowers on pottery. He went to London in 1819 and made a living by teaching and painting flower pieces, examples of which gained acceptance in the Royal Academy of 1824. He turned to landscape after a visit to Paris in 1831 and made several painting tours on the Continent. Italy and Portugal especially attracted him and he painted many Venetian scenes. He painted in both oil and watercolour and was made a member of the Old Water Colour Society in 1857. He died in London on 12 February 1870.

HOPKINS, *William H.*

A landscape, animal and sporting painter, whose hunting pictures were very popular in the second half of the nineteenth century, William Hopkins is documented from 1853 to 1890. He sometimes collaborated with Edmund Havell, who painted the figures in Hopkins's scenes. He died in 1892.

HUGHES, *Arthur*

Born in London on 27 January 1830, Arthur Hughes studied in 1846 at the School of Design, Somerset House, under Alfred Stevens and after at the Royal Academy Schools. His painting *Musidora* (Birmingham, City Museum and Art Gallery) was his first Academy exhibit in 1849. He was much impressed by the personalities and aims of the Pre-Raphaelite Brotherhood, and a number of works, such as *April love* (1856; bought by William Morris, now in the Tate Gallery), *The long engagement* (1859; Birmingham, City Museum and Art Gallery) and *Home from sea* (1863; Oxford, Ashmolean Museum), closely associate him with the Pre-Raphaelite movement. He collaborated with Rossetti and his other assistants in the attempt to decorate the debating hall of the Oxford Union in 1857. He became one of the distinguished book illustrators of the 1860s, his delicacy of line appearing in an example such as his designs for Christina Rossetti's book of nursery rhymes, *Sing Song*. Hughes was awarded a Civil List pension in 1912. He died at Kew on 23 December 1915.

HUNT, *William Holman*

Born in London on 2 April 1827, William Holman Hunt was the eldest son of a warehouse manager. For some years he was clerk to an estate agent and took lessons from a portrait painter, H. Rogers, in his spare time. At seventeen he was copying works in the British Museum and

National Gallery and about this time met John Everett Millais. He entered the Royal Academy Schools in 1844 and first exhibited at the Academy in 1846. With Millais he gained enthusiasm in 1847 for 'truth to nature' from Ruskin's *Modern Painters*. He came under the spell of Dante Gabriel Rossetti in 1848. He, Millais and Rossetti were the moving spirits of the Pre-Raphaelite Brotherhood of seven members, the others being William Michael Rossetti, F. G. Stephens, Thomas Woolner and James Collinson. Hunt shared a studio with Rossetti in 1848–9, and in 1849 went with him to Paris, Belgium and Holland.

Between 1849 and 1853 he produced many of his finest and best-known paintings: *Rienzi* (1849; Plate 74), *An Early Christian family sheltering from the persecution of the Druids* (1850; Oxford, Ashmolean Museum), *Claudio and Isabella* (1850; London, Tate Gallery), *Valentine rescuing Sylvia from Proteus* (1851; Birmingham, City Museum and Art Gallery), *The hireling shepherd* (1851; Plate 96), *The light of the world*, (1853; Keble College, Oxford), *The awakening conscience* (1853). His first trip to Egypt and Palestine in 1854–5 produced *The finding of the Saviour in the Temple*, finished in 1856 (Birmingham, City Museum and Art Gallery), and *The scapegoat* (1854; Port Sunlight, Lady Lever Art Gallery). The 1860s were years mainly of portrait painting. After the death of his first wife in 1866 he went abroad, staying in Jerusalem, 1869–72; he went again in 1875–8. He expended arduous labour on *The shadow of death* (1873; Leeds, City Art Gallery) and *The triumph of the innocents* (1887; Liverpool, Walker Art Gallery). The best of his later works were *The Lady of Shalott* (1886–1905; Manchester, City Art Gallery) and *May morning on Magdalen Tower* (1888–90; Port Sunlight, Lady Lever Art Gallery). His monumental but somewhat one-sided book *Pre-Raphaelitism and the Pre-Raphaelite Brotherhood* was published in 1905. He died in London on 7 September 1910 and was buried in St Paul's Cathedral.

INCHBOLD, *John William*

Born in Leeds on 29 April 1830, John William Inchbold was a son of the proprietor and editor of the *Leeds Intelligencer*. He had lessons in watercolour from Louis Haghe, topographical draughtsman and lithographer, and in 1847 became a student at the Royal Academy, where he exhibited from 1851 onwards. Ruskin praised him as one who carried Pre-Raphaelite detail into landscape; he singled out *The moorland* in the Royal Academy of 1855 and advised visitors to the Academy of 1856 to bring a small opera glass with them to examine 'the exquisite painting of withered heather and rock' in Inchbold's *The Burn, November: the Cucullen Hills*. Inchbold adopted a freer style in later years, mainly spent abroad. He died in Headingley, near Leeds, on 23 January 1888.

LANDSEER, *Sir Edwin Henry*

Born in London on 7 March 1802, youngest son of John Landseer the engraver, Edwin Henry Landseer showed a talent for drawing animals as early as the age of five. He had no regular education of a general kind but some tuition in art from his father and B. R. Haydon. He became a student in the Royal Academy Schools when he was fourteen, having already distinguished himself by gaining two awards from the Society of Arts for drawing animals from life and by showing two animal drawings in 1815 in the annual Academy exhibition. Paintings such as the *Fighting dogs getting wind* (1818) displayed a reaction to animal violence in contrast with the canine humours of his later works. In 1824 he made the first of many journeys to the Highlands, in the company of C. R. Leslie, visiting Sir Walter Scott in Abbotsford. The Romanticism of the period had its response in paintings of mountain and lake and wild life. In *The battle of Chevy Chase* (Plate 43) he seems to have drawn on two Romantic sources, Scott's *Border Minstrels* and, by internal evidence, Delacroix. Landseer quickly gained fame and popularity, was elected A.R.A. in 1826, R.A. in 1831, and on the accession of Queen Victoria was much in demand for pictures of the royal family and their household pets. He was a favoured visitor at Balmoral and Osborne and was knighted in 1850. An alternation appeared in his paintings of animals, between the comedy of dogs in human roles from *Jack in office* (1831) to *Alexander and Diogenes* (1848); the natural pathos of *The old shepherd's chief mourner* (1837); and the sense of the wild in *Man proposes, God disposes* (Plate 122). The lions at the base of the Nelson Monument in Trafalgar Square in London, his main work as a sculptor, were completed in 1867. Landseer's later years were clouded by mental illness. He died in London on 1 October 1873 and was buried in St Paul's Cathedral.

LAWRENCE, *Sir Thomas*

Sir Thomas Lawrence, born in Bristol on 13 April 1769, can be seen in both an eighteenth- and a nineteenth-century context. On the one hand he was a final representative of the great school of portraiture made illustrious by Reynolds and Gainsborough. Lawrence seemed the predestined successor to Sir Joshua Reynolds; on the latter's death in 1792 he followed as King's Painter in Ordinary. But he was only twenty-two when in 1791 in accordance with the royal wish he was elected A.R.A., an exception to the Academy rule that an Associate should be at least twenty-four. Precocious though he was, his main work was still to be accomplished in the new century. The death of Opie in 1807 and of Hoppner in 1810 left him without serious rival in portraiture. He was able to give a unique picture of British society during the Regency and the reign of George IV; he also produced that great assemblage of paintings of European sovereigns, ministers and soldiers begun in 1814, completed after the final defeat of Napoleon, and preserved in the Waterloo Chamber at Windsor. A restlessness of style that attracted the attention of Géricault and Delacroix belonged to the Romantic age. He made few departures from portraiture after his Miltonic effort of 1787, *Satan summoning his legions* (London, Royal Academy), and in the more than three hundred works he exhibited at the Academy until 1830. He withdrew reluctantly from the attempt to excel in imaginative composition, probably finding some compensation in the pleasure afforded him by his great collection of old master drawings, tribute to his excellent taste. He became President of the Royal Academy in 1820. In addition to being made a Fellow of the Royal Society and LL.D. of Oxford he was awarded many foreign distinctions. He died in London on 7 January 1830 and was buried in St Paul's Cathedral.

LEIGHTON, *Frederic, Lord*

Born in Scarborough, Yorkshire, in 1830, the son of a physician, Frederic Leighton had a liberal education abroad, visiting Italy, Germany and France; he had drawing lessons in Rome, attended the Academy in Florence and studied under the Austrian Nazarene, Johann Steinle, in Frankfurt. In 1849 he spent some time in Paris copying Titian and Correggio. From about 1852 to 1855 he worked independently in Rome, a result being his *Cimabue's Madonna carried in procession through the streets of Florence*, an Academy success in 1855 and bought by Queen Victoria. He settled in London about 1860, though he frequently travelled abroad, especially through the Mediterranean and in the Middle East. In 1866 he moved into the house built to his design at 2 Holland Park Road, soon famous for its Arabian Court and its social and musical gatherings. Leighton was one of the artists who made the 1860s eminent in illustration, contributing to the Dalziel Bible. He painted murals in spirit fresco—*The wise and foolish virgins* in Lyndhurst Church and *The industrial arts of war and peace* for the South Kensington Museum (1872–3). He also took up sculpture and his *Athlete struggling with a python* was a Chantrey purchase for the nation in 1877. In addition he painted many classically inspired pictures, of which his *Daphnephoria* of 1876 and *Captive Andromache* of 1888 were examples. He was elected A.R.A. in 1864, R.A. in 1868 and P.R.A. in 1878. As President, handsome, learned, socially accomplished, a great linguist and first-rate administrator, he brought the Royal Academy to its social zenith. He was made a baronet in 1886 and baron as Lord Leighton of Stretton on 1 January 1896. He was the first artist to be made a lord but died in London on 25 January of the same year. He was buried in St Paul's Cathedral.

LEWIS, *John Frederick*

Born in London on 14 July 1805, John Frederick Lewis was the eldest son of Frederick Christian Lewis, landscape painter and engraver, whose works included stipple engravings after chalk portraits by Sir Thomas Lawrence. J. F. Lewis first painted in oil and exhibited pictures of animals at the British Institution and Royal Academy in the early 1820s. Probably through the interest of Lawrence, a friend of the family, he was employed by George IV in 1824 to paint sporting subjects at Windsor Great Park. From 1827 when he first went abroad he devoted himself to watercolour. In 1830 he was elected member of the Old Water Colour Society and exhibited at the Society's annual exhibitions from 1827 to 1838. A visit to Spain in 1832–3 was important in his development, causing him to use pure colour to represent intensity of light. In 1837 he went

abroad again and did not return to England for thirteen years. After visiting Rome, Athens and Constantinople, he arrived at Cairo in 1841 where, although he lived in exotic splendour (described by Thackeray), he busied himself for years with studies of Egyptian streets, interiors and characters. The brilliant colour and minute detail in *The hhareem* (now in the Victoria and Albert Museum) astonished London, where it was exhibited in 1850. Having married an English girl in Cairo, he returned with her to London in 1851 and during the next twenty-five years drew on his accumulated Egyptian material for the pictures that Ruskin praised in superlative terms. He reverted to oil painting in 1858, at the same time resigning his presidency of the Water Colour Society. He was elected A.R.A. in 1859 and R.A. in 1865. In oil he intensified the brilliance of his watercolour.

LOUTHERBOURG, *Philip James de*

Born in Strasbourg on 1 November 1740, Philip James de Loutherbourg was a painter whose history in terms of years belongs mostly to the eighteenth century but who also represents the restless spirit that heralded and characterized the Romantic transition from the one century to the next. He painted with Romantic gusto scenes of storm, battle and shipwreck; his facility in dramatic composition increased with his employment as stage designer for David Garrick after he came to England in 1771. The appreciation of mighty forces at work to be found in other artists at the turn of the century appears in his choice of *The Deluge* and the *Angel destroying the Assyrian Host* as his illustrations for Macklin's Bible. He exhibited at the Royal Academy, 1772–1812, although he was a victim of religious mania in his late years. He was elected R.A. in 1781 and died in Chiswick on 11 March 1812.

McCULLOCH, *Horatio*

Born in Glasgow in 1805, the son of a weaver, Horatio McCulloch worked as a house painter in early life but determined to devote himself to landscape painting. He studied under a landscape artist named Knox and, after an interlude spent in colouring prints for an engraver in Edinburgh when he was about twenty, returned to Glasgow and began to exhibit landscapes there and in the

Scottish Academy in 1829. He was elected A.S.A. in 1834 and full Academician in 1838, when he moved to Edinburgh. He gained a considerable reputation for his paintings of Scottish scenery. He died in Edinburgh in 1867.

MACLISE, *Daniel*

Born in Cork on 2 February 1806, the son of a Scots ex-soldier who married and settled in the city, Daniel Maclise studied at the Cork School of Art. He saved enough from sketch portraits—an outline of Sir Walter Scott from life gained him some celebrity—to go to London in 1827 and study in the Royal Academy Schools. His early Academy exhibits, after his first contribution in 1829 of *Malvolio*, were watercolour portraits for the most part. He took to oil in 1832 and was prolific in such scenes of imagined history as *Merry Christmas in the Baron's Hall* and of drama as *Macbeth and the weird sisters*, the actor Macready serving as his model for Macbeth. Introduced by Forster to Dickens about 1838, Maclise painted the novelist's portrait in 1839 (Plate 61). His acquaintance with the literary world was shown in a remarkable series of outline portraits for *Fraser's Magazine*. Elected A.R.A. in 1835, he became R.A. in 1840. Paintings such as his *Caxton showing his printing-press to Edward IV* (1851; London, Victoria and Albert Museum) and *The marriage of Eva and Strongbow* (1854; Dublin, National Gallery of Ireland) encouraged him to volunteer huge historical wall paintings for the Houses of Parliament in 1857. He suffered both in health and spirits from the immense labour of painting the frescoes of *Wellington and Blücher* (Plate 109) and *The death of Nelson* that occupied him until 1865. In 1866 he declined the presidency of the Royal Academy though he continued to exhibit at the Academy; a last historical work, *The Earls of Desmond and Ormond*, appeared in the annual exhibition after he died in Chelsea on 25 April 1870.

McTAGGART, *William*

Born in Kintyre, Argyllshire, in 1835, William McTaggart left home when sixteen to study art in Edinburgh at the Trustees' Academy under Robert Scott Lauder, an influential teacher. Lauder's pupils also included William Orchardson and John Pettie. McTaggart was elected Associate of the Royal Scottish Academy in 1859. Apart

from working as a portrait painter, he developed an individual style of composition, figures being incidentally introduced and set against a landscape background, often a loch or sandy shore with a distant view of the sea. The broader style of his later years can be viewed as a kind of Impressionism but seems to have been independently evolved, without French Impressionist influence. He was elected R.S.A. in 1870. In his later years he exhibited mainly at the Scottish Water Colour Society. He died in Dalkeith, Midlothian, in 1910.

MARSHALL, *Thomas Falcon*

Born in Liverpool on 18 December 1818, Thomas Falcon Marshall first worked and exhibited as a painter in his native city from 1836. He became an Associate of the Liverpool Academy in 1843 and a Member in 1846; he had also exhibited at the Royal Academy since 1839 and in 1844 went to live in London. The paintings he exhibited at the Academy until 1878 included genre scenes, landscapes, portraits and historical subjects. He died in Kensington on 20 March 1878.

MARTIN, *John*

Born on 19 July 1789 in Haydon Bridge, Northumberland, in a poor but strictly religious household, John Martin began his career as apprentice to a coach painter in Newcastle but ran away. He was befriended by an Italian artist, Boniface Musso, who had settled in Newcastle and gave Martin lessons in painting. He went to London in 1806 and found employment for a time in glass painting. His *Sadak in search of the waters of oblivion* attracted notice in the Academy of 1812 and foreshadowed the supernatural drama of his later work. Home readings of the Old Testament affected him and his three brothers in various ways. Jonathan became a religious maniac, William an eccentric and Richard a poet on Biblical themes; John Martin painted apocalyptic visions of celestial wrath and violence. In stupendous succession came *The fall of Babylon* (1819), *Belshazzar's feast* (1820), *The Deluge* (1820) and *The fall of Nineveh* (1828). Paintings of Adam and Eve gained him the commission to illustrate *Paradise Lost* with mezzotints (1824–8). A last apocalyptic trilogy—*The Last Judgment*, *The Great Day of His Wrath* (with the earth splitting and

mountains crumbling) and in consolation *The plains of Heaven*—was produced between 1851 and 1854. Martin died on 17 February 1854 in Douglas, Isle of Man.

MILLAIS, *Sir John Everett*

Born in Southampton on 8 June 1829, John Everett Millais came of a Jersey family of French extraction. On the advice of Sir Martin Archer Shee, then President of the Royal Academy, he was sent at an early age to Sass's drawing school and at eleven was the youngest student ever to enter the Royal Academy Schools. He exhibited his first picture at the Academy, *Pizarro seizing the Inca of Peru* (London, Victoria and Albert Museum), when he was sixteen. His brilliant abilities fascinated his fellow student William Holman Hunt. They, together with Dante Gabriel Rossetti, who supplied much of the motive force, formed the Pre-Raphaelite Brotherhood in 1848. The idea of 'truth to nature' derived from Ruskin was applied by Millais with an astonishing virtuosity in his portraits of the Oxford printseller James Wyatt and his family (1849). Masterpieces of this time included *Lorenzo and Isabella* (1849; Plate 94), *Christ in the house of His Parents* (1850; London, Tate Gallery), *The return of the dove to the ark* (1851; Plate 76) and *Ophelia* (1852; London, National Gallery). *The order of release* of 1853 (London, Tate Gallery) was more in the popular genre style he later practised. The portrait of John Ruskin (1854) was finely Pre-Raphaelite, although it marked a divergence of ways, since before it was finished Ruskin's wife had left him and declared her intention of marrying Millais.

Memorable pictures later in the 1850s were *The blind girl* and *Autumn leaves* of 1856 (both in Birmingham, City Museum and Art Gallery), *Sir Isumbras at the ford* (Port Sunlight, Lady Lever Art Gallery) and *The vale of rest* of 1858 (London, Tate Gallery). In the following decade Millais adopted a broader and at the same time more Victorian mode of painting and a more popular choice of subject matter. Thereafter he painted sentimental pictures of childhood such as *My first sermon* and its companion picture *My second sermon;* and historical anecdote such as the average Victorian enjoyed, a celebrated example being *The boyhood of Raleigh* of 1870 (London, Tate Gallery). The best works of his later years were portraits, among them his portraits of Gladstone (1878; Plate 152)

and Louise Jopling (1879). He also painted a number of landscapes, including his *Chill October* of 1871. Millais was elected A.R.A. in 1853 and R.A. in 1863. He was made a baronet in 1885 and elected P.R.A. in 1896, although he died on 13 August of the same year. His illustrations to *Good Words, Cornhill*, the Moxon edition of *Tennyson*, and the Dalziel *Parables of Our Lord* (1864) were a distinguished section of his work.

MOORE, *Albert Joseph*

Born in York on 4 September 1841, Albert Joseph Moore was the fourteenth child of the portrait painter William Moore, and brother of the marine painter Henry Moore and the portrait and landscape painter John Collingham Moore. As a child he had some lessons from his father and at the York School of Design. When the family moved to London in 1855, four years after his father's death, he finished his education at Kensington Grammar School, exhibited two watercolours at the Royal Academy in 1857 and entered the Royal Academy Schools in 1858. Early works were Biblical in subject, an outstanding picture, painted during a visit to Rome, being *Elijah's Sacrifice* (Bury, Art Gallery), exhibited at the Academy in 1865. A dramatic change in both subject and style was *The marble seat* in the same exhibition, the first of the many compositions to which he thenceforward devoted himself, of female figures, mostly in decorative repose, whose classical draperies echoed the rhythms of the Parthenon sculptures he studied in the British Museum. Though his friend the architect William Eden Nesfield had interested him in design as related to architecture and helped him to secure commissions for wallpapers, tiles, stained glass and mural work, the easel picture was his main concern, each being devised with careful deliberation and preceded by detailed studies of figure and drapery. He led an uneventful bachelor existence without marks of official recognition (although his exhibited works extended over forty years) except for his election as Associate of the Royal Water Colour Society in 1884. In 1865 he met Whistler, who admired him as the one great English artist of the day and who for a time was influenced by the classical ideal implicit in Moore's work. Moore in return introduced elements of the *japonaiserie* that appealed so much to

Whistler and in this hybrid character his art became representative of the 'aesthetic' late Victorian tendency. He died in Kensington on 25 September 1893.

MÜLLER, *William James*

Born in Bristol on 28 June 1812, William James Müller was the son of J. S. Müller of Danzig, Curator of the Bristol Museum. He studied art under the landscape painter J. B. Pyne and, devoting himself to landscape, travelled extensively in search of subjects. In 1831 he visited Norfolk and Suffolk, in 1833 North Wales. He also travelled in Germany, Switzerland and Italy in 1834, Greece and Egypt in 1838 and France in 1840. He made his home in London in 1839 and exhibited works at the Royal Academy from 1833 to 1845. In 1843-4 he accompanied Charles Fellows on an official expedition to Lycia making numerous sketches of Oriental life and scenery. In failing health he went back to Bristol and died there on 8 September 1845. More than seventy of his drawings and watercolours were presented to the Tate Gallery by Lady Weston in 1908.

MULREADY, *William*

Born in Ennis, County Clare, Ireland, in April 1786, William Mulready was brought to London at the age of five when his parents migrated from Ireland. With an early aptitude in drawing he was admitted as a student at the Royal Academy Schools at the age of fourteen. Later he became an assistant teacher in the studio of John Varley, who had numerous pupils. When he was eighteen he married Varley's sister by whom, before they separated, he had four children. He began to exhibit at the Royal Academy in 1804 but it was not until 1809, after experimental efforts in 'high art', that he found his *métier* in domestic genre with *The carpenter's shop*, exhibited at the British Institution. He was elected A.R.A. in 1815 and R.A. in 1816, the year in which he exhibited his masterly *The fight interrupted* (London, Victoria and Albert Museum). Although he followed Wilkie's example in genre scenes with a touch of humour, his method was quite different, his compositions being worked out with great care and many preliminary drawings. He illustrated a number of

works, including the *Vicar of Wakefield*, and in 1840 designed the first penny-postage envelope for Rowland Hill. Though best known for his genre subjects he also painted landscapes, portraits and a very Victorian nude in *Bathers surprised* (1849; Dublin, National Gallery of Ireland). He died in London on 7 July 1863.

NICOL, *Erskine*

Born in Leith in 1825, Erskine Nicol studied art at the Trustees' Academy, Edinburgh, under Sir William Allan and Thomas Duncan and worked for some time as drawing master at the Leith Academy. He gained an appointment in Dublin and during four years' residence in Ireland acquired an appreciation of Irish life and character from which he derived his most successful pictures. He returned to Edinburgh but finally settled in England. He was elected Associate of the Royal Scottish Academy in 1855 and full Academician in 1859. He was also elected Associate of the Royal Academy in 1886 but retired because of ill health in 1885. He died in Feltham, Middlesex, in 1904.

O'CONNOR, *John*

An Irish painter and watercolourist, born in 1830, John O'Connor worked in Belfast and Dublin as a painter of theatrical scenery. He came to London in 1848 and was principal painter of scenery at the Drury Lane and Haymarket theatres. About 1855 he began painting topographical views, which he exhibited at the Royal Academy from 1857 to 1888. He travelled and painted towns in Germany, Italy, Spain and India. He died in 1889.

O'NEILL, *George Bernard*

Born in Dublin in 1828, George Bernard O'Neill studied in the Royal Academy Schools and was one of the popular genre painters of the Victorian years. Typical works were *The foundling* of 1852, a bequest to the Tate Gallery (since on loan to the Walker Art Gallery in Liverpool), and *Public opinion* of 1863 (Leeds, City Art Gallery) showing the throng round the 'picture of the year' that periodically required the protection of a rail. He died in 1917.

ORCHARDSON, *Sir William Quiller*

Born in Edinburgh in 1832, of Highland descent, William Quiller Orchardson was admitted to the Trustees' Academy, Edinburgh, when he was only thirteen; towards the end of his studentship he felt the stimulating influence of Scott Lauder, appointed headmaster in 1852. In 1862 Orchardson went to London. He first exhibited at the Royal Academy in the following year and was elected A.R.A. in 1868 and R.A. in 1877. He came into prominence in 1877 with *The queen of the swords* (version in the National Gallery of Scotland in Edinburgh), the title being taken from the description of a character in Sir Walter Scott's *The Pirate*. His varied output included social scenes in eighteenth-century costume; episodes of the Revolutionary and Napoleonic periods, e.g. *Napoleon on board the 'Bellerophon'* (London, Tate Gallery), a Chantrey Bequest purchase of 1880; scenes illustrative of contemporary manners; and portraits. He was an honorary R.S.A., a D.C.L. of Oxford and was knighted in 1907. He died in London on 13 April 1910.

PALMER, *Samuel*

Born in Newington on 27 January 1805, Samuel Palmer was the son of a bookseller, Samuel Palmer, and his wife, *née* Martha Giles, daughter of a well-to-do banker whose bequest of money was to give his grandson some years of independence as an artist. Samuel Palmer the younger was the elder of two surviving children; his brother William, who became an attendant in the Antique Gallery at the British Museum, is only of note as having sold the 'Rossetti MS' of William Blake to D. G. Rossetti for ten shillings. Samuel was educated at home and had some lessons in art from an obscure landscape painter, William Wate. In 1822 he met John Linnell, a prospering portrait and landscape painter of thirty who introduced him to the work of Dürer, Michelangelo and William Blake—and in 1824 to Blake in person. Blake's strength of personality and conversation inspired a visionary enthusiasm in Palmer that he communicated to his friends George Richmond, Edward Calvert and Frederick Tatham. From about 1826 to 1834, forced to leave London by ill health, he lived with his father at the village of Shoreham in Kent, entertaining his friends—styled as a group 'the Ancients'

—and painting and drawing with ecstatic fervour the pastoral subjects that were his main achievement. His later work in watercolour, though creditable in a Victorian style, lacked the imaginative force of the Shoreham years. A visit to Italy in 1837–9 marks the change in his work. He married Linnell's daughter in 1837 and seems to have suffered as an artist from the criticism of his masterful father-in-law. Palmer was made a member of the Old Water Colour Society in 1854 and contributed to the Royal Academy exhibitions until 1873. A member of the Etching Club, he made a few etched plates. He died in Redhill on 24 May 1881.

PATON, *Sir Joseph Noel*

Born in 1821 in Dunfermline, where his father was a pattern designer, Joseph Noel Paton was first employed for three years (1839–42) at Paisley as designer of muslins. In 1843 he entered the Royal Academy Schools, where he formed a lasting friendship with John Millais. He had success in the Westminster Hall cartoon competitions and seems to have absorbed something of the German Nazarene style. He was elected Associate of the Royal Scottish Academy in 1847 and full Academician in 1850. Appointed Queen's Limner for Scotland in 1865 and knighted in 1867 he devoted himself to religious, morally improving and Romantic compositions carried out with a Pre-Raphaelite copiousness of detail. He published *Poems of a Painter* in 1861 and received the honorary degree of LL.D. at Edinburgh University in 1876. He died in Edinburgh in 1901.

PETHER, *Henry*

Born in 1828, Henry Pether was the son of Abraham Pether and brother of Sebastian Pether, both painters. Henry Pether painted landscapes, particularly moonlight scenes, and exhibited at the Royal Academy (1828–62). He died in 1865.

PETTIE, *John*

Born in Edinburgh in 1839, John Pettie studied art at the Trustees' Academy, Edinburgh, under Scott Lauder. In 1858 he exhibited his first picture at the Royal Scottish Academy but the favourable reception of some of his paintings in London encouraged him to go south to the capital in 1862. He was elected A.R.A. in 1866 and R.A. in 1873. His work included imagined historical scenes, popular genre in costume, and subjects taken from Shakespeare and Sir Walter Scott. A sentimental survival of Romanticism was *The vigil*, a purchase for the nation through the Chantrey Bequest in 1884. Pettie died in Hastings in 1893.

PHILLIP, *John*

Born in Aberdeen in 1817, John Phillip was in youth apprenticed to a house painter, but his promise in art sent him to London in 1836 with the aid of Scottish patrons. In 1837 he became a student at the Royal Academy, where he first exhibited in 1838. Returning to Aberdeen in 1839, he remained there for six years painting portraits and genre subjects after the manner of Wilkie, then settled in London. In 1851, after a severe illness, he went to convalesce in the warmth of southern Spain; his stay in Seville led to a complete change of style and subject, which again brings Wilkie to mind. The scenes and characters he painted in Seville, Toledo and Segovia earned him the nickname of 'Phillip of Spain'. He was elected A.R.A. in 1857 and R.A. in 1859. Phillip three times visited Spain, with fruitful result. He died in Kensington on 27 February 1867.

POOLE, *Paul Falconer*

Born in Bristol on 28 December 1807, Paul Falconer Poole was a self-taught artist, whose work had two distinct phases. In the earlier he painted rustic scenes and single figures of country girls and children. In his mature phase he plunged into history with a dramatic force that went far beyond the usual type of anecdote. After first exhibiting at the Royal Academy in 1830 he allowed seven years to pass before submitting another painting. In 1843 his change of mood was marked by the sensational *Solomon Eagle exhorting the people to repentance during the plague in London of 1665*. He followed up this success with other imagined scenes of drama from the past, such as *The Goths in Italy* of 1851 (Plate 87). He was elected A.R.A. in 1846 and R.A. in 1861. He won an award of £300 in 1847 in the Westminster Hall cartoon competition, his subject

being *Edward the Third's generosity to the burgesses of Calais*. He died in Hampstead on 22 September 1879.

POYNTER, *Sir Edward John*

Born in Paris on 20 March 1836, Edward John Poynter was the son of the architect Ambrose Poynter and great grandson of Thomas Banks, the sculptor. He benefited by advice from Frederic Leighton on a visit to Rome in 1853, entered the Royal Academy Schools in 1855 and was a pupil of the classicist Gleyre in Paris, 1856–9, along with George Du Maurier and others of the group of students described in *Trilby*. Settled in London in the 1860s, he divided his efforts in that decade between decorative design such as his contribution to a mosaic frieze and painted tiles in the grill-room at the South Kensington Museum and to the exterior frieze circling the Albert Hall; and historical paintings with a strong narrative interest such as his Pompeian sentry *Faithful unto death* (1865), *Israel in Egypt* (1867), and *The catapult* (1868). In later works he varied from the scholarly formality of an academic classicism in his *Visit to Aesculpius* (1880) and more freely fanciful paintings of the nude in Utopian settings. An artist of many official distinctions, he was elected A.R.A. in 1869, R.A. in 1876 and was P.R.A. from 1896 until 1918. He was the first Slade Professor, University College London (1871–5), Director of the Art Training Schools in South Kensington (1875–81), and Director of the National Gallery in London (1894–1905). He died in London on 26 July 1919 and was buried in St Paul's Cathedral. His wife was the sister of Lady Burne-Jones and an aunt of Rudyard Kipling.

RAEBURN, *Sir Henry*

Born in Stockbridge, near Edinburgh, on 4 March 1756, Henry Raeburn was virtually self-taught as an artist. He already enjoyed some success before studying in Italy for two years (1785–7). Returning to Edinburgh he gained a leading place as a portrait painter and in 1795 built a large studio in York Place, where he painted the notabilities of law, literature and Scottish society. His style, basically formed on that of Sir Joshua Reynolds, took on a dramatic and Romantic character in his portraits of the early years of the nineteenth century. His Highland chiefs, in the picturesque attire of which he made the most, often seem to have stepped from the pages of Sir Walter Scott; a striking example is given in his portrait of Colonel Macdonell of Glengarry (Plate 22), said to have been the original of Fergus MacIvor in *Waverley*. In 1812 Raeburn was elected President of the Society of Artists and Associate of the Royal Academy, becoming an Academician in 1815. He was knighted when George IV visited Edinburgh in 1822 and was shortly after appointed His Majesty's Limner for Scotland. He died in Edinburgh on 8 July 1823.

RICHMOND, *George*

Born in the village of Brompton, now in central London, on 28 March 1809, George Richmond was the son of Thomas Richmond, a miniature painter. At fifteen he became a student at the Royal Academy Schools, where he was a pupil of Henry Fuseli. Like his friend Samuel Palmer, with whom he was associated in the group known as 'the Ancients', he was much influenced when about twenty by William Blake. Later he turned to portraiture and four portrait drawings in the Royal Academy of 1833 brought him many commissions. He spent two years in Italy, 1837–9, and then began to paint in oil. He was elected A.R.A. in 1857 and R.A. in 1866 (he retired in 1887). He died in London on 19 March 1896. His son, Sir William Blake Richmond (1842–1921), knighted in 1897, was painter and designer of mosaic decorations in St Paul's Cathedral.

RITCHIE, *John*

A London genre painter, John Ritchie exhibited at the Royal Academy from 1858 to 1875. Many of his pictures were imaginary scenes with figures in sixteenth- and seventeenth-century dress.

RIVIERE, *Briton*

Born in London on 14 August 1840 of Huguenot descent, Briton Riviere was the son of William Riviere, drawing master at Cheltenham College. He showed a precocious talent in animal drawing. Before he was twelve he had two

pictures exhibited in the British Institution; and, when eighteen, three in the Royal Academy of 1858. Pre-Raphaelitism at Oxford, where he took a degree, may have briefly influenced him but was soon rejected in favour of paintings in which animals played a prominent role. A regular exhibitor at the Royal Academy from 1858 to 1919, he was elected A.R.A. in 1877, R.A. in 1880. In the 1860s he also worked in black and white for *Good Words* and *Punch*. He died in London on 20 April 1920.

ROSSETTI, *Dante Gabriel*

Born in London on 12 May 1828, Gabriel Charles Dante Rossetti (who later preferred the form Dante Gabriel Rossetti) was the son of Gabriele Rossetti, Italian poet, political exile and professor of Italian at King's College, Cambridge. Dante Gabriel was educated at King's College and studied art at Sass's drawing school and in the Royal Academy Antique School (1845–6), there meeting Millais and Holman Hunt. In 1847 he bought from William Palmer the manuscript volume of William Blake's drawings and writings that greatly influenced him. In 1848 he was a pupil for a month or two of Ford Madox Brown. The Cyclographic Club, the sketching society to which he belonged, provided a nucleus in the same year for the Pre-Raphaelite Brotherhood, of which he was the main promoter; the other members were Holman Hunt, Millais, T. Woolner, F. G. Stephens, W. M. Rossetti and J. Collinson. Rossetti's first two Pre-Raphaelite pictures, *The girlhood of Mary Virgin* of 1849 and *Ecce Ancilla Domini* of 1849–50 (Plate 75), were exhibited independently of his friends of the Brotherhood. The latter work was severely criticized and as a result he ceased exhibiting in public and took to painting (in watercolour) poetic subjects taken from Dante and Browning (1850–4). About 1854 he discovered Malory's *Morte d'Arthur* and added Arthurian subjects in watercolour. He contributed poems to the *Oxford and Cambridge Magazine* in 1856 and in the same year gained disciples in two young Oxford men, Edward Burne-Jones and William Morris, with whom and other enthusiasts he made the attempt in 1857 to decorate the debating hall of the Oxford Union with frescoes. Though a technical fiasco the effort suggested other forms of design than the easel picture. Illustrations to Moxon's *Tennyson* (1857), designs for stained glass for the firm launched by William Morris (1861) and an altar piece for Llandaff Cathedral were his varied employments.

Rossetti married the beautiful Elizabeth Siddal in 1860. Her death in 1862 altered his way of life and his art. He again took to oil painting and became affluent though increasingly liable to melancholia. The recovery in 1869 of the book of manuscript poems he had buried with his wife and the subsequent attack on the published *Poems* by Robert Buchanan in 1871 were agitations that caused his collapse in 1872. Thenceforward an invalid, Rossetti continued to write poetry and paint; Mrs Morris, for whom he had a great affection, appeared in many mystically allegorical roles—in pictures such as his *Proserpine* (Liverpool, Walker Art Gallery). A late work in oil was *Dante's dream* (1870–81; Liverpool, Walker Art Gallery). His *Ballads and Sonnets* was published in 1881. He died in April 1882 in Birchington-on-Sea, near Margate, a holiday resort where he had hoped to recuperate.

SARGENT, *John Singer*

Born in Florence on 17 January 1856 of American parents, John Singer Sargent lived an expatriate life in Europe and England though he always remained an American citizen. He studied art at the Florence Academy, 1868–9, and with Carolus-Duran and at the École des Beaux-Arts in Paris, showing a precocious talent. Claude Monet, whom he met in 1876, was an early influence on his work, although his style was also formed by the study of Velazquez at the Prado and Hals at Haarlem. The scandal caused by his *Madame Gautreau* in the Salon of 1884, seemingly on no other ground than the portrait's brilliance, led to his moving to England in 1885. His *Carnation, Lily, Lily, Rose* (London, Tate Gallery), exhibited at the Royal Academy in 1887, was bought for the nation through the Chantrey Bequest. Though he was one of the founder members of the New English Art Club in 1886 with a certain Impressionist sense of light and open air in landscapes and figures painted in the open, his portraits were in the traditional grand manner with a facility and vigour that made them sought after on both sides of the Atlantic. In 1889 he painted his dramatic *Ellen Terry as Lady Macbeth* (London, Tate Gallery). In 1890 he was in the United States, inundated with portrait commissions, and was

commissioned to decorate the Boston Library with mural paintings (1890–1916). His great series of Wertheimer portraits was painted in 1898. Meanwhile he exhibited constantly at the Royal Academy and was elected A.R.A. in 1894 and R.A. in 1898. After 1905 he spent the summers sketching on the Continent and devoted himself increasingly to watercolour landscapes. During the First World War he produced war pictures, of which *Gassed* (1918; London, Imperial War Museum), was a moving example. He died on 15 April 1925 in his studio in Tite Street, Chelsea, when just about to go to America to instal murals, commissioned in 1916, in the Boston Museum.

SCOTT, *David*

Born on 10 October 1806 in Edinburgh, David Scott was the son of an engraver in the city, Robert Scott, and the elder brother of William Bell Scott, painter, poet and writer on art. David Scott studied under his father and at the Trustees' Academy. Ambition to excel in imaginative art caused him to rebel against the prospect of working as engraver in his father's workshop. In 1827 he began life drawing and planned a huge canvas of *Lot and his daughters fleeing from the cities of the plain*, completed in 1829. The gloomily Romantic trend of his thought appears in the subject of his first exhibited work, *The hopes of early genius dispelled by death*. He was elected an Associate of the Scottish Academy in 1829 and a full member in 1835. In 1831 he etched a series of illustrations to *The Ancient Mariner*, published in 1837 but meeting with little success. He visited Italy from 1832 to 1834, though his comments on the work of the Italian masters were defiantly critical. A huge work of this period was *Discord*, apparently symbolizing the revolt of a new order against the old (exhibited at the Scottish Academy in 1840). He was prolific in historical and fanciful subjects, but exhibited only two paintings at the Royal Academy; after the Academy had skied one of his paintings and rejected another, he refused to send any more. His largest picture, *The spirit of the storm* (Leith, Trinity House), exhibited at his own expense, failed to win applause. Another disappointment was his lack of success in the competition of 1842 for paintings in the new Houses of Parliament. His last years were marked by increasing gloom aggravated by illness. He died on 5 March 1849.

SICKERT, *Walter Richard*

Born on 31 May 1860 in Munich, Walter Richard Sickert was the son of the Danish artist Oswald Adalbert Sickert and his wife Nelly, who was of Anglo-Irish descent. As a young man he was on the stage for a while in minor parts but abandoned the stage for art in 1881. In 1882 he was at the Slade School for a short time but on meeting Whistler was invited to work as an assistant in his studio. In 1883 in Paris he met Degas, who greatly influenced his outlook. In 1885 he married Ellen Cobden. They set up house in Hampstead and he took a studio in the Camden Town region, of which his paintings so well caught the character. The years 1885–95 were the period of his early music-hall paintings varied by souvenirs of Dieppe, where he spent the summers. He was divorced in 1899 and for the next six years Dieppe was his headquarters. He painted in Venice also and returned to England in 1905. From 1905 to 1914 he produced further music-hall and Camden Town paintings. In 1911 Sickert gave an impetus to the formation of the Camden Town Group though the Post-Impressionist ideas of the younger men were little to his liking. His own work altered considerably with the course of time, notably in the 1920s, when he embarked on his 'Echoes' paintings done from the wood engravings of Victorian illustrators. Lightly sketched and coloured, they were not at all Victorian in character. For the authentic spirit of the late Victorian age it would be necessary to return to his work in the 1890s. Sickert was elected A.R.A. in 1924 and R.A. in 1934 but resigned a year later. He died at the age of eighty-two in Bathampton, near Bath, on 22 January 1942.

SMITH, *George*

A London genre painter born in 1829, George Smith attended the Royal Academy Schools. He painted mainly domestic scenes, often with children. He died in 1901.

SOLOMON, *Abraham*

Born in London in 1824, Abraham Solomon was a genre painter who exhibited with success in the Royal Academy exhibitions of the mid-century. A favourite device of his was that of painting pictures in pairs, giving a story in two

parts. Thus the tense family group in *Waiting for the verdict* (1857) found relief in *The acquittal* (1859). Both pictures (now in the Tunbridge Wells Public Library and Museum) were immediately popular. He had employed a similar method in his *Second class—the parting* and *First class—the meeting* (1854); they had the additional interest of accurately representing the first-class and second-class carriages of the period of the London and North Western Railway. Solomon died in Biarritz in 1862 on the day that he was elected A.R.A.

SOLOMON, *Solomon Joseph*

Born in London on 16 September 1860, the son of a leather manufacturer, Solomon Joseph Solomon studied art at the Royal Academy Schools and at the École des Beaux-Arts in Paris. He painted allegorical and Biblical subjects in the dramatic style of which his *Samson* (Plate 143) gives an example. He was also a portrait painter, whose sitters included the Earl of Oxford and Asquith, Ramsay Mac-Donald, the Gaekwar of Baroda, Lady Rhondda and Israel Zangwill. He was a camouflage officer in the British Army in 1916 and published a work on *Strategic Camouflage* as well as *The Practice of Painting*. He died in 1927.

STANFIELD, *William Clarkson*

Born in Sunderland in 1793, Clarkson Stanfield went to sea in the merchant service at the age of fifteen. In 1812 he was pressed into the Navy, from which he got his discharge in 1818. This experience of sea and ships stood him in good stead in the marine paintings by which he later became well known. Until 1834 he worked as a scene painter at various theatres, including Drury Lane, but began to exhibit pictures at the Royal Academy in 1820 and was a founder member of the Society of British Artists in 1823. From 1827 until his death he was a regular exhibitor at the Academy, elected A.R.A. in 1832 and R.A. in 1835. As well as sea pieces he painted views of France, Holland and Italy; he was especially fond of Italian scenery. A friend of Dickens and Wilkie Collins, he painted the drop-scene of Collins's melodrama *The Frozen Deep* that was much admired and hung by Dickens in the hall at Gad's Hill. Stanfield died in Hampstead on 18 May 1867.

STANHOPE, *John Roddam Spencer*

Born in 1829, John Roddam Spencer Stanhope was a pupil of G. F. Watts, who recommended him to make a special study of the Elgin Marbles. But as a youth at Oxford he was so far associated with Pre-Raphaelitism as to take part in 1857, with D. G. Rossetti and his allies, in the venture of decorating the debating hall of the Oxford Union. He was much influenced by Burne-Jones, as appears in the wistful and seemingly sexless figures of his imaginative compositions. The combination of allegory and symbolism in the manner of Watts with Pre-Raphael-ite detail was echoed in the work of his niece, Evelyn Pickering, who became the wife of the potter William de Morgan. After 1872 Stanhope lived in the Villa Nuti on the outskirts of Florence and died there in 1908.

STEER, *Philip Wilson*

Born in Birkenhead, Cheshire, on 28 December 1860, Philip Wilson Steer was the son of a portrait and landscape painter at that time teaching in Birkenhead. He was looked after by a Welsh nurse, Margaret Jones, later Mrs Raynes, who became his housekeeper in London. Failing to gain admission to the Royal Academy Schools in 1882, he went to Paris and studied under Cabanel at the École des Beaux-Arts, returning to England in 1884. Between 1884 and 1889 he painted on the east coast, in Walberswick mainly, fresh and atmospheric works that suggested some acquaintance with the ideas of Seurat and Neo-Impressionism. He was a founder member of the New English Art Club in 1886. In 1889 he exhibited eight paintings in the London Impressionists' exhibition at the Goupil Gallery with Sickert and other members of the New English Art Club. In 1893 he was appointed teacher of painting at the Slade School. In 1898 he settled at Cheyne Walk, Chelsea, and from then on made yearly expeditions to various districts of Britain, reviving a free style of water-colour. His oil paintings were influenced by both Constable and Turner. Though mainly considered as a landscape painter, Steer made excursions into other fields, including informal portraiture and nudes such as *The toilet of Venus* (1898; London, Tate Gallery). A large retrospective exhibition was held at the Tate Gallery in 1929. In 1930 he retired from the Slade and in 1931 was awarded the

Order of Merit. Almost blind, he continued to live in his Chelsea house during the Second World War until his death on 21 March 1942.

STEVENS, *Alfred*

Born in Blandford, Dorset, in 1817, Alfred Stevens was the son of a heraldic painter and house decorator. A great impression was made on him by years spent in Italy from 1833. He remained until 1842 studying architecture, sculpture and painting mainly in Florence and Rome and was assistant to the sculptor, Thorwaldsen (1841–2). From 1845 to 1847 he was a professor in the Government School of Design at Somerset House and in 1850 a designer for Messrs Hoole of Sheffield, securing them first place at the 1851 exhibition for their stoves and fenders. In 1852 he designed the lions for the British Museum railings. In 1856 he began his chief work—the design for the Wellington Monument in St Paul's Cathedral, which occupied him for the rest of his life. He planned an outstanding decorative scheme for Dorchester House (1858–62). In many drawings and designs he seemed to have taken on the character of an artist in the High Renaissance of Italy, but his few male and female portraits were masterpieces of a different kind, without the least trace of another period's style. He died in London on 1 May 1875.

TISSOT, *James Jacques Joseph*

Born on 15 October 1836 in Nantes, James Jacques Joseph Tissot went to Paris to study art in about 1856. His early exhibited works were historical scenes influenced by the Belgian painter Henri Leys. In 1864 he exhibited at the Royal Academy for the first time, a medieval subject. Later in the 1860s he turned to subjects from modern life. He contributed cartoons to the magazine *Vanity Fair* (1869–77). Living in London in the 1870s, after taking part in the Paris Commune, he had success with his conversation pieces, their riverside setting suggesting the attraction he had found in Whistler's early paintings and etchings of the Thames. From 1877 to 1879 he exhibited at the Grosvenor Gallery, and in these years also produced many etchings. The death of his beloved Kathleen Newton marks the end of his English period. He exhibited

pictures of Parisian life in 1885 and in 1886 made the first of his journeys to Palestine to work on illustrations for his *Life of Christ*. The drawings and the companion set of the Old Testament (1894–6) were, as works of art, far below the standard of his pictures of everyday life. From 1897 he lived as a recluse at the Château of Buillon, near Besançon, and died there on 8 August 1902.

TURNER, *Joseph Mallord William*

With the advent of the nineteenth century the scope and abilities of Joseph Mallord William Turner, born in Maiden Lane, London, on 23 April 1775, found immense expansion. He had come to the end of the formative years, 1787–99, when he was engaged mainly in the production of topographical watercolours. In 1802 he was able to go abroad for the first time, when the Treaty (or truce) of Amiens made foreign travel possible again; he travelled through France and Switzerland and studied masterpieces in the Louvre. His *Calais Pier* (London, National Gallery) magnificently signalized his Channel crossing. In 1802 he was also elected full member of the Royal Academy. In 1807 he was painting quietly delightful views direct from nature on the Thames between Walton and Windsor. But the Romantic spirit of the time affected him in several ways, inducing the restless journeying that became his continued habit and a love of dramatic effects of height and distance, of storm and unleashed natural forces, and scenes intended to convey reflection on the decline and fall of empires and the helplessness of humanity. In 1817 he made his first visit to the Netherlands and the Rhine Valley, and in 1819 the light of Italy—visited for the first time by way of Switzerland—was a revelation. Between 1821 and 1828 he travelled almost constantly in France, the Netherlands and Italy. In the intervals he worked much at Petworth, seat of his friend and patron the Earl of Egremont, there producing a number of his most unconventional masterpieces of colour. 1829 was the year of his great *Ulysses deriding Polyphemus* (Plate 52). In 1831 he visited Scotland for material to illustrate Scott's *Poems* and stayed in Abbotsford. In 1834 he painted the spectacular night scene of fire at the Houses of Parliament. A final phase of foreign travel between 1835 and 1844 took him twice to Venice and several times to Switzerland. In 1839 or thereabouts he took a cottage in Chelsea (118–19

Cheyne Row), where whimsically adopting the name of his housekeeper, Mrs Booth, he lived in seclusion. It was usual to think of his work as virtually over with *The 'fighting Téméraire'* of 1838 but not only had he such masterpieces still to paint as the *Snowstorm at sea* and *Rain, steam and speed*, re-examination of his great bequest to the nation has brought to view many poetic abstractions never publicly exhibited. The first volume of Ruskin's *Modern Painters*, with its sustained eulogy of Turner, was published in 1843. Turner exhibited paintings for the last time in 1850 and died at his Chelsea cottage on 19 December 1851, his extraordinary genius having taken its independent course over the whole first half of the century. He was buried in St Paul's Cathedral.

WALLIS, *Henry*

Born in Sutton, near London, in 1830, Henry Wallis was a pupil at Cary's Academy and the Academy Schools and in the studio of Charles Gleyre in Paris. He exhibited at the Royal Academy from 1854 to 1877. His best-known work is *The death of Chatterton* (1856; London, Tate Gallery), which Ruskin described as 'faultless and wonderful'. The model for Chatterton was George Meredith, with whose wife Wallis eloped in 1858. His other famous work is *The stonebreaker* (1857; Plate 106), one of the most beautiful of Pre-Raphaelite paintings. Wallis travelled extensively in Italy and the Near East and produced several books on Italian and Persian ceramics. He died in Croydon, near London, in 1916.

WARD, *James*

Born in London on 23 October 1769, the son of a fruit merchant, James Ward was an artist whose long life extended into the second half of the nineteenth century. He first studied engraving under John Raphael Smith, but left him in 1783 and became apprentice to his elder brother, the mezzotint engraver William Ward. He took up painting in this period imitating the style of his brother-in-law, George Morland, and becoming popular for his portrayal of animals. He first exhibited at the Royal Academy in 1797 and remained a frequent contributor until 1855. In 1794 he was appointed painter and mezzotint engraver to the Prince of Wales, and was elected

A.R.A. in 1807 and R.A. in 1811. The Romantic ambition of the new century was a virus that caused him to develop a contempt for the homely subjects of Morland as well as reproof for Morland's Bohemian way of life. Instead he took Rubens as his guide, with powerful result in his *Bulls fighting* (Plate 9). The Romantic love of vastness incited him to the huge and gloomy landscape of *Gordale Scar, Yorkshire* (London, Tate Gallery). Ambition overleapt with his attempt to make a huge allegory from the Battle of Waterloo that occupied him from 1815 to 1821. He returned to the emulation of Paul Potter, if not Morland, in cattle pieces, and painted numerous horse portraits. He died in Cheshunt, near London, on 16 November 1859.

WATSON, *George*

Born in 1767 at his father's estate of Overmains, Berwickshire, George Watson first studied art under the portrait and landscape painter Alexander Nasmyth. After working for two years in London he settled in Edinburgh, where he gained an extensive practice as portrait painter at the same time as, and to some extent in competition with, Raeburn. When the Scottish Academy was founded in 1826 he was elected its first President, retaining this position until his death. He died on 24 August 1837 in Edinburgh.

WATTS, *George Frederic*

Born in London on 23 February 1817, George Frederic Watts entered the Royal Academy Schools in 1835 and studied the Parthenon sculptures in the British Museum. He also gained ideas of art from frequenting the studio of William Behnes, the sculptor. At twenty he was an exhibitor at the Royal Academy and in 1843 won a prize of £300 in the competition for the Westminster Hall cartoons that enabled him to go to Florence for about three years. In England in 1847 he won a second prize in the Westminster Hall concours with his *Alfred inciting his subjects to prevent the landing of the Danes* (House of Lords). Indifference to his desire to paint mural paintings resulted in two directions of effort: the portraits in which he seemed to give so much of the majesty and at the same time the doubts and tensions of the great Victorians; and the allegories of love, life and death in which during the 1880s he tended to become over-didactic. Among his few pieces of sculpture, the

heroic *Physical energy* (English version in London, Kensington Gardens), a monument to Cecil Rhodes on the Matoppo Hills in South Africa, was an outstanding work. The Renaissance style of patron and domestically entertained genius was repeated in his thirty years' stay at Little Holland House with Mr and Mrs Thoby Prinsep, only briefly disturbed by his unfortunate marriage to the young Ellen Terry. Latterly he had a country house, Limnerslease, in Compton, Surrey, where his second wife built the neighbouring gallery that houses a permanent collection of his work. Watts was elected R.A. in 1867 and received the Order of Merit in 1902. He died in Compton on 1 July 1904.

WHISTLER, *James Abbot McNeill*

Born in Lowell, Massachusetts, on 11 July 1834, James Abbot McNeill Whistler was the third son of Major George Washington Whistler, civil engineer, and eldest son of his second wife, Anna Matilda McNeill. In 1843 the family moved to Russia, where Major Whistler had taken a post as civil engineer on the St Petersburg–Moscow railroad. In 1845 James took drawing lessons at the Imperial Academy of Science in St Petersburg. Returning to America, he entered the West Point Military Academy in 1851 but was discharged in 1854. He then worked on the U.S. Coast Survey but resigned in 1855. From 1856 to 1859 he was an art student in Paris, where he met the English students Poynter, Du Maurier and L. M. Lamont at the atelier of Gleyre. A tour of northern France produced his 'French Set' of etchings in 1858. In the same year he met Henri Fantin-Latour and Courbet, whose influence appears in Whistler's first important oil painting, *Au piano* (Cincinnati, Art Museum), exhibited at the Royal Academy in 1860. In 1859 Whistler moved to London and began the superb series of etchings known as the 'Thames Set'; his painting of the river, *The Thames in ice* (Washington, D.C., Freer Gallery of Art), was accepted at the Academy in 1862. In 1863 he lived in Cheyne Walk, Chelsea, a few doors from D. G. Rossetti, and at this time was a link between the *avant-gardes* of France and England. His *Symphony in white, no.1 : the white girl* (Washington, D.C., National Gallery of Art) was prominent in the Salon des Refusés of 1863. He brought the French vogue for Far Eastern art to England. In 1865 he met Albert Moore and

was encouraged to attempt a similar kind of classicism. His visit to Valparaiso in 1866 and the seascapes it produced were a prelude to his Thames 'Nocturnes'. The art of Albert Moore, and the Japanese prints that inspired his *Nocturne in blue and gold: Old Battersea Bridge* (Plate 135) combined in his renunciation of Courbet's realism in 1867.

The 1870s were the great years of Whistler's art, when he gave his titles musical description, e.g. 'Nocturne', 'Symphony', 'Arrangement', to denote his sole concern with beauty uncomplicated by subject. The aesthetic development is marked by *The artist's mother* (1871–2; Paris, Louvre), *Thomas Carlyle* (Plate 133), *The falling rocket* (1875; Detroit, Institute of Art) and that brilliant work of decoration, the *Peacock Room*, painted for F. R. Leyland's London home and now in the Freer Gallery of Art, Washington. Ruskin's harsh criticism of *The falling rocket* led Whistler to sue Ruskin for libel. The trial took place in 1878, and although Whistler won a moral victory by being awarded one farthing damages, the cost of the action led to his bankruptcy. He travelled a great deal on the Continent thereafter and was much taken up with etchings, and lithographs of Venice, Amsterdam, Paris and London. Appointed President of the Royal Society of British Artists, he resigned in 1888 with the famous quip 'the artists went out and the British remained'. He delivered his famous Ten o'clock Lecture in 1885, and in 1900 published *The Gentle Art of Making Enemies*, which included the account of the 1878 trial and sparkled with his brilliance of wit. He died in London on 17 July 1903.

WILKIE, *Sir David*

Born on 18 November 1785 in Cults, near Edinburgh, David Wilkie was the son of the local minister. Showing an early liking for art and especially the work of the Dutch and Flemish genre painters, he was sent to study at the Trustees' Academy, Edinburgh, in 1799. A work of early promise was *Pitlessie Fair* (1804; Edinburgh, National Gallery of Scotland). He also showed an aptitude for portraiture, much in the style of Raeburn. He went to the Academy Schools in London in 1805 and quickly gained patrons and popularity with works exhibited at the Academy. His *Village politicians* (1805; private collection) and *The blind fiddler* (1806; London, Tate Gallery) began the

series of immensely popular compositions of an anecdotal and humorous kind, facile in sentiment but minutely detailed; the best of them in animated action are *Blind man's buff* of 1812 and *The penny wedding* of 1818 (both in the Royal Collection). In a more soberly realistic vein, his *Chelsea Pensioners reading the Gazette of the Battle of Waterloo* (London, Wellington Museum) won great acclaim when exhibited in 1822. In 1825, after a severe illness, he went on a long tour of Italy and Spain and was the first English painter of his time to visit Madrid. From 1829, the paintings in a broader style, influenced by his study of Correggio, Velazquez and Murillo, lost him the popularity he had earlier enjoyed and critics long continued to agree with B. R. Haydon (Wilkie's companion in 1814 on a first visit to Paris) that 'Italy was Wilkie's ruin'. Impartial judgement in more recent times has praised the 'richer denser kind of painting' he achieved. The pitfalls of historical anecdote are evident in his *Preaching of John Knox before the Lords of Congregation, 10th June 1559* (1832; London, Tate Gallery); but his portraiture as Painter in Ordinary to the King, after the death of Lawrence in 1830, vigorously continued Lawrence's tradition, as in his *King William IV* (1833; London, Wellington Museum). In 1840 he visited Constantinople and Jerusalem with a view to painting religious themes in the Holy Land. Apart from many drawings (well represented in the Ashmolean Museum, Oxford), portraits such as his *Muhemed Ali* (1841; London, Tate Gallery) and *Sultan Abdul Meedgid* (Royal Collection) show the distinction of his later style. He died at sea on 1 June 1841 on his return journey. As quarantine laws prevented the landing of his body at Gibraltar, he was buried at sea, the event commemorated in Turner's great pictorial *in memoriam: Peace: burial at sea of Sir David Wilkie* (Plate 69).

List of collections

COMPTON (SURREY)
Watts Gallery Watts: *Ellen Terry as Ophelia* 111
 Watts: Oil sketch for *Mammon* 150

DUBLIN
Municipal Gallery of Modern Art Watts: *Mrs Louis Huth* 116

EDINBURGH
National Gallery of Scotland Etty: *Benaiah slaying two lionlike men of Moab* 45
 McTaggart: *Spring* 123
 Nicol: *An Irish emigrant landing at Liverpool* 127
 Raeburn: *Colonel Alastair Macdonell of Glengarry* 22
 Watson: *Miss Zoë de Bellecourt* 16

GLASGOW
Art Gallery and Museum McCulloch: *Glencoe* 124
 Moore: *Reading aloud* 136
 Orchardson: *Le mariage de convenance* 142
 Whistler: *Arrangement in grey and black, no. 2 :*
 Thomas Carlyle 133

The Hunterian Museum, Scott: *Russians burying their dead* 44
 University of Glasgow

LAWRENCE, KANSAS
University of Kansas Museum of Art Rossetti: *La Pia de' Tolomei* 139

LISBON
Gulbenkian Foundation Turner: *The wreck of the Minotaur on the Haak Sands* 3

LIVERPOOL
Sudley Art Gallery and Museum Raeburn: *Girl sketching* 15

Walker Art Gallery Millais: *Lorenzo and Isabella* 94, 95
 Phillip: *Gypsy sisters of Seville* 72
 S. J. Solomon: *Samson* 143
 Stevens: *Emma Pegler* 48

LONDON
Houses of Parliament

Maclise: Detail from *The meeting of Wellington and Blücher* 109

Leighton House Art Gallery
and Museum

Leighton: *Mrs Evan Gordon* 119
Leighton: *The bath of Psyche* 163 (on loan)
Lewis: *The siesta* 120 (on loan)
S. J. Solomon: *Conversation piece* 146
Stevens: *William Blundell Spence* 86 (on loan)

The London Museum

O'Connor: *St Pancras Hotel and Station* 148

National Gallery

Turner: *Ulysses deriding Polyphemus* 52, 53

National Portrait Gallery

Beechey: *Horatio Lord Nelson* 4 (on loan)
Maclise: *Charles Dickens* 61
Millais: *Thomas Carlyle (detail)* 132
Millais: *William Gladstone* 152, 153
Tissot: *Frederick Gustavus Burnaby* 154
Watts: *Cardinal Manning* 151

Royal Academy of Arts

Landseer: *John Gibson* 64

Royal Holloway College,
University of London

Collins: *Borrowdale, Cumberland, with children playing by the banks of a brook* 34
Constable: Oil sketch for *View on the Stour near Dedham* 24
Holl: *Newgate: committed for trial* 126
Holland: *Piazza dei Signori, Verona* 55
Landseer: *Man proposes, God disposes* 122
Pettie: *A state secret* 156
Riviere: *Sympathy* 147
A. Solomon: *Departure of the Diligence, Biarritz* 101
Stanfield: *The battle of Roveredo, 1796* 79

South London Art Gallery

Smith: *Sleeping boots boy* 157

The Tate Gallery

Beardsley: *Caprice* 166

Blake: *The spiritual form of Nelson guiding Leviathan* 5

Constable: *Flatford Mill, on the River Stour* 33

Constable: *The Grove, Hampstead (the admiral's house)* 47

Constable: *Chain Pier, Brighton* 58

Cox: *A windy day* 57

Crome: *Moonrise on the Yare* 10

Crome: *Slate quarries* 11

Dadd: *Fairy Feller's masterstroke* 113

Danby: *The Deluge* 65

Delamotte: *Waterperry, Oxfordshire* 13

Deverell: *Twelfth Night* 82 (on loan)

Eastlake: *The Colosseum from the Campo Vaccino* 27

Frith: *Derby Day* 93, 103

Fuseli: *Lady Macbeth seizing the daggers* 8

Greaves: *Old Battersea Bridge* 134

Haydon: *Punch or May Day* 19

Landseer: *The hunted stag* 54

Landseer: *Loch Avon and the Cairngorm Mountains* 59

de Loutherbourg: *The battle of the Nile* 1, 2

Palmer: *Coming from evening church* 38

Rossetti: *Ecce Ancilla Domini (The Annunciation)* 75

Sickert: *Aubrey Beardsley* 158

Turner: *The Thames near Walton Bridges* 12

Turner: *Hannibal and his army crossing the Alps* 20

Turner: *Chichester Canal* 50

Turner: *Snowstorm: steamboat off a harbour's mouth* 66

Turner: *Peace: burial at sea* 69

Whistler: *Symphony in white, no. 2: the little white girl* 110

Whistler: *Nocturne in blue and gold: Old Battersea Bridge* 135

United Grand Lodge Museum

Martin: *Joshua commanding the sun to stand still upon Gibeon* 21

Victoria and Albert Museum

Constable: *Willy Lott's house* 29
Constable: *Study of two ploughs* 30
Constable: *Study of a cart and horses, with a carter and dog* 31
Creswick: *A summer's afternoon* 70
Danby: *Disappointed love* 40
Landseer: '*There's no place like home*' 68
Mulready: *The seven ages* 67
Ward: *Bulls fighting* 9
Watts: *Thomas Carlyle* 131

Wellington Museum

Lawrence: *Arthur Wellesley, first Duke of Wellington* 6

MANCHESTER
City Art Gallery

Brown: *Work* 92, 99
Dicksee: *Funeral of a viking* 161
Etty: *The destruction of the temple of vice* 71
Hunt: *The hireling shepherd* 96, 97, 98
Poole: *The Goths in Italy* 87
Stanhope: *Eve tempted* 140

NEWCASTLE-UPON-TYNE
Laing Art Gallery and Museum

Hodgson: *European curiosities* 115

NEW YORK
Brooklyn Museum

Sargent: *Paul Helleu sketching with his wife* 138

NORWICH
Castle Museum

Crome: *Study of a burdock* 14

NOTTINGHAM
City Art Gallery and Museum

Bonington: *Saint Bertin, near Saint Omer— transept of the abbey* 35

WORCESTER, MASSACHUSETTS
Worcester Art Museum

Tissot: *Gentleman in a railway carriage* 128

ROYAL COLLECTION

Holl: *No tidings from the sea* 125
Landseer: *Queen Victoria, the Prince Consort and the Princess Royal at Windsor* 62
Lawrence: *Charles Philip, Prince Schwarzenberg* 7
Lawrence: *Pope Pius VII* 23
Mulready: *The wolf and the lamb* 18
Watts: *Lady Holland* 63

PRIVATE COLLECTIONS

Atkinson: *The upset flower cart* 105
Constable: *Salisbury Cathedral from the meadows* 60
Crome: *Old houses at Norwich* 46
Faed: *The last of the clan* 107, 108
Frith: *The private view at the Royal Academy* 144, 145
Gale: *The convalescent* 90
Grimshaw: *Piccadilly by night* 149
Herbert: *Children of the painter* 83
Hughes: *The knight of the sun* 102
Hughes: *Mrs Harriet Susanna Trist and son* 118
Hunt: *Rienzi* 74
Landseer: *Zippin, a dog* 28
Marshall: *The return to health* 89
Millais: *The violet's message* 85
Millais: *Amy, Marchioness of Huntly* 129
Poynter: *The cave of the storm nymphs* 171
Ritchie: *Hampstead Heath* 104
Sargent: *Robert Louis Stevenson and his wife* 155
Sargent: *Beatrice Townsend* 170
Sickert: *The mammoth comique* 167
Steer: *Nude sitting on a bed* 164
Wilkie: *Distraining for rent* 17

Acknowledgements

The author gratefully acknowledges the collaboration of Keith Roberts in the choice of the illustrations, and wishes to thank Peyton Skipwith of the Fine Art Society, and Clovis Whitfield and Miss Gabriel Naughton of Thomas Agnew and Sons Ltd for their help in procuring photographs.

Plates 7, 18, 23, 62, 63 and 125 are reproduced by gracious permission of Her Majesty The Queen.

Grateful acknowledgement is made to the following for permission to reproduce paintings in their collections: *The Trustees of Sir Colin and Lady Anderson (85); Lord Ashton of Hyde (60); Auckland City Art Gallery, Auckland (130); City Museum and Art Gallery, Birmingham (106, 112); Museum and Art Gallery, Bolton (117); City Art Gallery, Bristol (56, 91); Burnley Corporation, Burnley (100); Public Library and Art Gallery, Bury (26, 51, 73, 81, 88); Fogg Art Museum, Harvard University (Grenville L. Winthrop Bequest), Cambridge, Massachusetts (121); The National Museum of Wales, Cardiff (49); Watts Gallery, Compton (111, 150); Lord Cottesloe (167); Municipal Gallery of Modern Art, Dublin (116); The Trustees of the National Galleries of Scotland, Edinburgh (16, 17, 22, 45, 123, 127); Art Gallery and Museum, Glasgow (124, 133, 136, 142); The Hunterian Museum, University of Glasgow (44); The Marquess of Huntly (129); University of Kansas Museum of Art, Lawrence, Kansas (139); The Leggatt Trustees (4); Gulbenkian Foundation, Lisbon (3); Walker Art Gallery, Liverpool (15, 48, 72, 94, 95, 143); Kensington and Chelsea Borough Council (119, 146); The London Museum (148); The Trustees of the National Gallery, London (52, 53); The Trustees of the National Portrait Gallery, London (61, 132, 151, 152, 153, 154); Royal Academy of Arts, London (64); Royal Holloway College, University of London (24, 34, 55, 79, 101, 122, 126, 147, 156); London Borough of Southwark (157); Controller of Her Majesty's Stationery Office (Crown Copyright), London (109); The Trustees of The Tate Gallery, London (1, 2, 5, 8, 10, 11, 12, 13, 19, 20, 27, 33, 38, 47, 50, 54, 57, 58, 59, 65, 66, 69, 75, 86, 93, 103, 110, 113, 120, 134, 135, 158, 163, 166); United Grand Lodge Museum, London, (21); Victoria and Albert Museum, London (6, 9, 29, 30, 31, 40, 67, 68, 70, 131); Manchester City Art Galleries (71, 87, 92, 96, 97, 98, 99, 140, 161); Mr and Mrs Paul Mellon (46, 170); The National Trust (32, 36, 42); Laing Art Gallery and Museum, Newcastle-upon-Tyne (115); Brooklyn Museum, New York (138); City of Norwich Museums (14); City Art Gallery and Museum, Nottingham (35); National Gallery of Canada (Gift of the Massey Collection, 1946), Ottawa (168); Ashmolean Museum, Oxford (37, 39, 41, 76, 80, 84); The Earl of Plymouth (160); Ponce Art Museum, Ponce, Puerto Rico (77); Mr C. J. R. Pope (144, 145); The Trustees of the Lady Lever Art Gallery, Port Sunlight (137, 141, 162, 165); Harris Museum and Art Gallery, Preston (78); Henry E. Huntington Library and Art Gallery, San Marino, California (25); Sheffield Corporation, Sheffield (43); The Duke of Sutherland (28); Freer Gallery of Art, Washington, D.C. (114, 159); The Phillips Collection, Washington, D.C. (169); Mr and Mrs John Hay Whitney (155); Worcester Art Museum (Alexander and Caroline Murdock De Witt Fund), Worcester, Massachusetts (128).*

The publishers are also grateful to all other private owners who have given permission for works in their possession to be reproduced but who wish to remain anonymous.

Among those who have kindly provided photographs are The Arts Council of Great Britain (104); Christie's (149, 171) and Sotheby's Belgravia (89, 105).

AMES, WINSLOW: *Prince Albert and Victorian Taste* (1967)

BALSTON, THOMAS: *John Martin, 1789–1854: His Life and Works* (1947)

BARRINGTON, MRS RUSSELL: *The Life, Letters and Work of Frederic Leighton;* 2 vols (1906)

BATE, PERCY H.: *The English Pre-Raphaelite Painters: their Associates and Successors* (1899)

BECKETT, R. B.: *John Constable's Discourses* (1970)

BELL, QUENTIN: *Victorian Artists* (1967)

BOASE, T. S. R.: *English Art, 1800–1870* (1959)

BROWSE, LILLIAN: *Sickert* (1960)

BURNE-JONES, GEORGIANA: *Memorials of Edward Burne-Jones;* 2 vols. (1904)

BUTLIN, MARTIN: *Turner Watercolours* (1962)

CUNNINGHAM, ALLAN: *Lives of the Most Eminent British Painters;* Vol. 3, *continued to the present time,* by MRS CHARLES HEATON (1880)

DAVIS, FRANK: *Victorian Patrons of the Arts* (1963)

FARR, DENNIS: *William Etty* (1958)

FILDES, L. V.: *Luke Fildes, R.A., a Victorian Painter* (1968)

FINBERG, A. J.: *The Life of J. M. W. Turner, R.A.,* 2nd ed. (1961)

FREDEMAN, WILLIAM E.: *Pre-Raphaelitism: a Bibliocritical Survey* (1965)

FRITH, WILLIAM POWELL: *My Autobiography and Reminiscences;* 2 vols. (1887)

FRY, ROGER: *Reflections on English Painting* (1934)

GAUNT, WILLIAM: *The Aesthetic Adventure* (1945)

GAUNT, WILLIAM: *The Pre-Raphaelite Tragedy* (1942)

GRAY, HILDA ORCHARDSON: *The Life of Sir William Quiller Orchardson, R.A.* (1930)

GRIGSON, GEOFFREY: *Samuel Palmer: The Visionary Years* (1947)

HARDIE, MARTIN: *Water-Colour Painting in Britain;* ed. by Dudley Snelgrove with Jonathan Mayne and Basil Taylor; Vol. II: *The Romantic Period* (1967); Vol. III: *The Victorian Period* (1968)

HAYDON, BENJAMIN ROBERT: *Diary,* ed. Willard B. Pope; 5 vols. (1960–3)

HENDERSON, PHILIP: *William Morris: his life, work and friends* (1967)

HUEFFER, FORD MADOX: *Ford Madox Brown: a Record of His Life and Work* (1896)

HUNT, WILLIAM HOLMAN: *Pre-Raphaelitism and the Pre-Raphaelite Brotherhood;* 2 vols. (1905)

IRONSIDE, ROBIN: *Pre-Raphaelite Painters;* with a descriptive catalogue by John Gere (1948)

JACKSON, HOLBROOK: *The Eighteen Nineties* (1913; Pelican Books edition 1939)

KLINGENDER, FRANCIS D.: *Art and the Industrial Revolution* (1947); edited and revised by Sir Arthur Elton (1968)

LAUGHTON, BRUCE: *Philip Wilson Steer* (1972)

LESLIE, C. R.: *Memoirs of the Life of John Constable* (1951)

MAAS, JEREMY: *Victorian Painters* (1969)

MACKAIL, J. W.: *The Life of William Morris;* 2 vols. (1899)

MARILLIER, HENRY CURRIE: *Dante Gabriel Rossetti: an illustrated Memorial of His Art and Life* (1899)

MILLAIS, JOHN GUILLE: *The Life and Letters of Sir John Everett Millais;* 2 vols. (1899)

MOORE, GEORGE: *Modern Painting* (1893)

ORMOND, RICHARD: *John Singer Sargent* (1970)

PALMER, A. H.: *Samuel Palmer, A Memoir* (1882)

PEACOCK, CARLOS: *Samuel Palmer, Shoreham and after* (1968)

READE, BRIAN: *Aubrey Beardsley* (1966)

REDGRAVE, S. and R.: *A Century of Painters of the English School;* 2 vols. (1886); ed. by Ruthven Todd as *A Century of British Painters* (1947)

REYNOLDS, GRAHAM: *Victorian Painting* (1966)

ROSSETTI, WILLIAM MICHAEL: *Some Reminiscences;* 2 vols. (1906)

ROTHENSTEIN, SIR JOHN and BUTLIN, MARTIN: *Turner* (1964)

RUSKIN, JOHN: *Academy Notes* (1902)

RUSKIN, JOHN: *Modern Painters;* 5 vols. (1843–60)

RUSKIN, JOHN: *Pre-Raphaelitism* (1851)

STANDING, PERCY CROSS: *Sir Lawrence Alma-Tadema* (1905)

STIRLING, A. M. W.: *The Richmond Papers; from the correspondence and manuscripts of George Richmond, R.A., and Sir William Richmond, R.A., K.C.B.* (1926)

SURTEES, VIRGINIA: *The Paintings and Drawings of Dante Gabriel Rossetti: A Catalogue Raisonné;* 2 vols. (1971)

SUTTON, DENYS: *James McNeill Whistler* (1966)

TOWNDROW, KENNETH ROMNEY: *Alfred Stevens: a Biography with New Material* (1939)

TREVELYAN, G. M.: *English Social History* (1944)

WATTS, M. S.: *George Frederic Watts: The Annals of an Artist's Life;* 2 vols. (1912)